Presented by the author Dr. P. J. Menen Rao on the occasion of Nandyal Diocese Mission Festival held in Nandyal from 19th to 21st Feb. 2012

P. J. Menen Rao
20/02/2012

Walking with Jesus in the Holy Land
A PILGRIM'S PICTORIAL NARRATIVE

Walking with Jesus in the Holy Land

A PILGRIM'S PICTORIAL NARRATIVE

By

P.J. MANOHAR RAO

Foreword by
Rev. Dr. Ashish Amos
General Secretary, ISPCK

ISPCK
2009

Walking with Jesus in the Holy Land—Published by the Rev. Dr. Ashish Amos of the **Indian Society for Promoting Christian Knowledge** (ISPCK), Post Box 1585, Kashmere Gate, Delhi-110006.

ISBN: 81-7214-941-7

Cover design: VIRENDRA SINGH

Photo credits:

▲ Author

■ Ashish Amos

● Source Unknown

Front cover photo : Church of All Nations on the Mount of Olives

Back cover photo : The author at the Church of the Beautitudes, Capernaum

Laser typeset at **ISPCK,** Post Box 1585, 1654 Madarsa Road, Kashmere Gate, Delhi-110006, India
Tel: 91-011-23866323
e-mail–ashish@ispck.org.in • mail@ispck.org.in
website: www.ispck.org.in

Author's Complete Address:
P.J. Manohar Rao,
A-101, Yamuna Apartments,
Alaknanda, New Delhi-110 019, India
Tel: 91-011-26001581, 40533455
Fax: 91-011-4607080
e-mail: scgtc@yahoo.com

Contents

Foreword

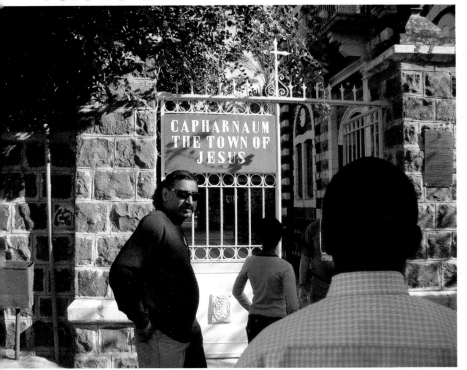

Ashish Amos in Capernaum

We are living through one of the great ages of evangelism and growth in the history of the Christian church. Geographically, ethically and culturally Christian faith has spread further and faster in this generation than ever before. In the past three decades, church membership increased from 1.2 billion to 2.05 billion. People are becoming Christians in large numbers, many new congregations are established, Christianity is becoming a force to be reckoned with globally. Such is the vigour of their engagement with the biblical gospel that these new movements generate a freshly minted faith, recovering the joy, hope and love which arise from the knowledge of Christ.

While the whole church rejoices with them and seeks to benefit from this renewal of Christian faith in our time, Christians today live in an increasingly fragmented world, and almost everywhere one looks, it seems that people are becoming more desperate in their search for personal wholeness and happiness. If the present spread of interest in astrology, new age spirituality and the occult is any indication people are no longer satisfied with the answers of conventional Christianity and growing numbers are looking beyond it to the realm of personal holiness and are fascinated by the truth and historicity of their faith.

Globalization has made things easier for the soul-searching traveller to get to the very sites and roots of their faith and bear witness to the historical facts of the faith they live. It's this life changing walk with Jesus through the land of his birth, mission, suffering, death and resurrection which P. J. Manohar Rao, a devout Christian has endeavoured to explore through this pictographic work, 'Walking with Jesus in the Holy Land'.

P. J. Manohar Rao is known to me for several years. He was a senior officer of the Government of India and after his retirement, started writing books, on technical subjects. ISPCK has published two of his books, of about 700 pages each with many coloured pictures, which have impacted the globe.

His visit to the Holy Land, Israel in 2006 inspired him to collect as much data as possible, shooting 500 unique photographs with 2 cameras. This is a unique offering to all believing Christians with pictures of important spots of biblical interest in the Holy Land.

I am sure that the readers, who have already visited the Holy Land will recollect their sweet memories and those who cannot visit the Holy Land will have a full picture of it before them, vicariously visiting the Holy Land through the author's eyes.

I hope many will be blessed by reading this book.

Rev. Dr. Ashish Amos
General Secretary

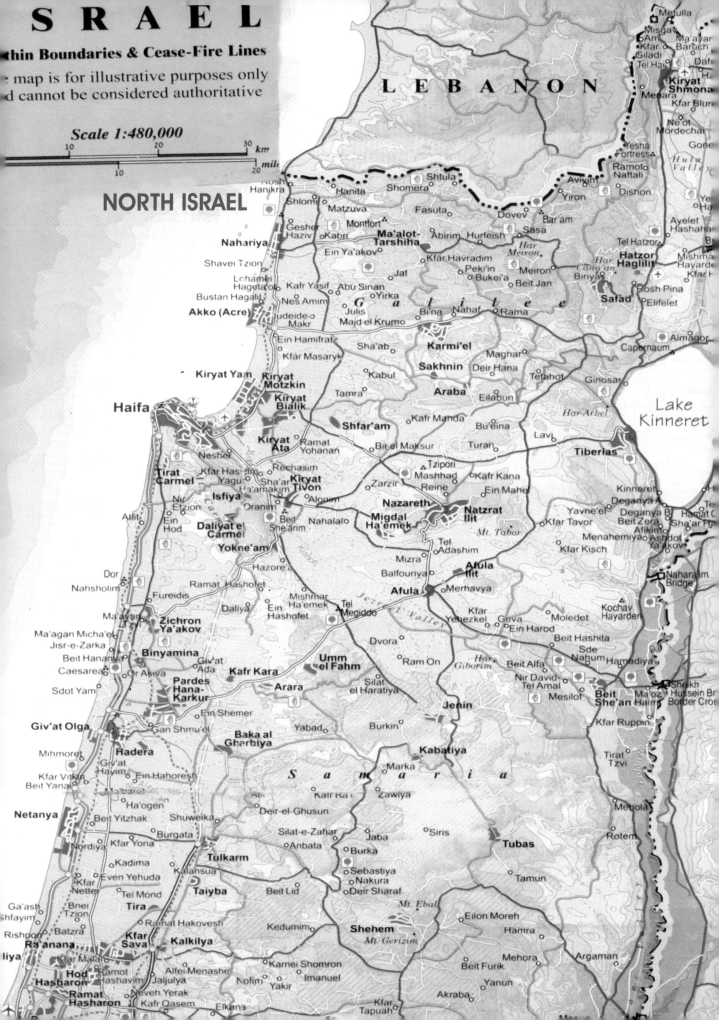

Preface

▲ *P.J. Manohar Rao in Jerusalem*

The author of this pictorial and narrative book is a Christian, hailing from the state of Andhra Pradesh (Nandyal) in India. He was a Senior Executive Officer of the Government of India (in the earlier Ministry of Food and Agriculture) New Delhi (India) for 35 years. During his service with the Government of India, he published about 200 technical articles and 6 books, all on the sugar industry, in which he specialised. He visited 62 countries in the world and now 64 including Jordan and Israel.

The author cherished a desire to write something on biblical subjects also. He started contributing articles on biblical subjects from the year 2004 onwards for Christian magazines in India.

By God's abundant grace, he could visit the Holy Land in April 2006 at his age of 79 years. To show his gratitude for this blessing, he desired to bring out a pictorial and narrative book entitled *'Walking with Jesus in the Holy Land'* for the benefit of all Christians, whether they have visited the Holy Land or not. He has explained in this book, the birth of Jesus Christ and his mission in different parts of the Holy Land in a chronological order and pilgrimage to different parts of the Holy Land, with relevant pictures, as pictures guide the readers better than narration.

A special mention needs emphasis here, as most of the pictures printed in this book have been selected by the author out of about 500 photos taken by him with two zoom cameras and about 100 picture post cards. A few photos were taken by Rev. Dr. Ashish Amos who also visited the Holy Land.

The author had long correspondence with scholars in the Holy Land to obtain as much material as possible to make this book complete in all respects.

The main intentions of the author in bringing this pictorial and narrative book are as follows:-

● To those, who had already visited the Holy Land, this book will bring sweet and unforgettable memories,

● To those, who intend to visit the Holy Land, this book will, to some extent, guide them before their visit,

● To those, who are not in a position to visit the Holy Land due to various reasons, this book will help them to know about the different parts of the Holy Land, the churches, synagogues, chapels, monasteries etc.

'Via Dolorosa', the *'Way of Sorrow'* or the *'Way of Cross'* and the 14 stations of the cross have been explained in this book with the help of unique paintings photographed by the author.

The author desires that this book should be circulated to as many people as possible for their knowledge.

May our Lord and Saviour Jesus Christ bless you all abundantly.

P.J. Manohar Rao

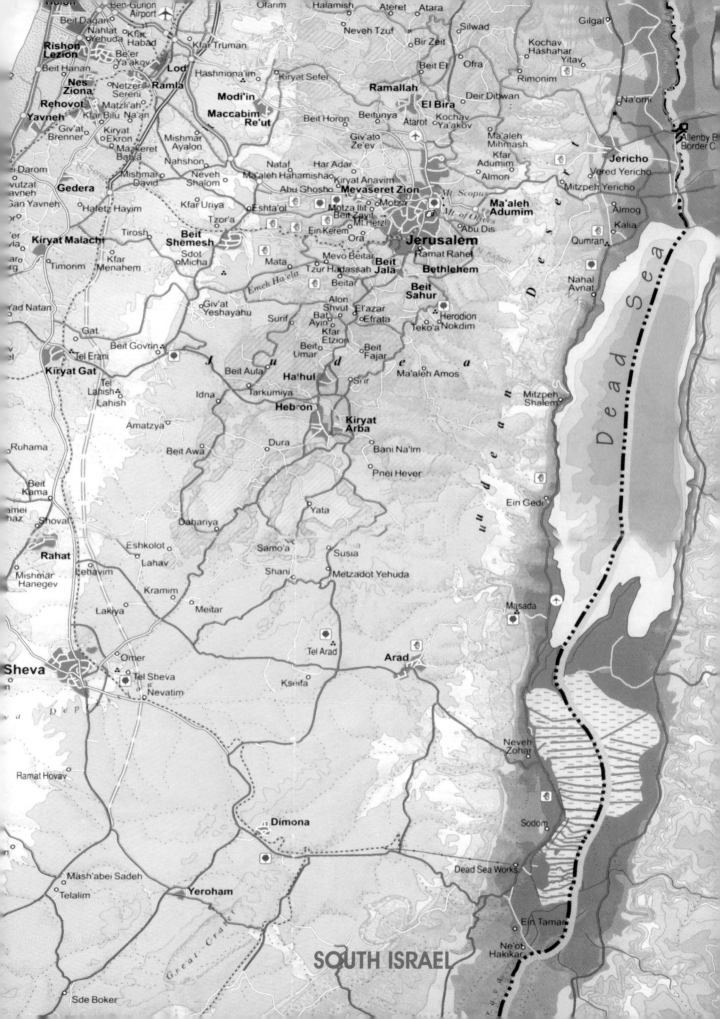

SOUTH ISRAEL

1. Geographical Location of Israel
AND ITS REGIONS

The name 'Holy Land' is given to a small country of Israel where Jesus Christ was born, brought up, preached and finally crucified. Hence, Israel is known as the 'Holy Land'. Israel has a recorded history of more than 5000 years. It is the 'Promised Land' as said in the Bible and a land of faith. Israel is a holy place for Christians, Jews and Muslims (Arabs).

During the last 2006 years (after the death of Jesus Christ), Israel has been known by many names:-

- Eretz Israel (Land of Israel)
- Zion (One of the hills in Jerusalem)
- Palestine (The name derived from 'Philista' and the name used by Romans)
- The Promised Land
- The Holy Land
- Ha'aretz (known to most Israelites).

The text illustrates the geographical location of Israel and its different regions, important cities, rainfall, water resources, population, climate etc., to help readers follow the events that took place in different parts of the Holy Land during the mission of Jesus Christ.

MAP OF ISRAEL

A map of Israel shows the cities, towns, rivers, mountain ranges, Sea of Galilee, (also known as Lake of Kinneret), Dead Sea (also known as Salt Sea).

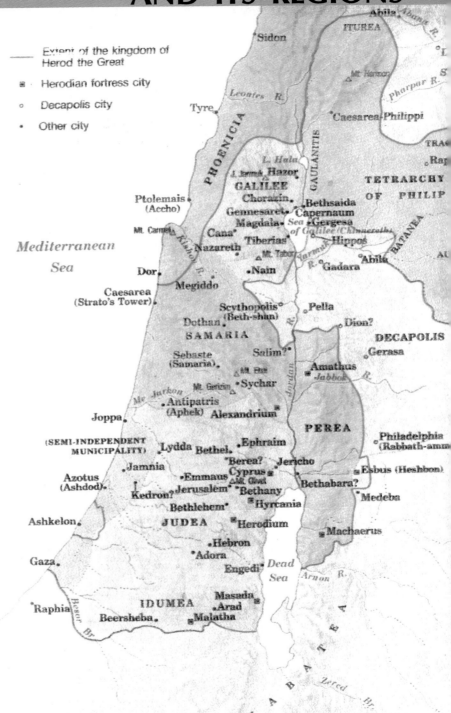

Map of Israel, in Jesus' days

Geographical location of Israel in the World Map

Israel is located in the middle of

three continents – Europe, Asia and Africa. Some scholars say that Israel is in the centre of the world and Jerusalem is in the centre of Israel.

Israel's western border is the Mediterranean Sea. In the north, Israel is bound by two countries – Lebanon and Syria. In the east, it is bound by the country of Jordan. In the south, it is bound by the Red Sea and the country of Egypt. All these neighbouring countries also have biblical importance, though Israel has the greatest biblical importance.

Israel is a long strip of land with 290 miles (470 kilometers) from north to south and with a narrow width of 85 miles (135 kilometers) from east to west at its widest point. The total land area of the country of Israel is 10,840 square miles (27,817 square kilometers), enclosed by its boundaries and cease-fire lines.

Israel can be divided into four geographical regions:-

The Mediterranean Coastal Plain

This is a narrow strip of fertile land

Central Mountain Range, Judea

along the Mediterranean Sea. Most of the Israelites live in this coastal plain, as agriculture and industries are concentrated in this plain.

Haifa, which is Israel's main sea port, is located in the northern part of this plain. This part also includes part of the fertile plain of Esdraelon. A broad stream known as Qishon flows through this plain. Most of Israel's citrus crop is grown in the plain of Sharon, which is south of Haifa.

The city of Tel Aviv is located towards the south of Haifa on the sea coast. Tel Aviv the international airport of Israel and airport is called Bengurian airport. Tel Aviv or Jaffa was earlier called Joppa, which is of biblical importance.

The Central Mountain Range (Judea and Galilean High Lands)

This region includes a series of mountain ranges that run from Galilee (the northern most part of Israel) to the southern part of Israel, known as, Negev Desert. There are six mountain peaks in this region:-

● Mount Hermon (Northern most part of Israel) –9, 220 feet (2,810 meters) high.

● Mount Meron (in upper Galilee) –3, 964 feet (1, 208 meters) high.

● Mount Tabor (in lower Galilee) –1, 930 feet, (566 meters) high.

● Mount Carmel (Near Haifa city) –1, 792

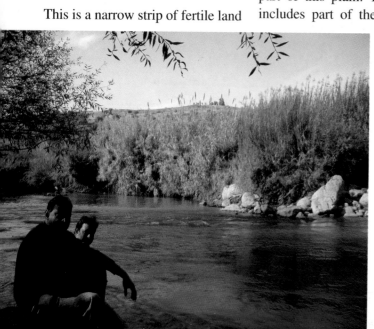

River Jordan where Jesus was baptized

feet (546 meters) high.

- Mount of Olives (in Jerusalem) −2, 739 feet (835 meters) high.

- Mount Ramon (in Negev Desert) −3, 396 feet (1, 035 meters) high.

The mountains of Galilee stretch southwards to the plain of Esdraelon. Galilee, which is in the northern part of Israel is the home of most of Israel's Arabs. Galilee includes the city of Nazareth, the largest Arab center.

The city of Jerusalem is located in the northern part of the Judean hills. Rural people of these hills cultivate land on the hill slopes and the valley. The land to the south of Judea is more rugged and not suitable for cultivation, hence it is used only for grazing of cattle.

The Rift Valley

This is a long and narrow strip of

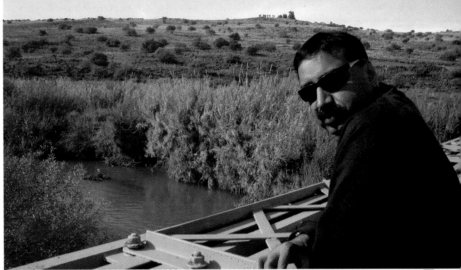

Sermon on the Mount near Galilee

land to the far east of Israel. This region includes a small part of the Great Rift Valley that extends from the country of Syria to Mozambique. The edges of the Rift Valley are steep but, the floor is flat. Most of this region lies below sea level. This region includes:-

- **Jordan River,** which is Israel's longest and most famous river. Its source is at a place known as 'Banias' in Golan Heights located in the northern most part of Israel near Mount Hermon. The sweet water of River Jordan flows into the Sea of Galilee and further flows southwards to empty its water into the Dead Sea.

- **Dead Sea (Salt Sea),** which is the lowest point on earth. As such, water cannot get out of it and gets dried up there itself.

- **Gulf of Eilat,** which is one of the northern branches of the Red Sea and it is an entrance to Egypt.

Arid Region

This is Israel's desert region, consisting of Negev Desert, Arava Valley and lime stone mines along the Dead Sea. The entire region is mountaneous. This area was traditionally used for grazing of cattle, as rainfall in this area is

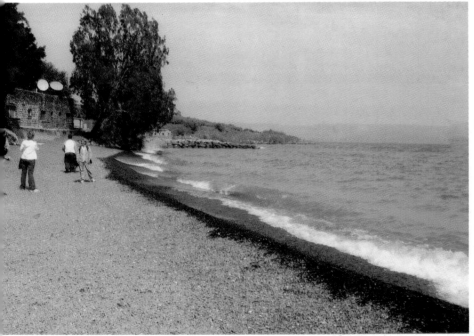

▲ *Sea of Galilee*

limited and as such, nothing grows here except grass. In recent years, some portions of this region have been brought under cultivation by introducing irrigational facilities. Water from the Sea of Galilee is pumped to this area through National Water Carrier Scheme, which is an extensive system of canals, tunnels etc., for flow of water from Sea of Galilee to different areas. Since 1967 the Government of Israel has diverted the water for the Sea of Galilee for irrigation.

BIBLICAL SPOTS IN ISRAEL

Important biblical places, as in Jesus' days.

Galilee Province

This province consists of Mount Hermon, Golan Heights in the north, Nazareth, Cana, Nain, in the centre and Mount Tabor, Bethsaida, Sea of Galilee, Jordan River, Capernaum, Geredene, Korazin, Tiberias in the east.

Samaria Province

This province consists of only a place known as 'Sycar', which is of biblical importance.

Judea Province

This province has many places of biblical importance. Some of these are Jerusalem, Jericho, Bethany, Bethphage, Emmaus, Hebron, Dead Sea, Allenby Bridge (Husein Bridge) to cross River Jodran.

Negev Province

This is a desert, with only one or two places of biblical importance. The city of Bersheva is one such place.

RAIN FALL AND WATER RESOURCES IN ISRAEL

Unfortunately, since many centuries, water has been scarce in Israel, as there is very little rainfall of 1000 millimeters (mm) in the north and as low as 30 mm in the southern part of Israel. The rainfall is between November and March, much of it is in December. In some years, there are droughts also, making water availability still worse. History shows that during many battles fought in Israel in the earlier years, the armies suffered a lot for want of drinking water, and they had to surrender only on this account.

Israel's water resources include, River Jordan, which is formed by emerging of three mountain springs in Golan Heights. The sweet water from River Jordan enters the Sea of Galilee after the river flows about 20 kilometers southwards from Golan Heights. The Jordan River merges out of the Sea of Galilee in the south and again flows for about 124 kilometers southwards and enters the Dead Sea. Once, the sweet water of the River Jordan enters the Dead Sea, the water becomes salty and is not useful for drinking or irrigation. It is learnt that even the fish swim in the sweet water of River Jordan upto the entrance of Dead Sea and once the water enters the Dead Sea, the fish swim back into River Jordan, as fresh water fish cannot survive in the salt water of Dead Sea.

The other water resources of Israel are natural springs and under ground water. But, these are sparingly used. Due to the acute shortage of drinking water in Israel, the Government, with the help of scientists and engineers, has introduced other methods of generating water resources, like recycling of waste water, cloud

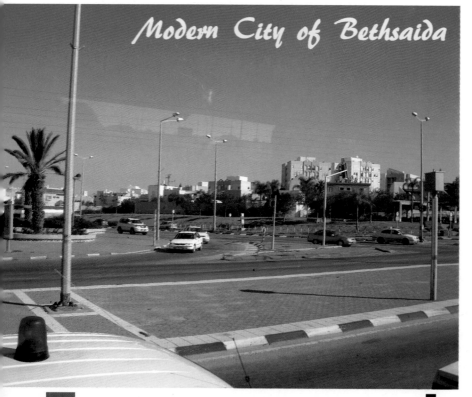

Modern City of Bethsaida

seeding to create artificial rain, and de-salination of sea water to generate drinking water.

To get over the acute shortage of water, the Government of Israel has made arrangements to join all water resources in an integral grid, whose central stream, known as the 'National Water Carrier' brings water from the water resources in Golan Heights in the north, to the central and southern parts of Israel, through a network of huge pipes, aqueducts, open canals, reservoirs, tunnels, dams and intermediate pumping stations etc. About 25% of Israel's population resides in the cities of Jerusalem, Tel Aviv etc., where drinking water is available.

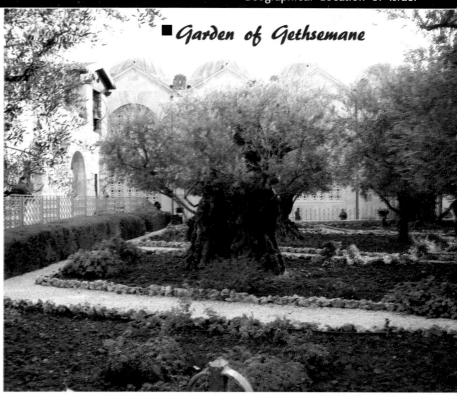

■ *Garden of Gethsemane*

CLIMATE

Israel has hot and dry summers (April to October) and cool and mild winters (November to March). The climate in Israel varies from region to region, depending on the altitude of that region. It is cool on high altitudes and warm in low altitudes. In August, which is the hottest month in Israel, the maximum temperature may reach 37°C in the hilly regions and as high as 49°C near the Dead Sea area, which is the lowest point on earth. In January, which is the coldest month in Israel, the maximum temperature may vary between 9°C in Jerusalem to 14°C in Tel Aviv.

Israel has continuous sunshine from May to October. A hot and dusty wind known as 'Khamsin' sometimes blows from deserts to west, which is the Mediterranean coastal plain.

FLORA AND FAUNA

Some 47,000 living species have been identified in Israel. Another 4000 are assumed to exist. There are 116 species of mammals native to Israel, 511 kinds of birds, 97 types of reptiles and 7 types of amphibians, 2780 types of plants are grown in Israel.

POPULATION AND LANGUAGES

In the year 2005, Israel's population was 6,631,000. Out of this, 5,350,000 (more than 80%) are Jews and the remaining are Arabs (Muslims) and Christians. The Jews speak Hebrew language, whereas the Arabs speak Arabic language. But, most of them including Christians speak English language.

Hebrew, (the language of Bible) and Arabic are the official languages in Israel. Hebrew, Arabic and English are compulsory subjects in all schools of Israel.

All the names of the streets and sign boards of commercial establishments are in Hebrew, English and sometimes in Arabic also.

HOLIDAYS AND TIMINGS

All Muslim establishments are usually closed on Fridays. Jewish establishments are closed on Saturdays (Sabbath day). Christian establishments are closed on Sundays.

The Sabbath (Saturday), the day of rest is the greatest dividing line between secular and religious Israelis. Sabbath day lasts from sunset on Friday until sunset on Saturday. It is a day for all Jews to participate in prayers in synagogues, learn 'Torah' and spend time with their families. Work of any type is prohibited, including the use of electricity and travel by vehicles, except in times of life and death. Two festivals have become collective national

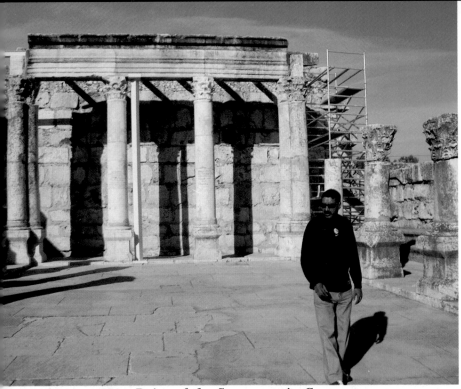

■ *Ruins of the Synagogue in Capernaum*

holidays- 'Succot' (festival of tabernacles) and 'Pesach' (feast of Passover) and on these days, the entire country seems to be on a vacation.

The biblical spots of interest to pilgrims usually remain open from 8 a.m. to 12 noon and from 2 p.m. to 5 p.m. So, the pilgrims have to avoid holidays and visit biblical spots within the hours indicated above. It is advisable for the pilgrims to make best use of the visiting hours advantageously and devote time for shopping and relaxation after visiting hours.

CURRENCY

Israel's unit of currency is the 'Shekel' from the olden days. Genesis 23:13 and 15 to 17 say that Abraham offered Ephron four hundred shekels of silver for a piece of land. In the present days, currency in Israel is known as 'New Israeli Sheqel' (NIS). The plural of this is 'Sheqalim'. Each

Sheqel is divided into 100 'Agorot' (singular of this is 'agora'). Bank notes are in denomination of NIS 200, 100, 50, and 20 Sheqels. Coins are in denomination of 10 Sheqels, 5 Sheqels, 1 Sheqel, 50 Agorot and 10 Agorot. Foreign currency may be exchanged into Israeli currency in any bank or hotel.

Shops are not obliged to accept foreign currency. Even if payment is made in foreign currency, they may give the balance in Sheqels. In April 2006, the exchange rate for 1 U.S. Dollar was equivalent to 4.71 NIS. This may vary slightly from time to time.

ACCOMMODATION

Israel, being a pilgrimage country, there are more than 300 hotels to suit pilgrims from any country and any budget. In addition to hotels, there are many holiday villages, youth hostels, kibbutz hotels

(Collective Settlements), Christian hospices etc.

BEST TIME FOR A PILGRIMAGE

Climate in the Holy Land is pleasant throughout the year. The autumn and spring seasons are not felt for a long period and hence, there are long summers and short winters. Rain is scarce.

Considering the budget for pilgrimage, the low season in the Holy Land is from November to February (except at the time of Christmas and New Year), when the rates for land travel by coach and air fares may be low. March to October is also good, though the rates may be high at times. At the time of Christmas, Palm Sunday and Easter, the rates are very high, due to rush of pilgrims from different countries, who desire to take part in all festive activities and processions. But, it is a wonderful experience to be in the Holy Land on these festive occasions. The Jews festival of 7 passover days are not convenient for the pilgrims, as there are no transport facilities. On these days, only unleavened bread (Matza) is available.

MODE OF TRANSPORT

In the days of Jesus, which means 2006 years ago, there were no modern vehicles like trains, buses, etc., in any country and even in Israel. So, the people in Israel including Jesus, his parents and disciples must have walked to different places in Israel. As we read in the four gospels of New Testament, Jesus and his disciples were almost continuously visiting many places in Israel, as Jesus was

preaching and healing the sick throughout Israel. Though Israel is a small country, it is a hilly country, with many uplands, mountains, deserts, valleys, caves and rugged roads in those days. There were a few water sources only and the people had to travel through these parts only to have drinking water during their journey. Added to all this, there were robbers, dacoits on these lonely roads, as can be seen from the parable of 'Good Samaritan', when a person travelling from Jerusalem to Jericho (24 kilometers) was attacked by robbers (Luke 10:30 to 37).

In his childhood, Jesus along with his parents visited the temple of Jerusalem during the festival of Passover. The distance between Nazareth, where they stayed and Jerusalem is 131 kilometers. According to some records, this journey on foot lasted for 3 days, stopping in the nights at some place, where there was drinking water.

In the days of Jesus, only rich businessmen owned camels and travelled on camels in caravans (a group of travellers) from place to place on business. It is recorded that Nazareth is located on the highway from Egypt to Mesopotamia and as such, Jesus must have watched the caravans on camels passing through Nazareth. But, maintaining a camel was very expensive even in those days. Middle class people owned one or two donkeys or mules to carry them to distant places. Some rich people owned a few donkeys or mules to be rented out to people for transport of goods or people to distant places.

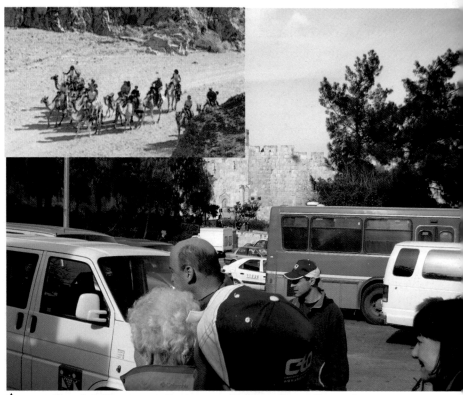

▲ *Tourist Transport System at Golden Gate, Jerusalem*

According to Luke 2:1-5 Joseph went from Nazareth to Bethlehem to be taxed with Mary, his espoused wife, being great with child. The distance between Nazareth and Jerusalem is 131 kilometers and from there Bethlehem is 10 kilometers. So, a total distance of 141 kilometers. Joseph might have hired a donkey and made Mary sit on it and he walked all the way. Again, while returning from Bethlehem to Nazareth, Joseph might have made Mary and baby Jesus sit on the donkey and walked 141 kilometers. More strenuous than this journey was the journey from Nazareth to Egypt with Mary and baby Jesus to escape the killing of all male infants below 2 years, as ordered by King Herod (Matt. 2:13-15). The distance between Nazareth and Egypt border is 291 kilometers. Joseph must have made Mary and baby Jesus sit on

the donkey and walked all the way from Nazareth to Egypt and back to Nazareth stopping at some suitable places in the night. This is unimaginable now a days. But, this is nothing but God's presence and constant protection to the holy family all the way.

When Jesus grew up, he travelled to many parts of Israel with his disciples on his mission of preaching and healing the sick. Some of the important places visited by Jesus and their distances are:

- Jerusalem to Bethlehem – 10 kilometers.
- Jerusalem to Jericho – 24 kilometers.
- Jerusalem to Nazareth – 131 kilometers.
- Jerusalem to Capernaum – 145 kilometers.
- Jerusalem to Samaria – 56 kilometers.

- Jerusalem to Bethany/Bethphage – 3 kilometers.
- Nazareth to Capernaum – 30 kilometers.
- Nazareth to Cana – 3 kilometers.
- Within Jerusalem city, temple, Upper Room, palaces of Pontius Pilate, Herod, are within one kilometer.
- Mount of Olives, Garden of Gethsemane are about one kilometer from Jerusalem.

Jesus and his disciples walked to all these places and some times, even as far as Tyre and Sidon on the Mediterranean sea coast.

Unlike the strenuous way of travelling in the olden days, modern day pilgrims have the option of travelling more comfortably. Some even travel by helicopters between the airports of Israel, like Tel Aviv, Jerusalem, Galilee, Haifa and Eilat and rent a car or engage a taxi to reach the biblical places near each airport. Some pilgrims travel in groups from airport to airport in Israeli airlines and from the airport, travel in A.C. coaches to the biblical spots. All other pilgrims from other countries reach either Tel Aviv or Amman (Jordan) airports and travel by A.C. coaches.

PILGRIMAGE TRAVELS

A religious scholar wrote "Pilgrimage has to be differentiated from tourism- Tourism is an escape from one's everyday life into something unusual for relaxation, where as a pilgrimage is a journey towards a definite goal, a journey rich in symbolism." A pilgrim travels towards a shrine as to "the house of the Lord", that is, towards the symbolic house of the Lord, which expressed in mythical language, is in heaven. Thus, symbolism is the specific element that distinguishes pilgrimage from tourism.

Pilgrimage is a symbolic act-

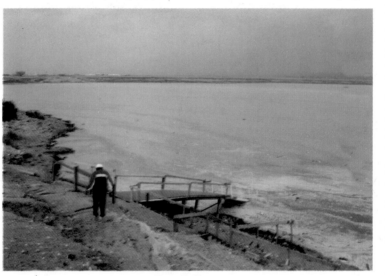

Dead Sea

A symbolic journey towards God, as mentioned in Psalms 63:1 to 3 "O God, thou art my God; early will I seek thee: my soul thirsteth for thee, my flesh longeth for thee in a dry and thirsty land, where no water is", which is a psalm of David, when he was in the wilderness of Judah.

In short, for all who undertake a pilgrimage, it is a spiritual search for inspiration, strengthening of faith, a renewal of bonds and vows. It is very essential to prepare for the pilgrimage to the Holy Land, as the time actually spent in the Holy Land is very limited and every pilgrim should have a thorough knowledge of the Holy Land and ministry of Jesus Christ in different places. Pilgrims should be very conversant with the four gospels of the New Testament. Fortunately, almost all the places of biblical importance are known by the same names, as mentioned in the New Testament, though some names are in Hebrew language, but usually shown in brackets.

A pilgrimage can change one's life for ever. For many people, pilgrimage to the Holy Land is a dream that is fulfilled only once in a life time. For those, who are fortunate enough to visit the Holy Land many times, each visit rekindles the miracles of the places. The food for the soul and for the spirit awaits replenishment and it is in the Holy Land that the body and soul come together to be whole, a glorious oneness with God.

Records show that Christian pilgrims travelled to the Holy Land in large numbers from the second century onwards. The first well known pilgrim was Queen Helena, the mother of Emperor Constantine of Rome. Queen Helena's visit to the Holy Land has an interesting story. Before 312 A.D., the Romans were not Christians. One night, Emperor Constantine had a vision, in which he saw a cross in the sky and on it was written "By

this, conquer". Next day onwards, Emperor Constantine made the cross as the symbol of his army. After which, Emperor Constantine attained phenomenal success in all his efforts and he became a monarch of the entire Europe and Western Asia. To show his gratitude to Jesus Christ and Christianity in general for his success, he sent his mother, Queen Helena to the Holy Land to look for the exact place of the crucifixion of Jesus Christ and the tomb in which the body of Jesus was laid, after his death. Queen Helena went to the Holy Land with archaeologists. When she was in Jerusalem, she was accompanied by Eusebius, the Bishop of Caesaria and Macrius, the Bishop of Jerusalem to help her in locating the actual place of crucifixion and the tomb. Emperor Constantine got a magnificent church known as the 'Church of Holy Sepulchure' constructed on this spot located by his mother Queen Helena. Later on, two more churches were built by them. After the visit of Queen Helena to the Holy Land in 326 A.D., and construction of many churches, the number of pilgrims to the Holy Land increased. Later on, due to the rule of many powerful kings of different countries, pilgrimage declined but from the 19th century onwards, pilgrims increased a lot.

AUTHOR'S IMPRESSION OF THE HOLY LAND

After studying a lot of literature on Holy Land and actually visiting the Holy Land in April 2006 and discussing with many knowledgeable scholars in the Holy land, the author now knows the Holy Land as a place of many mountains, valleys, caves, deserts etc. Now a days, water availability has improved unlike the olden days. During the last 4000 years, more than 40 battles were fought

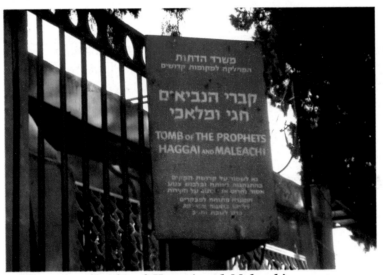
■ *Tombs of Haggai and Maleachi*

in the Holy Land and as a result of these battles, ruins of fortresses, palaces, synagogues, churches, water systems etc,. can be seen by the pilgrims throughout the country, particularly in spots of biblical importance. It is learnt that excavations carried out upto 100 feet below the present ground level in some places, revealed many structures, vessels etc., which are still to be identified.

Vegetation and greenery can be seen only in the northern parts of Israel, where there were water resources in the earlier days. In places like Jericho, Capernaum in east and in Mediterranean coastal plains in the west, greenery can be seen. But, desert trees like date palms can be seen everywhere and more in Jericho area and so, Jericho is known as the 'City of Palms', even in the Bible. In the deserts, pilgrims can see only 'Bedouins', who are nomads, depending on cattle development.

Some undertake walking tours, going up and down the terrain, crossing the huge boulders of the ruins, caves etc. With these walking tours, the pilgrims learn more about the Holy Land and its ancient dwellings etc. But, they have to take adequate supply of drinking water, food and protect themselves from sun burns, sand, dust etc. Other pilgrims, who travel by coaches also must be prepared to walk atleast 5 kilometers in a day. The reason is that the parking places for the vehicles is atleast one kilometer from these spots. Pilgrims, who cannot miss to walk along 'Via Dolorosa' and walk on the foot steps of Jesus Christ while carrying the cross on his shoulders from 'Gabbatha' to 'Golgotha' must be prepared to walk atleast 2 kilometers from the vehicle parking place to inside the Church of Holy Sepulchure, where the tomb of Jesus is and back to the parking place. In spite of all this, pilgrims in wheel chairs are also seen, as it is their life time desire to visit the place of birth and

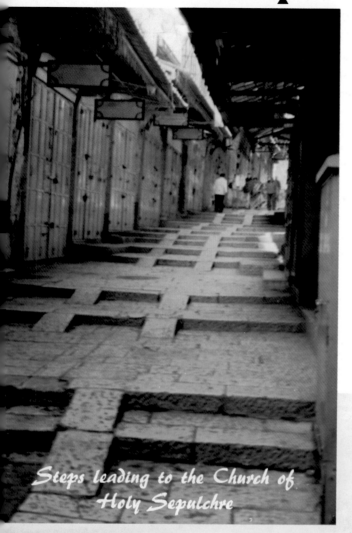

Steps leading to the Church of Holy Sepulchre

crucifixion of Jesus Christ, our Lord and Saviour.

Tourist guides in the Holy Land prepare the itinerary of the pilgrims depending on their interest and explain clearly as the pilgrims travel in coaches and when they get down at the spot of biblical interest. It is claimed that the licensed tourist guides in the Holy Land have knowledge of every inch of land, history of each church, synagogue, and ancient history and Bible verses connected with each spot of biblical importance. The guides are multi-lingual. It is learnt that the tourist guides in the Holy Land have to undergo a two years rigorous training to obtain a licence from the Tourism Department of the Government. In addition to this, they have to undergo a short refresher course once in six months. They should have excellent knowledge of Bible and current affairs. By and large, the tourist guides are excellent with very polite manners and make the pilgrims comfortable and explain everything clearly within the short stay of 7 days. So, it is always better to engage a licensed tourist guide, who can speak in your language, so that you can learn more about the Holy Land.

■ **Mount Tabor, Valley of Jezreel, The Mount of Transfiguration**

2. Chronology of Jesus'
BIRTH AND MISSION

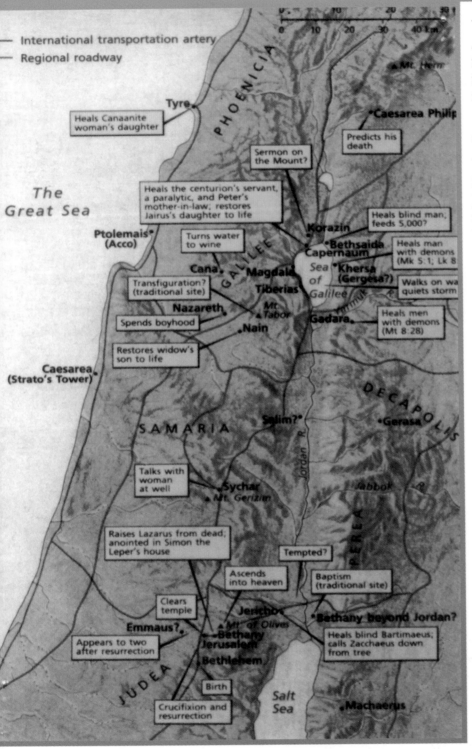

Legend:
— International transportation artery
— Regional roadway

The Great Sea

PHOENICIA

Tyre
Heals Canaanite woman's daughter

Caesarea Philip

Predicts his death

Sermon on the Mount?

Heals the centurion's servant, a paralytic, and Peter's mother-in-law; restores Jairus's daughter to life

Ptolemais (Acco)

Korazin

Heals blind man; feeds 5,000?

Bethsaida
Capernaum

Heals man with demons (Mk 5:1; Lk 8)

Turns water to wine

Cana

Magdala

Sea of Galilee

Khersa (Gergesa?)

Walks on wa quiets storm

Transfiguration? (traditional site)

Tiberias

Nazareth

Mt. Tabor

Gadara

Heals men with demons (Mt 8:28)

Spends boyhood

Nain

Restores widow's son to life

Caesarea (Strato's Tower)

DECAPOLIS

SAMARIA

Salim?

Gerasa

Talks with woman at well

Sychar
Mt. Gerizim

Jordan R.

Jabbok

Raises Lazarus from dead; anointed in Simon the Leper's house

Tempted?

Ascends into heaven

Baptism (traditional site)

Clears temple

Jericho

Bethany beyond Jordan?

Emmaus?

Mt. of Olives
Bethany

Heals blind Bartimaeus; calls Zacchaeus down from tree

Appears to two after resurrection

Jerusalem

Bethlehem

JUDEA

Birth

Crucifixion and resurrection

Salt Sea

Machaerus

Holy Land, depicting the places of Jesus' ministry and the events

Many scholars in the Holy Land have mentioned that the best guide to the Holy Land is the Holy Bible, particularly the four gospels in the New Testament.

A brief mention is given in chronological order of the birth of Jesus Christ in Bethlehem, his growing up in Nazareth along with his parents, his mission in different parts of the Holy Land and finally his crucifixion, resurrection and ascension to heaven in Jerusalem. In the subsequent chapters, the biblical spots to be visited by the pilgrims are also explained in the same chronological order, as far as possible so that, the pilgrims can easily follow and understand. All this is based on the actual visit to the various biblical spots by the author and study of four gospels and other literature.

Jesus Christ performed 35 miracles in different parts of the Holy Land to heal the sick and even raised the dead. Similarly, Jesus Christ narrated 40 parables to the multitudes in different places in the Holy Land to make them understand heavenly things easily. According to Matthew 13:1 to 13, when Jesus Christ narrated to the multitudes by the Sea of Galilee many parables, his disciples asked Jesus "Why speakest thou unto them in parables?" Jesus answered "Because it is given to you to know the mysteries of the kingdom of heaven, but unto them, it is not given."

Though in the four gospels, all these events have been mentioned, their sequence differ from gospel

to gospel. By reading the following, the pilgrims will be able to understand better, when they actually visit the biblical spots in the Holy Land.

CHRONOLOGICAL ORDER OF VARIOUS EVENTS

- The angel of the Lord appeared to Zechariah to announce the birth of a son to his wife Elizabeth. (Luke 1:5-25).

- Angel Gabriel was sent from God to Nazareth to announce to Virgin Mary, about the birth of Jesus (Luke 1:26-38).

- Birth of Jesus in Bethlehem. Shepherds and three wise men from east visited Jesus and worshipped him. (Luke 2:1-20).

- On the eighth day after Jesus was born, he was taken by his parents to the Jerusalem temple, to be blessed by Simeon. (Luke 2:21-39).

- Joseph took Mary and baby Jesus from Nazareth to Egypt to escape King Herod's killing of infants. (Matt. 2:14).

- Joseph returned with Mary and baby Jesus to Nazareth after the death of Herod, as told by the angel of Lord. (Matt. 2:19-23).

- Jesus grew up in Nazareth and waxed strong in spirit, filled with wisdom and the grace of God was upon him. (Luke 2:40).

- When Jesus was twelve years old, he went to the Jerusalem temple along with his parents and he tarried behind in Jerusalem and he was sitting in the midst of the doctors, both hearing them and asking them questions. All were astonished at his understanding and answers.

(Luke 2:42-47).

- Nothing is known about Jesus from the age of 12 to 30. At the age of 30, Jesus went to John the Baptist to be baptised by him in River Jordan. When Jesus was baptised and went out of water; the heavens were opened and he saw the Spirit of God descending like a dove and lighting upon him. And a voice from heaven, saying, "This is my beloved Son, in whom I am well pleased. (Matt. 3:13-17).

- Jesus was led up of the Spirit into the wilderness to be tempted of the devil, for forty days and forty nights. Jesus conquered the devil in his three temptations. (Matt. 4:1-11 and Luke 4:1-13).

- After temptations, Jesus returned in the power of the Spirit into Galilee and taught in the synagogues. (Luke 4:14 & 15).

- Jesus, walking by the Sea of Galilee, saw two brethren Simon called Peter and Andrew his brother, casting a net into the sea, for they were fishers. And Jesus said to them, follow me and I will make you fishers of men. They both followed him. Going a little further, Jesus saw other two brothers, James the son of Zebedee and John his brother in a ship, mending their nets. Jesus called them also and they followed him. Thus, Jesus chose his first four disciples who were fishermen in the Sea of Galilee. (Matt. 4:18-22).

- Jesus went about all Galilee,

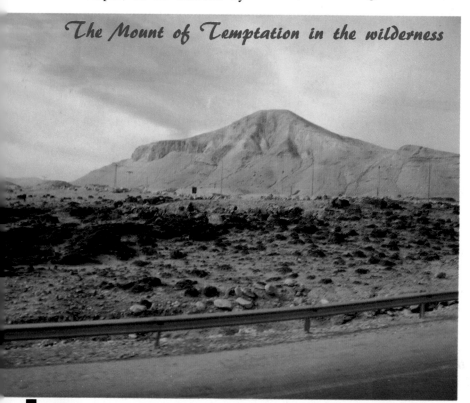

The Mount of Temptation in the wilderness

teaching in their synagogues and preaching the gospel of the kingdom, and healing all manner of sickness and all manner of disease among the people. His fame went throughout all Syria and people from Galilee, Decapolis, Jerusalem and from beyond Jordan followed him. (Matt. 4:23-25).

- Jesus performed the first miracle of converting water into wine at a wedding in Cana, where his mother and disciples were also present, and he manifested forth his glory and his disciples believed on him. (John 2:1-11).

- From Cana, Jesus went to Jerusalem through Capernaum, as it was the Passover festival and he wanted to spend it at Jerusalem. Jesus saw people trading in the temple by selling oxen, sheep, and doves and money changers doing their business. Jesus was annoyed at this and drove them all out of the temple saying "Make not my father's house an house of merchandise." (John 2:12-16).

- Jesus explained to Nicodemus, a ruler of the Jews, who came to Jesus by night, about "Born again". (John 3:1-21).

- Jesus and his disciples went into the land of Judea and stayed there for some time and baptised many people. John the Baptist was imprisoned by Herod the tetrarch. (Luke 3:19 and 20).

- Jesus left Judea and again

■ *John the Baptist Shrine*

came to Galilee, passing through Samaria. Jesus came to a city called Sycar where Jacob's well was. Jesus met a Samaritan woman there and told her history, when she and all the people of the city were surprised and believed on him. (John 4:1-42).

- Then Jesus came to Galilee and all Galileans received him joyfully, having seen all things that Jesus did at Jerusalem at the time of the feast of Passover. (John 4:45).

- Jesus came to Cana of Galilee. There was a nobleman, whose son was sick at Capernaum. He invited Jesus to Capernaum to heal his son. Jesus said "Go thy way; thy son liveth." The noble man believed and found that his son was healed at the same time when Jesus said so. The noble man and his family believed in Jesus. This is the second miracle of

Jesus. (John 4:46-54).

- Jesus went to Nazareth and in the synagogue, they gave him the book of the prophet Isaiah and he read. All were surprised how Joseph's son had such knowledge. Jesus said to them, "No prophet is accepted in his own country." (Matt. 13:54-58).

- Jesus came to Capernaum and taught people on sabbath days. Jesus healed a man possessed by unclean spirit, Simon's mother-in-law from fever, performed many miracles. (Mark 1:28-32).

- Jesus ordained his twelve disciples. (Mark 3:13-19).

- Jesus, seeing the multitude went up a mountain and delivered the famous 'sermon on the mountain'. (Matt. 5:1-14).

- From the mountain, Jesus went to Capernaum, where a centurian whose servant was sick of palsy met him. Jesus marvelled at the faith of the

centurion and healed his servant. (Matt. 8:5-13 and Luke 7:1-10).

- Jesus then went to a city called Nain and saw a dead man, only son of a widow being carried. Jesus raised him. (Luke 7:11-17).

- John the Baptist, who was in the prison, sent two disciples to Jesus to find out, whether it was he that should come or they should look for another. Jesus said, "Go and tell John all things that you are seeing." (Matt. 11:2-13 and Luke 7:18-36).

- Jesus' mother and brothers came to meet him. Jesus said, "Whosoever does the will of God is my brother, sister and mother." (Matt. 12:46-50, Mark 3:31-35 and Luke 8:19-21).

- Jesus spoke in many parables-like a sower who reaped many folds, kingdom of heaven is like grain of mustard seed, leaven, a treasure hid, a merchant seeking good pearls, like a net cast into sea. (Matt. 13:1-58; Mark 4:1-34; Luke 8:14-28).

- Jesus went to all cities and villages around the Sea of Galilee and performed many miracles-like making the sea calm, healing a man possessed with many unclean spirits, raising Jairus' daughter who was dead, healing a woman having issue of blood for 12 years, giving sight to two blind men. People marvelled and said that they never saw such things in Israel. Jesus was moved with compassion. (Matt. 8:23, 9:8; 9:18-26; Mark 4:35; 5:43; Luke 8:22-56).

- Jesus again came to his native place, Nazareth and preached in the synagogue. People were surprised and Jesus said "A prophet is not honoured except in his country and in his own house." (Matt. 13: 54-58; Mark 6:1-6).

- Jesus called his twelve disciples and sent them two by two to preach and heal the sick. (Matt. 11:1; Mark 6:7-13; Luke 9:1-6).

- Herod got John the Baptist beheaded in prison. (Matt. 14:1-12: Mark 6:14-28 and Luke 9:7-9).

- The twelve disciples of Jesus returned after preaching and Jesus took them to a desert city of Bethsaida to take rest, as many people were coming to Jesus. (Mark 6:32-34; Luke 9:10).

- Jesus went over to a desert place but a great multitude came to him. In the evening Jesus had compassion on them and fed 5000 men by blessing five loaves and two fishes. After they ate, they gathered twelve baskets of remnants. (Matt. 14:13-21, Mark 6:33-44; Luke 9:11-17 and John 6:1-14).

- Jesus walked on the Sea of Galilee. (Matt. 14:22-33, Mark 6:45-52; John 6:15-21).

- Jesus went into the coasts of Tyre and Sidon, when a woman of Cannan met him and asked him to heal her daughter vexed with devil. Jesus healed her. (Matt. 15:21-28).

- Jesus healed the lame, blind and dumb near Sea of Galilee. (Matt. 15:29-31).

- Jesus fed 4000 men with seven loaves and a few little fishes. (Matt. 15:32-39).

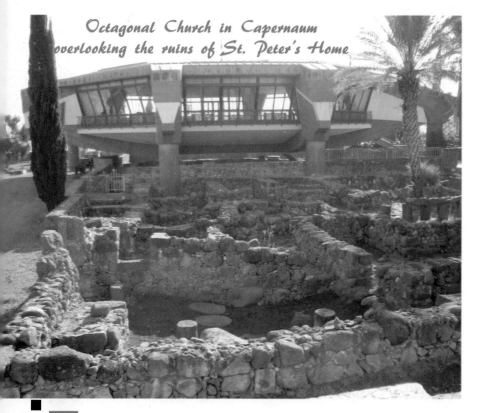

Octagonal Church in Capernaum overlooking the ruins of St. Peter's Home

- Jesus warned people against pharisees, who desired to see a sign from heaven. (Matt. 16:1-12).

- Jesus healed a blind man in Bethsaida. (Mark 8:22-26).

- Jesus came to the coasts of Caesaria Philippi and his disciple, Simon affirmed that he was Christ, the son of the living God. (Matt. 16:13-20).

- Jesus was transfigured on a mountain, in the presence of his disciples, Peter, James and John. (Matt. 17:1-9).

- As Jesus came down the mountain, a man knelt down before Jesus and prayed him to heal his son, a lunatic. Jesus healed him. (Matt. 17:14-21).

- When Jesus was with his disciples in Galilee, Jesus predicted his death and resurrection. (Matt. 17:22 and 23).

- When Jesus and his disciples came to Capernaum, the people that collect tribute money came to Peter and asked him whether his master paid tribute. Peter said yes. Jesus asked Peter to go to the sea and cast a hook and take the fish that came first and open its mouth when he would find a piece of money and give it to them for him and Simon. (Matt. 17:24-27).

JUDEAN MINISTRY OF JESUS

- Jesus departed from Galilee and came into the coasts of Judea beyond Jordan. A great multitude followed him and he healed the sick there. (Matt. 19:1 and 2).

- Jesus went from Galilee to Jerusalem at the feast of Tabernacles and taught many things in the temple. (John 7:11-52)

- Jesus excused a woman taken in adultery. (John 8:3-11).

- Jesus, in a temple at Mount of Olives taught many things, saying, "Ye shall know the truth and the truth shall make you free." (John 8:12-32).

- Jesus saw a man blind from his birth. His disciples asked Jesus whether this man sinned or his parents, that he was born blind. Jesus said that neither this man sinned nor his parents, but that the works of God should be made manifest in him. Jesus asked the blind man to go to the pool of Siloam. He went and washed and got his sight. (John 9:1-41).

- Jesus said that he was a good shepherd. (John 10:1-21).

- Jesus appointed other seventy also and sent them two by two for preaching the gospel. (Luke 10:1-24).

- Jesus narrated the parable of 'Good Samaritan' to teach people, who was a neighbour and do like the Samaritan. (Luke 10:30-37).

- Jesus visited the home of Mary, Martha and Lazarus in Bethany. (Luke 10:38-42).

- When the disciples asked Jesus to teach them a prayer as John taught his disciples, Jesus taught them the 'Lord's Prayer'. (Luke 11:1-4).

- Jesus accused Pharisees as 'Hypocrites'. (Luke 11:14-54).

- Jesus warned people, saying "Beware ye of the leaven of the pharisees, which is hypocrisy". (Luke 12:1-59).

Entrance to the Upper Room where the Lord's Supper was celebrated ■

- In Jerusalem, Jesus walked in Solomon's porch of the temple at the feast of dedication. (John 10:22-42).
- Jesus healed a woman, who had a spirit of infirmity for 18 years and as it was a sabbath day, the rulers of the synagogue were unhappy, but Jesus made them realise and they were ashamed. (Luke 13:11-17).
- Jesus went to the house of the chief of pharisees to eat bread on a sabbath day and there healed a man with dropsy and taught many things to people. (Luke 14:1-24).
- Jesus told people to forsake all and bear the cross to become his disciples. (Luke 14:25-35).
- Jesus said that there would be joy over one sinner that repented and narrated the parable of 'Prodigal Son'.

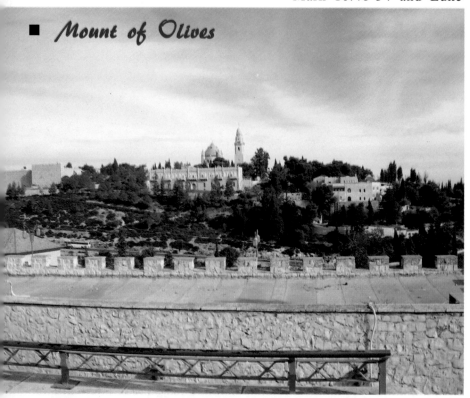

■ *Mount of Olives*

(Luke 15:1-32).
- Jesus taught his disciples, the story of a rich man and his stewards, rich man and beggar, Lazarus. (Luke 16:1-31).
- In Bethany, Jesus raised Lazarus, brother of Mary and Martha, as Lazarus was dead. (John 11:1-44).
- The chief priests and pharisees plot to kill Jesus, as he was performing many miracles and convincing people. (John 11:45-57).

LAST DAYS OF JESUS

- On his way to Jerusalem through Jericho, Jesus predicted his death and told his disciples. (Matt. 20:17-19; Mark 10:32-34; Luke 18:31-34).
- As Jesus reached Jericho, he saw two blind men and healed them. (Matt. 20:29-34; Mark 10:46-54 and Luke

18:35-43).
- On his way to Jerusalem, Jesus arrived at Bethany and Mary anointed his feet with spikenard. (John 12:1-8).
- When Jesus and his disciples came to Bethphage on Mount of Olives near Jerusalem, Jesus sent two of his disciples to a village to bring a colt. People made Jesus sit on the colt and as they descended Mount of Olives and entered Jerusalem, they sang "Hosanna to the Son of David." (Matt. 21:1-9; Mark 11:1-10; Luke 19:29-40; and John 12:12-14).

SUNDAY

- Jesus entered Jerusalem sitting on a colt, and he beheld the city and wept. (Luke 19:41-44). He stayed in Bethany in the night.

MONDAY

- In the morning, as he was going from Bethany to Jerusalem, he was hungry and seeing a fig tree, he went to eat the figs. But, there were no figs on it. Jesus cursed the fig tree and it withered away. Later, in Jerusalem temple, Jesus healed many sick people. (Matt. 21:18-20; Mark 11:12-21).

TUESDAY

- On Tuesday, when Jesus was talking to people in the temple, the chief priests asked him by what authority he was doing all these works. Jesus asked them a question, but they did not answer. So, Jesus also did not answer

their question. (Matt. 21:23-27; Mark 11:27-33; Luke 20:1-8).

- Jesus predicted his crucifixion and told his disciples. The chief priests and elders plotted how to kill Jesus, but not the feast day. (Matt. 26:1-5).

- Judas Iscariot agreed with the elders to betray Jesus for thirty pieces of silver. (Matt. 26:14-16; Mark 14:10 & 11; and Luke 22:3-6).

WEDNESDAY AND THURSDAY

- Jesus sent Peter and John to prepare the Passover in the 'Upper Room'. Jesus had the last supper with his disciples and washed their feet. Peter said that he was prepared to go with Jesus both to prison or death. But, Jesus said to Peter that before the cock crew, he would deny Jesus thrice. Then after singing a hymn, they went to the Mount of Olives. (Matt. 26:17-30; Mark 14:12-30; Luke 22:7-39 and John 13:1-38).

- Jesus went with his disciples on to the Mount of Olives and entered the Garden of Gethsemane. He said to his disciples to sit there, as he went further to pray. He took Peter, James and John and told them to wait and watch, as he went further to pray. Jesus kneeled down and prayed saying "O my father, if it be possible, let this cup pass from me; nevertheless not as I will, but as thou wilt". Three times, Jesus

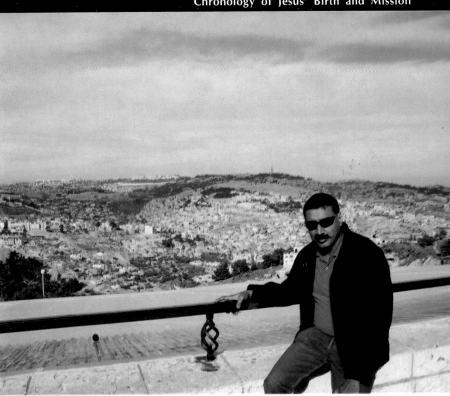

View of the City of Jerusalem

came back to his disciples and he found them sleeping. (Matt. 26:36-46; Mark 14:32-42; Luke 22:39-46 and John 18:1-12).

- Jesus told his three disciples, that they could sleep now, as the time had come for his arrest. As he spoke, Judas Iscariot came with many people, who took hold of Jesus and went away for his trial. (Matt. 26:47-56; Mark 14:42-53; Luke 22:47-53 and John 18:2-12).

- They took Jesus first to Annas, the father-in-law of Caiaphas, who was the chief priest at that time. (John 18:12-23).

- Caiaphas asked Jesus "Are you the Christ, the son of God?" Jesus answered "You said it." Caiaphas handed over Jesus to Pontius Pilate, the Governor. (Matt. 26:57-

68; Mark 14:55-65; Luke 22:63-65 and John 18:24-29).

- Peter denied Jesus thrice and the cock crew. Peter remembered Jesus' words and wept bitterly. (Matt. 26:69-75; Mark 14:66-72; Luke 22:54-62 and John 18:15-18).

FRIDAY

- In the morning, the chief priests and elders bound Jesus and took him to Pontius Pilate, the Governor. Pilate tried to convince the people saying that Jesus had not done any wrong to condemn him to death. But, the people were not convinced. When Pilate heard that Jesus was a Galilean, he sent Jesus to Herod, who was also in Jerusalem at that time and Herod had jurisdiction over Galilee and authority to judge Jesus, a Galilean. Jesus did

not answer any question of Herod. Herod mocked Jesus and sent him back to Pilate. (Matt. 27:1-22, Mark 15:1-10, Luke 22:66-71).

- Pilate could not convince the people, who cried that Jesus should be crucified and Barabbas, a robber, should be released as was customary to release one prisoner on festival day. At last, Pilate agreed, as people desired. The chief priests and elders took away the purple robes and put his own clothes and took Jesus to Calvary to crucify him. Outside Pilate's palace, they found Simon Cyrene and they compelled him to bear the cross. They came to Golgotha in Calvary to crucify Jesus. (Matt. 27:31-34; Mark 15:20-23; Luke 23:26-32 and John 19:16

and 17).

- At the third hour of the day, (9 a.m.), they crucified Jesus. From the sixth hour (12 noon) to ninth hour (3 p.m.), there was darkness over the whole land. Jesus spoke seven words when he was on the cross. Jesus cried with a loud voice and gave up the ghost. (Matt. 27:36-56 ; Mark 15:24-41 ; Luke 23:33-49 and John 19:18-30).

- When Jesus died on the cross, Joseph of Arimathaea took permission from Pilate to bury Jesus in a new tomb. (Matt. 27:57-60; Mark 15:42-46; Luke 23:50-54; and John 19:31-42).

SATURDAY

- Mary Magdalene and other women saw the tomb and

went home to prepare spices and ointments for anointing Jesus on the third day. The chief priests appointed watchmen to see that the disciples of Jesus do not steal the body of Jesus in the night, and say that he rose from the dead. (Matt. 27:61; Mark 15:47 and Luke 23:55-57).

SUNDAY

- On the first day of the week, early in the morning, Mary Magdalene and others went to the sepulchure and were surprised to find that the big stone at the mouth of the sepulchure was already rolled away. An angel appeared to them and said that Jesus was arisen. (Matt. 28:1-8; Mark 16:1-8; Luke 24:1-12 and John 20:1-10).

- Jesus appeared to Mary Magdalene and also to two men, who were going from Jerusalem to nearby village of Emmaus. Later on, Jesus appeared to eleven disciples and after dinner, Jesus went with his disciples up to Bethany and in their presence, Jesus ascended to heaven, after blessing them.

The disciples worshipped Jesus as he ascended to heaven and returned to Jerusalem with great joy. They were continuously praising God. They went forth and preached every where, the Lord walking with them and confirming the word with signs following. Amen. (Matt. 28:9, 20; Mark 16:9,14; Luke24:31,36,50-53).

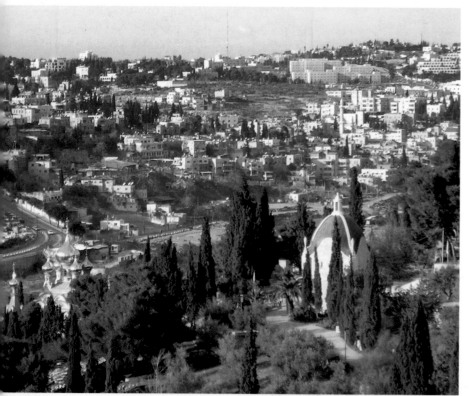

■ *'Jesus wept' Church of Dominus Flevit on Mount of Olives*

3. The Holy Pilgrimage

Judean Hills

Jesus Christ's childhood begins from **Nazareth**, the place where he lived with his parents **Joseph** and **Mary** and where he grew up. So, very often, Jesus is known as **Jesus of Nazareth**

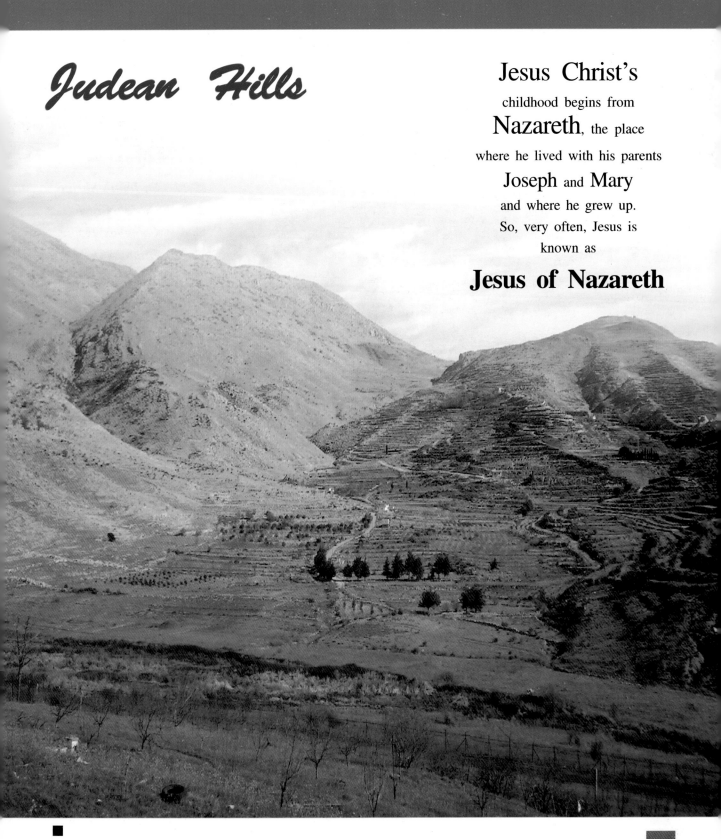

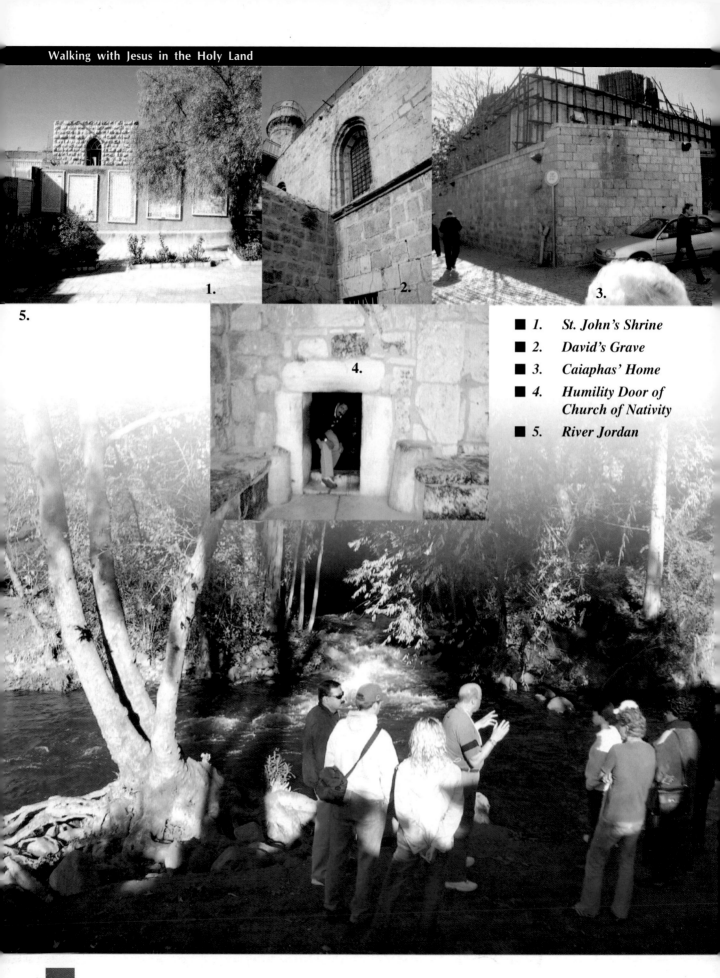

1.

2.

3.

5.

4.

- ■ 1. *St. John's Shrine*
- ■ 2. *David's Grave*
- ■ 3. *Caiaphas' Home*
- ■ 4. *Humility Door of Church of Nativity*
- ■ 5. *River Jordan*

4. Nazareth

In the days of Jesus Christ, Nazareth was a small village located in a valley of southern Galilee province of Israel. Nazareth is 131 kilometers north of the city of Jerusalem.

The province of Galilee is rich in the memories of Jesus' ministry; and no piligirm's journey can be considered complete without a visit to the biblical places in Galilee, where Jesus travelled extensively and preached. Some scholars, who have studied the four gospels in the New Testament have come up with an impressive conclusion that 83% of the 35 miracles performed by Jesus Christ and recorded in the four gospels were performed in the province of Galilee alone.

The importance of Galilee in the life of Jesus Christ cannot be overlooked. It was in Galilee that Jesus spent most of his life. Jesus walked on the shores of the Sea of Galilee many times, walked on the Sea of Galilee also, chose his first four disciples (Simon called Peter and his brother Andrew, John and his brother James) who were all fishermen in the Sea of Galilee, and healed many sick people while preaching in the synagogues of Galilee.

The most important biblical spots in Nazareth are:

- The Church of Annunciation or Basilica of Annunciation.,
- The Church of the Archangel Gabriel.,
- St. Joseph's Carpentry.,
- Mary's Well or Virgin's Spring.

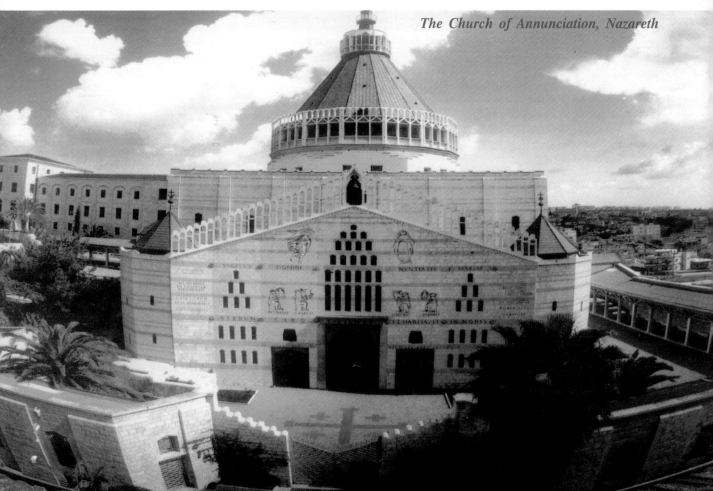

The Church of Annunciation, Nazareth

Grotto of Annunciation

The Church of Annunciation or Basilica of Annunciation

According to Luke 1:26 to 38, in the sixth month, the Angel Gabriel was sent from God unto a city of Galilee, named Nazareth, to a virgin espoused to a man whose name was Joseph. The virgin's name was Mary. The angel said to her "Hail, thou that art highly favoured, the lord is with thee: blessed art thou among women. Fear not, Mary: for thou hast found favour with God. Thou shalt conceive in thy womb and bring forth a son, and shalt call his name Jesus."

To commemorate this announcement of the birth of Jesus, a beautiful church known as the Church of Annunciation or Basilica of Annunciation has been constructed at the exact place where the Angel Gabriel appeared to Virgin Mary in Nazareth. The present church is the largest church in the middle east. Actually, it is the 5th church built on the ruins of the earlier four churches. The first church was constructed in 326 A.D. by Emperor Constantine of Rome and his mother Queen Helena. The second church was constructed during the Byzantine period, the third church was built in the beginning of the 12th century and the fourth church was built in 1877. The present church was completed in 1969.

One of the peculiar features of this church is its conical top (cupola), which is in the shape of an inverted lily with 16 petals. On these petals, letter 'M' has been

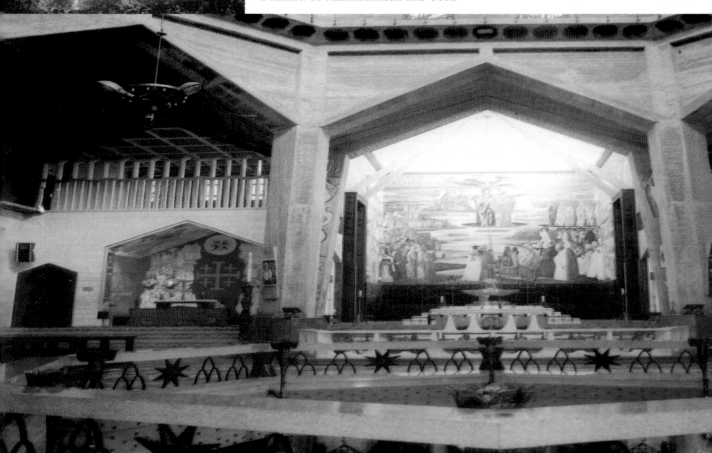

Upper Level of the Church of Annunciation

inscribed, which stands for Mary. Through these transparent petals, natural sunlight lights the interior of the church. Magnificent mosaics, works of art and ceramic reliefs, banners etc., contributed by Roman Catholic communities throughout the world adorn the vast interior of this church. An imposing Italian designed mosaic adorns the holy altar.

This church consists of two levels. The lower level contains the grotto or cave, which is the exact place, where Angel Gabriel appeared to Mary, announcing the birth of Jesus.

The grotto is the holiest part of the Church of Annunciation. Just in front of this grotto is the main altar.

The upper level of this Church of Annunciation serves as the church of the Parish. It is about 200 feet long and 80 feet wide. This is adorned with many stained glass windows and mosaics contributed by many Roman Catholic countries to show their devotion to Mother Mary.

The Church of Annunciation dominates the entire city of Nazareth.

The Church of the Archangel Gabriel

Not far away from this

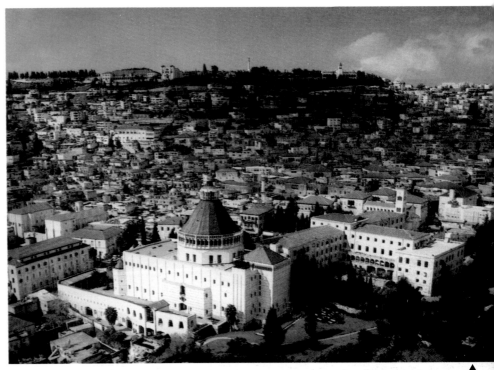

Dominating view of the Church of Annunciation

site of the Church of Annunciation, is the Greek Orthodox Church of St. Gabriel. This church is constructed over the only spring of water in Nazareth.

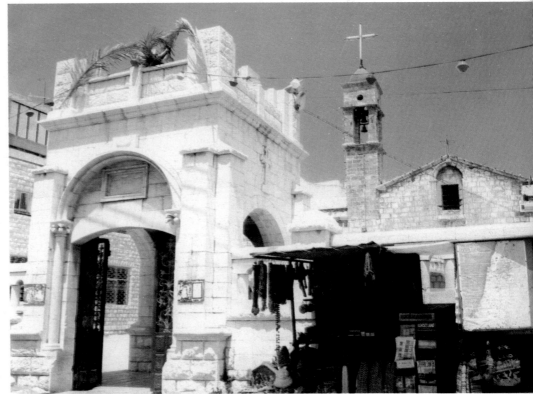

The Church of the Archangel Gabriel

St. Joseph's Carpentry

St. Joseph's Carpentry

Just outside the Church of Annunciation a courtyard connects the Church of St. Joseph's Carpentry. Joseph was a carpenter and Jesus as a boy helped his father in carpentry.

Mary's Well or Virgin's Spring

The spring over which the Church of St. Gabriel was constructed, flows into the heart of Nazareth. This was the only source of drinking water to the people in Nazareth. Some scholars say, that even Mary and her son Jesus must have been to this spring. Some scholars believe that it was at this spring that the angel appeared to Mary.

In the recent years, a structure has been made over this well.

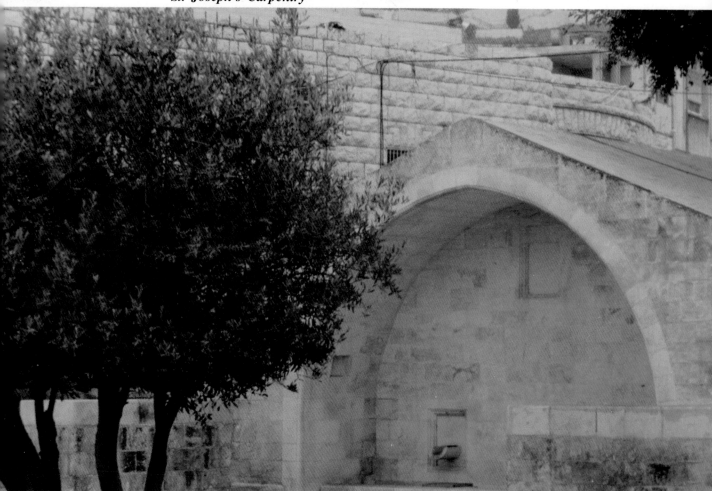

Mary's Well or Virgin's Spring

5. Ein Karem

Ein Karem is not mentioned in any of the four gospels in the New Testament. But, Ein Karem was the place where the priest Zechariah and his wife Elizabeth stayed and so, it was here that they were blessed with a son, whose name was John (later, known as John the Baptist). According to the chronological order of Jesus Christ's mission, the place Ein Karem deserves to be mentioned immediately after Nazareth.

Ein Karem is located 7 kilometers south-west of Jerusalem. So, every day the priest Zechariah went to the Jerusalem temple to perform his duty of burning incense in the temple. Zechariah and his wife were well stricken in years but they had no children (Luke 1:5 to 25). One day, an angel of the Lord appeared to Zechariah in the temple and said "Thy prayer is heard, and thy wife Elizabeth shall bear thee a son, and thou shalt call him, John."

According to Luke 1:26 to 40, in the sixth month, Angel Gabriel appeared to Mary in Nazareth and announced the birth of Jesus. Mary arose in those days and went into the hill country (probably Ein Karem) with haste, into a city of Judea. And entered into the house of Zechariah and saluted Elizabeth. And it came to pass that when Elizabeth heard the salutation of Mary, the babe leaped in her womb and Elizabeth was filled with the Holy Ghost. And she spake out with a loud voice and said "Blessed art thou among women and blessed is the fruit of thy womb. And whence is this to me that the mother of my Lord should come to me? For Lo, as

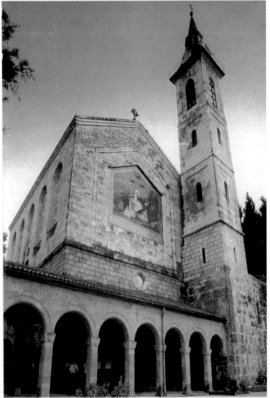

Church of Visitation or Church of Magnificat

soon as the voice of thy salutation sounded in my ears, the babe leaped in my womb for joy." (Luke 1:39 to 44).

And Mary said, "My soul doth magnify the Lord and my spirit hath rejoiced in God my Saviour....." (Luke 1:46 to 55).

This song of Mary is now known as the "Magnificat".

Priest Zechariah, who was dumb for some time, (as he did not believe the word of angel) began speaking after the birth of a baby (John) to his wife Elizabeth and praised the Lord saying "Blessed be the Lord God of Israel: for he hath visited and redeemed his people ———" (Luke 1:67 to 79). This song (prophesy) of Zechariah is now know as 'Benedictus'. John (later on known as John the Baptist) grew and waxed strong in spirit, and was in the deserts till the day of his showing unto Israel (Luke 1:80).

An interesting incident, is how John escaped the massacre by King Herod when he ordered his soldiers to kill all male children below the age of two. While Joseph and Mary took baby Jesus to Egypt to escape the killing by Herod's soldiers, Elizabeth hid John in one of the walls of her house, when Herod's soldiers entered the house. looking for babies below 2 years of age.

In one of the two churches now existing in Ein Karem, a stone in one of the walls bears the imprint of a baby's body. It is believed that this is the imprint of baby John, whom Elizabeth hid when soldiers entered her house.

The most important biblical

spots to be visited by the pilgrims in Ein Karem are:-

- The Church of Visitation (Church of Magnificat).
- The Church of St. John the Baptist.

The Church of Visitation or Church of Magnificat

To commemorate the visit of Mary to Elizabeth, a church was constructed by Queen Helena and Emperor Constantine of Rome in the fourth century. This church was named the Church of Visitation.

also destroyed. The present church was built in 1935 and now owned by Franciscons.

This church was built on the house of Zechariah and Elizabeth, where Mary visited Elizabeth.

This church has a lower crypt. On the inner wall of the courtyard, on 45 mosaic slabs, the 'Magnificat' is written in 45 languages. There are many beautiful murals depicting the visit of Mary to Elizabeth.

The painting right above the altar depicts, Mary saluting

1999 revealed a cave, which is believed to be the place, where John the Baptist sought his first solitude in the wilderness (Luke 1:80) and where he practised his baptism procedures. In addition to this, they found the largest ritual bathing pool ever found in Jerusalem area and installations connected with early baptism procedures, including an unique foot-anointing stone.

The Church of St. John the Baptist

This is a large complex. The

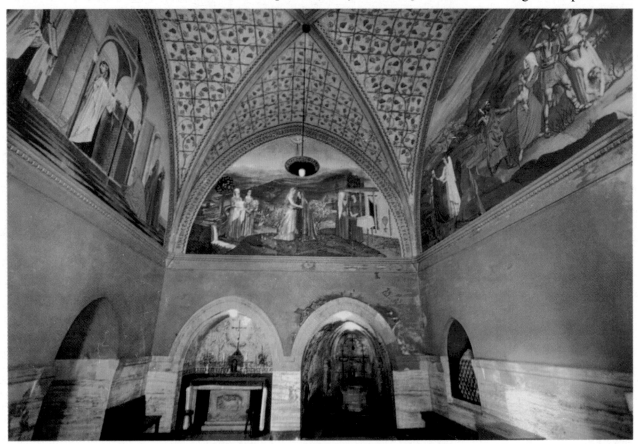

● *Interior view of the Church of Visitation*

The Church of Visitation in Ein Karem is also known as the Church of Magnificat. The original church was destroyed and in its place another church was constructed by Crusaders. This was

Elizabeth. The painting on right depicts, the Roman soldiers snatching the infants from their mothers, to kill them as ordered by King Herod.

An excavation carried out in

church first built under the Byzantines, was destroyed and again rebuilt by the Crusaders. This was also destroyed. It was rebuilt in 1800 and is now in the Franciscon custody.

Inside the church, there are beautiful paintings and decorated ceramic tiles, which are all from Spain. There are steps leading down to a natural cave or grotto, where it is believed that infant John was born. On the lintel is inscribed a verse from the 'Benedictus' or song of Zechariah, "Blessed be the Lord God of Israel; for He hath visited and redeemed his people". A marble star beneath the altar bears a Latin inscription *'Hic Precursor Domininatus Est'*, which means, 'Here the precursor of the Lord was born'.

Queen Helena's Tour to Ein Karem

When Queen Helena of Rome toured Ein Karem during the fourth century, she found a temple built by Emperor Hadrian with statue of a Goddess. Queen Helena got it destroyed and built a church on its site and dedicated it to the thousands of infants below two years of age massacred by the soldiers of King Herod. On a hill opposite this church, she constructed a church dedicated to Elizabeth, the mother of John the Baptist. But, both these churches were later on destroyed by Persian soldiers and again reconstructed by the Crusaders.

The Church of John the Baptist

6. Bethlehem

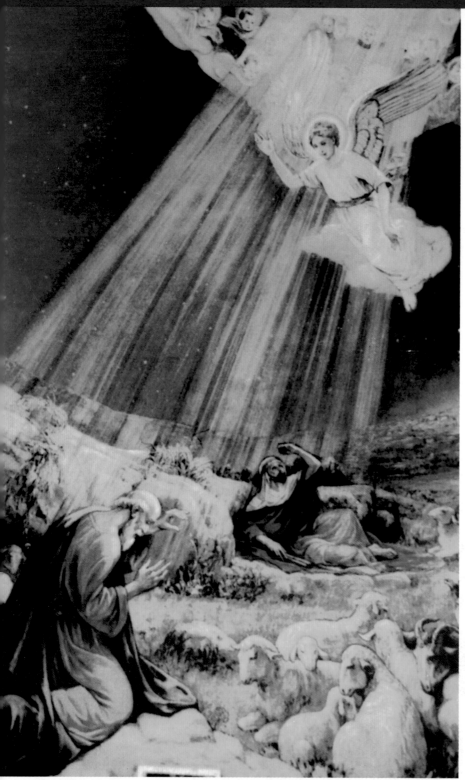

● *Angel appearing to shepherds in field at Beit Sahur*

Bethlehem is located in the province of Judea and it is 9.7 kilometers south of Jerusalem. In the Old Testament, Bethlehem is known as 'Ephratah' or 'Ephrath'. (Gen 35:18 and Ruth 4:11). Bethlehem is a Hebrew name, meaning in English 'House of Bread'. In the Old Testament, it is mentioned that Jacob's wife, Rachel died near Ephrath (which is Bethlehem) and was buried by her husband Jacob on the way to Ephrath (Gen 35:19). Another event is David was born as the son of that Ephrath-ite of Bethlehem-Judah (I Samuel 17:12). Ruth's story started from Bethlehem. (Ruth 1:1 to 5 and 4:11).

Prophesizing about Jesus' birth, Micah 5:2 says "But thou, Bethlehem Ephratah, though thou be little among the thousands of Judah, yet out of thee shall he come forth unto me that is to be ruler in Israel; whose going forth have been from of old, from everlasting." Another prophesy of Isaiah 7:14 says "Behold, a Virgin shall conceive, and bear a son, and shall call his name Immanuel."

Both these prophesies were fulfilled with the birth of Jesus, in Bethlehem.

According to Luke 2:1 to 7, it came to pass in those days, that there went out a decree from Caesar Augustus, that all the world should be taxed. And all went to be taxed, every one into

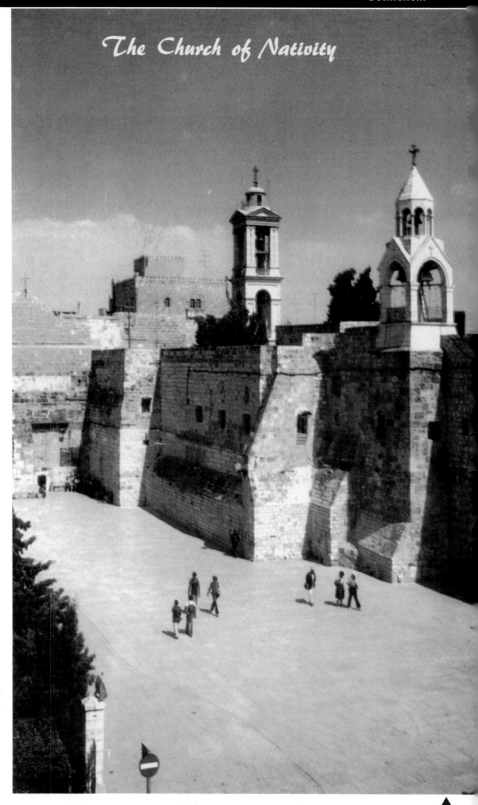

The Church of Nativity

his own country. And Joseph also went up from Galilee, out of the city of Nazareth into Judea, unto the city of David, which is called Bethlehem (because, he was of the house and lineage of David). To be taxed with Mary, his espoused wife, being great with child. And so it was, that while they were there, the days were accomplished that she should be delivered. And she brought forth her first born son, and wrapped him in swaddling clothes, and laid him in a manger; because there was no room for them in the inn.

Not far away from Bethlehem (about 8 kilometers to the south-east of Bethlehem) there is a small place known as 'Beit Sahur'. According to Luke 2:8 to 14, there were in the same country (Bethlehem) shepherds abiding in the field, keeping watch over their flock by night. And lo, the angel of the Lord came upon them and the glory of the Lord shone round them: and they were sore afraid. And the angel said unto them "Fear not; for, behold, I bring you good tidings of great joy, which shall be to all people. For unto you is born this day in the city of David a Saviour, which is Christ the Lord. And this shall be sign unto you; ye shall find the babe wrapped in swaddling clothes, lying in a manger." And suddenly, there was with the angel a multitude of heavenly host praising God and saying, "Glory to God in the highest and on earth peace, good will toward men".

According to Mark 2:1 to 11, when Jesus was born in Bethlehem of Judea, in the days of Herod the King, behold, there came wise men from the east to Jerusalem, saying, "Where is he that is born king of Jews ? For we have seen his star in the east, and are come to worship him". Herod enquired from the wise men, when the star appeared and sent them to Bethlehem and said, "Go and search diligently for the young child; and when ye have found him, bring me word again, that I may come and worship

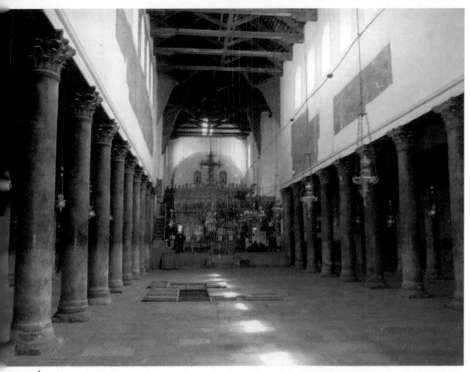

Interior of the Church of Nativity

also." When they heard the king, they departed and lo, the star, which they saw in the east, went before them, till it came and stood over, where the young child was. When they saw the star, they rejoiced with exceeding great joy. And when they were come into the house, they saw the young child with Mary his mother, and fell down, and worshipped him: and when they had opened their treasures, they presented unto him gifts; gold, and frankincense, and myrrh.

The most important biblical spots to be visited by the pilgrims, in Bethlehem are:

● The Church of the Nativity.,

● The Church of St. Catherine of Alexandria.,

● The Chapel of Milk Grotto.,

● The Church of the Shepherd's Field.,

● The Tomb of Rachel.

The Church of Nativity

This church is the oldest church in the entire Christian world. Jesus was born in a cave that was used as a stable in those days, as there was no room for them in the inn.

This Church of Nativity was constructed exactly over this cave. The first church on this site was constructed by Emperor Constantine of Rome and his mother Queen Helena in the fourth century. (326 to 330 A.D.).

The original church built by Queen Helena was partially destroyed in the Samaritan Revolt of the sixth century. But, the octagonal altar constructed by the Queen remained as such. The present church, which was renovated, was built in 530 A.D., by Emperor Justinian.

There are two interesting things about the Church of Nativity. One is, in 614 A.D., when the Persian armies invaded the Holy Land, they destroyed almost all the churches. But, surprisingly, when they came to this Church of Nativity to destroy it, they did not destroy it. The reason was that when the soldiers entered the church on their horse back and looked around inside the

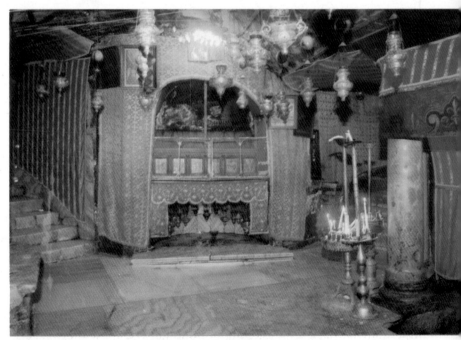

Grotto of Nativity

church before destroying it, they observed a beautiful mosaic on one of the walls of this church, depicting the three wise men from east wearing Persian robes. The soldiers were afraid that they would have some curse from these three wise men if they destroyed this Church. So, they did not touch any part of this church but, rode away on their horses.

Another interesting thing about this church is that though this church is huge and looks like a fortress, the entrance to the church is very narrow with a low door. This door is known as the 'Door of Humility'. The original door was a wide door. But, the enemies started riding on their horse back directly to the holy altar. In order to arrest the entry of animals like horses into the church, this door was modified. Thick stone slabs were placed on the sides to make it narrow and on the top to reduce its height. As a result, now a days, the pilgrims have to bend and enter the church.

As the pilgrims enter through the narrow Door of Humility into the Church of Nativity, they will come across huge pillars of 18 feet high and 2 and half feet diameter each, constructed of red lime stone. There are 44 pillars in all, arranged in four rows with 11 pillars in each row. These pillars are believed to be existing from Justinian period. On each pillar, a picture of a saint is portrayed. On the side walls, the remains of the gold mosaics from crusaders period can be seen. Some parts of the flooring are covered with wooden panels, below which the original flooring made by Emperor Constantine in 335 A.D. can be seen. The lower part of the walls were covered with marble panels, while the upper part of the walls were decorated with mosaics.

During all these years, the Crusaders decorations were destroyed. But the four rows of red lime stone pillars still stand, supporting the oak ceiling, that was presented by Edward IV of England and Philip Duke of Burgundy in 1482.

In the foreground of this church is the main altar constructed by the Greek orthodox community, just over the cave, where Jesus was born. Below the choir area in the church, at the east end of the church, steps lead down to a level of 20 feet below floor, where there is 'Grotto of Nativity'. This is the most sacred place for all Christians in the world, as our Lord and Saviour Jesus Christ was born here. There is a chapel room of 12 feet wide and 40 feet long. The walls of this chapel are completely concealed by tapestry and from the ceiling beautiful lights are hung. These are made of silver, gifted by Christian princes.

To the right of the grotto is the Roman Catholic Chapel, where Jesus was worshipped by the three wise men who

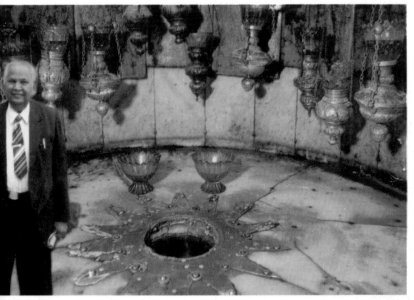

Star of Bethlehem

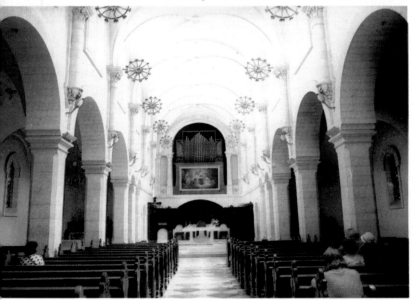

Inside view of the Church of St. Catherine

came from the east.

The most sacred spot here is the *'Star of Bethlehem'* which depicts the bright star, which appeared in the sky, when Jesus was born in Bethlehem and which guided the three wise men from east, who followed the star and located the place, where Jesus was born and worshipped him. This is a silver star of about 3 feet in diameter with 14 petals and the star is fixed on an oval shaped marble of vermillion colour of about 6 feet diameter. At the center of this silver star, there is a dish like depression, in which blessed oil is filled, so that the pilgrims can take a drop of it and anoint their forehead, usually making a cross. Around this silver star, there are 16 silver lamps hung in a semi-circular manner.

This silver star was laid in the year 1717 by the Franciscons, with a Latin inscription *'Hic De Virgine Maria Jesus Christus Natus Est'*, which in English means 'Here, Jesus Christ was born of Virgin Mary. This is the spot, which is positively visited by all pilgrims, who kneel down before the *'Star of Bethlehem'*, pray and kiss the star.

By the side of the *'Star of Bethlehem'* is the manger, which is the place, where the infant Jesus was laid, as there was no room for them in the inn. The original manger is believed to have been taken to Rome by Sixtus V and is now placed in the Church of Santa Maria Maggiore in Rome, Italy.

The Church of St. Catherine of Alexandria

In the year 1881, next to the Church of Nativity, the Franciscon

Church of St. Catherine of Alexandria was built. This was built on the ruins of the twelfth century crusaders church.

To the right of this church is Mary's altar with a glass enclosure called 'Bambino' meaning, 'Child of Bethlehem'. This is taken by the patriarch every year on Christmas eve and ceremoniously carried to the Grotto of Nativity, after the midnight mass. There, it

Statue of St. Jerome in front of St. Catherine Church

is laid upon the silver *'Star of Bethlehem'* and a gospel verse on the birth of Jesus is read. This infant Jesus (Bambino) is placed in the opposite manger till the feast of Epiphany and then returned to its original place in the Church of St. Catherine. The midnight mass held in this church every year is televised throughout the world. Christmas bells from the tower of the Church of Nativity ring and on every Christmas eve, thousands of Christians from all over the world

participate in celebrations of Christmas.

Just outside the Church of St. Catherine, is a big statue. This statue is believed to be that of St. Jerome, who came from Italy to translate the Bible into Latin language and stayed in Bethlehem for 36 years. At the foot of St. Jerome in the statue, a skull of a baby can be seen.

At the bottom of the statue of St. Jerome is inscribed *'St. Hierony-Mus'*. It is interpreted by some scholars, that St. Hieronymus (probably St. Jerome) was invited from Italy to translate some portions of the Bible into Latin. When he was in Bethlehem, he hired a room for his stay. It is believed that after a few months, he found that the flooring of his room was false and could be removed easily. When he removed the false flooring, to his great surprise, he found a few thousands of babies skulls there. These are believed to be the skulls of thousands of infants massacred by the soldiers of King Herod. Hence, a skull of a baby is shown under the foot of St. Hieronymus, in the statue.

The Chapel of Milk Grotto

According to Matt. 2:13 and 14, the angel of the Lord appeared to Joseph in a dream, saying "Arise, and take the young child and his mother and flee into Egypt, and abide thou there until I bring thee word: for Herod will seek the young child to destroy him". Then, Joseph arose, took the young child and his Mother by night and departed into Egypt. The distance between Nazareth and border of Egypt is roughly about 300

kilometers. It is surprising that with a little baby, they had to perform this strenuous journey to and fro. It is presumed that Joseph might have made Mary and infant Jesus sit on the donkey and he might have walked all the way, stopping during the nights in some convenient places. Some scholars say that they stopped at Bethlehem and some say that they stopped at Gaza while returning to Nazareth.

Just a few meters away from the Church of Nativity is the Chapel of Milk Grotto, built in 1871, by Franciscons.

This Chapel had been constructed to commemorate the Holy Family's flight to Egypt from Nazareth to escape killing of infants by Herod. It is believed that on their way to Egypt, they stopped at Bethlehem for one night. It is also believed that while Mary was feeding infant Jesus, in a cave in Bethlehem, some of the mother's milk spilled within these confines, turning the grotto into myriad of white spots. This chapel has been built exactly on the cave.

In the upper level of this Chapel, even now a days, they sell small bottles of milk powder blessed, and it is believed that the women not bearing children can be blessed with children by consuming this blessed milk powder of the Chapel of Milk Grotto in Bethlehem. Favourable reports have been received from different countries, when the women were blessed with children.

The street adjoining the Chapel of Milk Grotto is noted for making many items of Olive wood, mother of pearls and

● *A hand carved model of Joseph fleeing into Egypt with Mary and Baby Jesus*

different handicrafts.

The Church of the Shepherd's Field

According to Luke 2:8 to 11, There were in the same country (Bethlehem) shepherds abiding in the field, keeping watch over their flock by night. Lo, the angel of the Lord came upon them and said, "Fear not: for behold, I bring you good tidings of great joy. For unto you is born this day, a Saviour, which is Christ the Lord." Verse 16 says that they (shepherds) came in haste and found Mary and Joseph, and the babe lying in a manger.

A Greek orthodox Church was built over a cave and another church was built by Barluzzi, the Italian architect for the Franciscons, in 1950.

There is a cave at this spot, which according to tradition was used by the shepherds. There are also ruins of a church that existed there from the fourth century upto eleventh century. Christian sources from the seventh century reported that Christmas celebrations actually begin on the 24th December every year in this Church of the Shepherd's Filed, from where the priests and believers begin a festive procession to the Church of

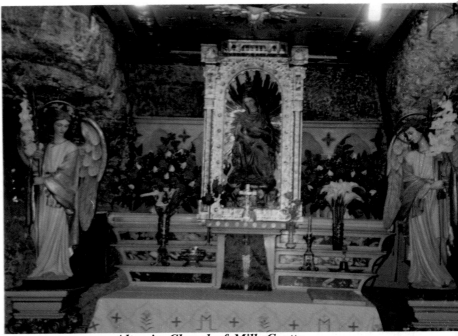

▲ *Altar in Chapel of Milk Grotto*

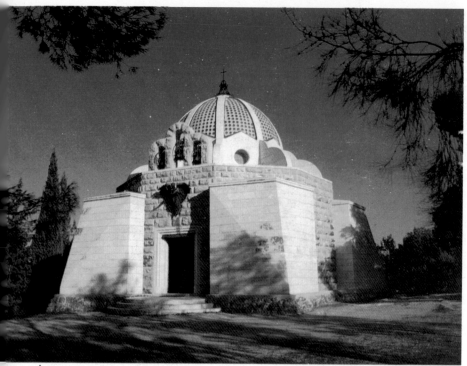

The Church of the Shepherd's Field

Nativity in the nearby Bethlehem (8 kilometers).

From the beginning of seventh century, an additional tradition developed, in which the pilgrims are shown the tombs of the three wise men, who came from east to worship infant Jesus. These tombs are in the western section of this Church of Shepherds.

In the eleventh century, this church and a monastery were destroyed and only the cave of the shepherds remained, which became the pilgrimage site for a few years. This cave served as church for the Greek Orthodox Community in the village of Beit Sahur, till the new church was constructed in 1955 on the same site.

This church is in the shape of a tent of the nomadic shepherds (Bedouin tribes). Its peculiar feature is its dome, in which small glass windows are fixed to allow bright sunlight to come into this

church, to depict the bright star that appeared in the sky when Jesus was born in Bethlehem and the shepherds saw this star.

At the top of the dome, there is a cross and a star. At the foot of the dome, there are 3 big bells of identical shape and size, known as "Bethlehem Bells". When they start ringing, they produce a beautiful musical sound. On the outside wall, just above the entrance door to the church, there is a statue of an angel, to depict the angel that appeared to the shepherds in the field at night with good tidings. This church and the cave are now under the auspices of the Greek Orthodox Patriarchates.

The Tomb of Rachel

According to Genesis 35:16 to 20, Jacob and his wife Rachel were travelling from Bethlehem and when they were a little way to come to Ephrath, Rachel travailed and she had hard labour. But, as her soul was departing (for she died), she called her new born son 'Ben-oni', but his father Jacob called him 'Benjamin'. And Rachel died, and was buried by her husband, Jacob on way to Ephrath, which is Bethlehem. And Jacob set a pillar upon her grave: that is the

Women praying in Rachel's Tomb

pillar of Rachel's grave unto this day.

Today, on the outskirts of the city of Bethlehem besides the highway, Rachel's Tomb still stands as pilgrim's spot. This is a small domed structure tomb.

Till today, Jews and other believers visit the tomb of Rachel and pray here asking for mercy in times of troubles. Women pray here for fertility and safe child birth.

On the eighth day after Jesus was born, his parents took Baby Jesus to Jerusalem temple to be blessed by Simeon. Then, they returned to Nazareth and the child grew up and waxed strong in spirit, filled with wisdom and the grace of God was upon him. His parents went to Jerusalem every year at the feast of the Passover. When Jesus was twelve years old, they went to Jerusalem after the custom of the feast. But, Jesus did not follow his parent while returning to Nazareth and he stayed back at Jerusalem. After 3 days search, his parents came back to Jerusalem and found Jesus in the temple, sitting in the midst of doctors, both hearing them and asking them questions. All that heard him were astonished at his understanding and answers. Then Jesus went to Nazareth with his parents, and he increased in wisdom and stature and in favour with God and man (Luke 2:21 to 52).

When Jesus was thirty years old, he was baptised by John the Baptist in River Jordan. (Luke 3:23 and Matt. 3:13 and 17). Then, Jesus was led up of the spirit into the wilderness to be tempted of the devil. From here, Jesus started his mission, mostly in the surroundings of the Sea of Galilee, Jordan River and Dead Sea areas. The activities of Jesus Christ from the age of twelve to thirty years have not been mentioned in any of the four gospels.

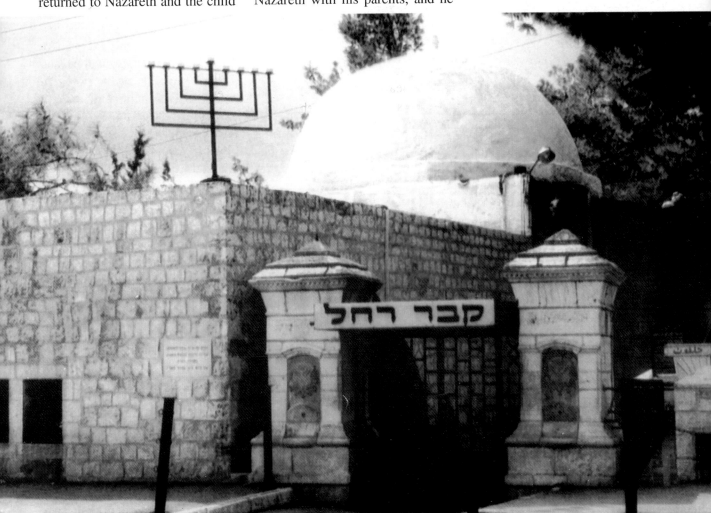

The Tomb of Rachel

7. Eastern Region of Israel

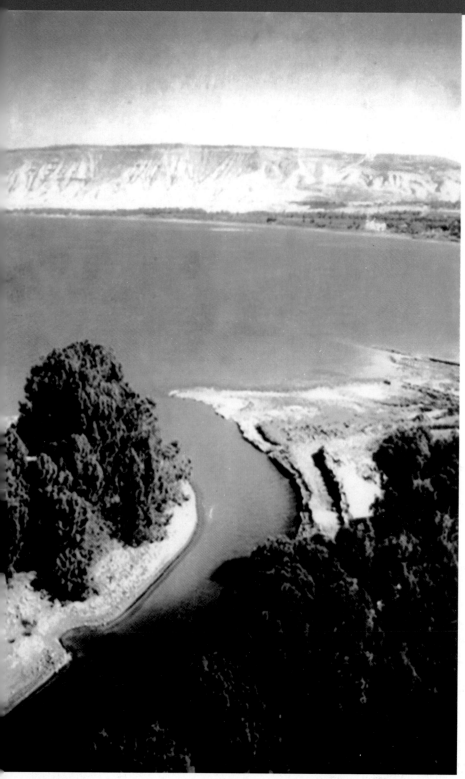

● *Entry of River Jordan into the Sea of Galilee, Capernaum*

RIVER JORDAN

It was in River Jordan that Jesus Christ was baptised by John the Baptist (Matt. 3:1 to 17 and Mark 1:2 to 11).

The healing power of the water of River Jordan are explained in II Kings 5:1 to 15. Prophet Elisha sent a messenger to Naaman, a captain of the host of the king of Syria (who was a leper) saying, "Go and wash in River Jordan seven times and thy flesh shall come again to thee and thou shalt be clean" (verse 10). Then, he (Naaman) went down and dipped himself seven times in Jordan River according to the saying of the man of God, and his flesh came again like unto the flesh of a little child and he was clean. (verse 14).

From that time onwards and even till today, millions of pilgrims coming from all over the world to River Jordan take a bath in it or get baptised in it by a priest. The pilgrims fill up bottles with Jordan River's holy water and carry it to their home countries for distributing this holy water to friends and relatives. Small bottles filled with this Holy Water are also sold through out the Holy Land, as souvenirs to be purchased by the pilgrims.

River Jordan is the natural boundary between the countries of Israel and Jordan. This Holy River Jordan has its birth in the Golan Heights (Mount Hermon) located in the northern most part of Israel,

about 70 kilometers from the city of Jerusalem. There are three perennial mountain springs in these hills, known as Banias, Dan and Hazbani, which merge to form River Jordan.

From these Golan Heights, this river flows southwards for about 20 kilometers (12 miles), before it enters the Sea of Galilee. Till this point, River Jordan is only about 50 feet wide and about 10 to 15 feet deep. This river itself is 212 meters below the sea level. Hence, the water from this river flows by natural gravity into the Sea of Galilee, which is 222 meters below the sea level. There is a gradient of 10 meters over a distance of 20 kilometers till the water gets into the Sea of Galilee and hence, the flow in the river is not rapid.

About 8 kilometers from the city of Madaba in the country of Jordan, there is the First Baptismal site of John the Baptist on River Jordan. (John 10:40).

The fresh water from river Jordan enters the Sea of Galilee, which is also known as the 'Sea of Tiberias' or 'Lake Kenneret', as both Tiberias and Kenneret cities are located on the shores of the Sea of Galilee. At this entry point, to the west of it is the city of Capernaum and to the east of it is the city of Bethsaida.

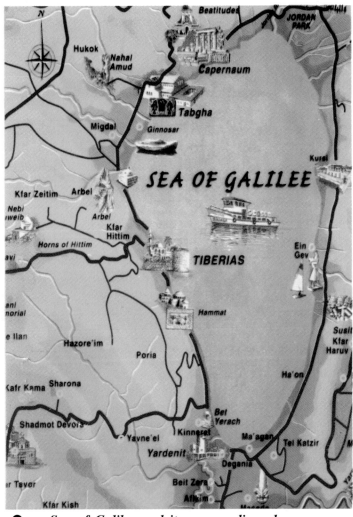

● *Sea of Galilee and its surrounding places*

After filling up the Sea of Galilee, the fresh water of River Jordan flows out as River Jordan and flows southwards for about 125 kilometers (63 miles) and enters the Dead Sea (Salt Sea). Till this point, River Jordan is about 60 feet wide and 15 to 20 feet deep. But, as water from a level of 222 meters below sea level is flowing into the Dead sea at a level of 398 meters below sea level, that is a gradient of 176 meters over a distance of 125 kilometers, the flow of water is very rapid. There are few water falls on the river.

Immediately, after the River Jordan comes out of the Sea of Galilee, there is a place known as 'Yardinit', where Jesus Christ was baptised by John the Baptist.

Dead Sea, which is 398 meters below sea level is considered to be the lowest point on earth. As all its surrounding places are at a higher level than the water in the Dead Sea, the water cannot flow out from the Dead Sea and gets evaporated there itself, thereby increasing the saltish nature of the water. From 1967, water from river Jordan is not allowed to flow to the Dead Sea.

As the Dead Sea is no more getting water into it, the remaining water in the Dead Sea is getting evaporated and year after year, the water level is going down and the water is getting more salty. Heaps of different types of salts are getting deposited in the Dead Sea.

SEA OF GALILEE

The Sea of Galilee is 140 kilometers to the east of Jerusalem. Sea of Galilee is also known as 'Sea of Tiberias' or 'Sea of Kenneret' or 'Sea of Gennesareth', or 'Lake Kenneret', as these two cities of Tiberias and Kenneret are located on the western shore of the Sea of Galilee. The name of the Sea of Galilee is rich in the memories of Jesus' ministry and no pilgrimage can be complete without a visit to the Sea of Galilee and a boat ride on the sea, as Jesus might have done many times during his ministry.

Capernaum. This city is 145 kilometers towards east of Jerusalem. Very near Capernaum, there are two other places of biblical importance- Mount of Beautitudes, on which Jesus Christ delivered the famous 'Sermon on the Mountain', and Tabgha, where Jesus Christ fed 5000 people by blessing and multiplying five loaves and two fishes. On the western shore of the Sea of Galilee, almost at the middle is the city of Tiberias.

Usually, all pilgrims enjoy a boat ride on the Sea of Galilee, sailing from Tiberias to Capernaum (about 10 kilometers), singing hymns, reading relevant portions of the Bible, remembering Jesus Christ sailing on this sea many times and preaching from the boat etc.

▲ *Passenger boat in the Sea of Galilee*

The Sea of Galilee is about 21 kilometers (13 miles) from north to south and 10 kilometers (6 miles) at its widest point, at a place known as Arbel in the west and Kursi in the east. Thus, the total area of this sea is about 210 square kilometers. The depth of the water in this sea is about 15 feet on average at different points. This being a fresh water lake, from ancient days onwards, it is used for fishing. There are 22 species of fish in this sea at present, and more than 60% of the catch contains sardines. In fact, the first four disciples of Jesus Christ, by names Simon Peter, Andrew, John and James were fishermen and Jesus called them, when they were in their boats, fishing. In those days, they used small wooden boats rowed by hand. But, now a days, big boats propelled by diesel engines are used with improved

methods of fishing. These boats also carry passengers from Capernaum to Tiberias.

The most important place of biblical importance in the north-west of the Sea of Galilee is

In a restaurant known as 'Marina Sun Rise' near Tiberias city, a special dish known as 'Peter's Fish' is served. This is

▲ *Pilgrims singing in the boat on Sea of Galilee*

reported to be a special type of tasty fish from the Sea of Galilee. Most of the pilgrims do not miss it.

On the different shores of the Sea of Galilee, there are many places of biblical importance.

- Kenneret – On the west coast of this Sea.

- Yardinit – At the southern tip of this Sea.

- Kursi. – On the east shore of this Sea.

- Korazin. – On the east shore of this Sea.

- Tel Hadar (Dodekathronon) – On the east shore of this Sea.

- Dalmanutha. – On the west shore of this Sea.

- Magdala – On the west shore of this Sea.

- Kibbutz Ginosar. – In the neighbourhood of this Sea.

- Bethsaida (Jordan Park) – On the north shore of this Sea.

All these places of biblical importance are located around the Sea of Galilee.

The Church of St. Peter's Primacy, Capernaum

Just by the Sea of Galilee, on its shore is located the Church of St. Peter's Primacy. It is also known as 'Mensa Christi', which means, 'The Table of Christ'.

The Church of Peter's Primacy is constructed with black ballast rocks. It marks the place, where Jesus appeared for the third time after his resurrection.

According to John 21:4, when the morning was now come, Jesus stood on the shore; but the disciples knew not that it was

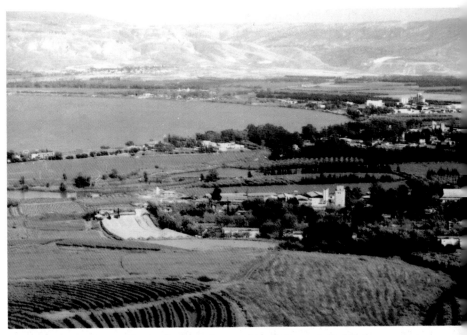

- *Cities located on the southern tip of Sea of Galilee*

Jesus. Then, Jesus saith unto them, "Children, have ye any meat?" They answered him, "No". As Jesus asked them to cast their net on the right side of the ship, they did so and caught 153 great fishes. Jesus ate bread and fish with them.

John 21:14 says that this is now the third time that Jesus showed himself to his disciples, after he was risen from the dead (resurrection).

Jesus appointed Simon Peter to the office of the 'Primacy', with the words "Feed my lambs–Feed my sheep"(John 21:15 to 19).

▲ *The Church of St. Peter's Primacy, Sea of Galilee*

Inside this Church, there is the rock known as 'Mensa Christi', which, means the 'Table of Jesus Christ' on which, Jesus ate with his disciples.

St. Peter's Church and Ruins of Synagogue in Capernaum

Capernaum is located 145 kilometers towards the east of Jerusalem. It is on the northern shore of the Sea of Galilee. Capernaum is also known as the 'Town of Jesus', as Jesus Christ spent most of his time in Capernaum and its surrounding places, preaching in the synagogues, healing the sick, performing miracles, narrating parables etc.

In the days of Jesus, Capernaum was a small fishing village on the shores of the Sea of Galilee.

According to Matt. 8:1 to 16, Jesus performed many miracles in Capernaum and its surrounding areas. Jesus healed a leper, healed a servant of a centurion, healed Peter's mother-in-law, healed many people possessed with devils. Jesus taught many things in parables like, the parable of a sower, parable of tares among wheat, parable of a grain of mustard seed, parable of treasure hidden in a field etc. But, the people of Capernaum did not believe in Jesus and therefore, he cursed Capernaum by saying "Thou Capernaum, which are exhalted unto heaven, shalt be brought down to hell: for, if the mighty works, which have been done in thee, had been done in Sodom, it would have remained until this day." (Matt. 11:23)

As the pilgrims enter the compound of St. Peter's house in Capernaum, they will come across a beautiful garden with a big statue of St. Peter, holding a staff in his left hand and a big key in his right hand, depicting the saying of Jesus to Peter in Caesaria Philippi "And I will give unto thee, the keys of the kingdom of heaven." (Matt. 16:19). There is a fish at the legs of St. Peter in this statue to depict that Peter was a fisherman.

The ruins of synagogue, where Jesus was preaching on Sabbath days in Capernaum still remain.

Excavations carried out at this site reveal the ruins of the house of Peter. A new church in an octagonal shape has been constructed on these ruins.

Greek Orthodox Monastery Capernaum

Just behind this Church of St. Peter and on the shore of the Sea of Galilee itself, there is a beautiful Greek Orthodox Monastery. This monastery is conspicuous from any distance in Capernaum area, due to its red domes and crosses on each dome.

MOUNT OF BEAUTITUDES

Mount of Beautitudes is near the

▲ *Garden in St. Peter's Compound, Capernaum*

▲ *Statue of St. Peter, Capernaum*

Sea of Galilee. The term 'Beautitudes' means 'Blessings'.

According to Matt. 5:1 to 11, seeing the multitude, Jesus went up to a mountain and when he was set, his disciples came unto him. And Jesus taught them saying:

- "Blessed are the poor in spirit: for theirs is the kingdom of heaven,

- Blessed are they that mourn: for they shall be comforted,

- Blessed are the meek: for they shall inherit the earth,

- Blessed are they which do hunger and thirst after righteousness: for they shall be filled,

- Blessed are the merciful: for they shall obtain mercy,

- Blessed are the pure in heart: for they shall see God,

- Blessed are the peace makers: for they shall be called the children of God,

- Blessed are they which are persecuted for righteousness sake for theirs is the kingdom of heaven."

These eight blessing for the righteous people indicated by Jesus Christ in his sermon are now known as the 'Sermon on the Mountain'. To commemorate this Sermon on the Mountain, a beautiful octagonal church was constructed on the Mount of Beautitudes, overlooking the Sea of Galilee. This was also constructed by the architect Antonio Barluzzi of Italy in 1937. Octagonal shape is selected to recall the eight blessings or Beatitudes. A peculiar feature of this Church of Beautitudes is that in the dome of this church,

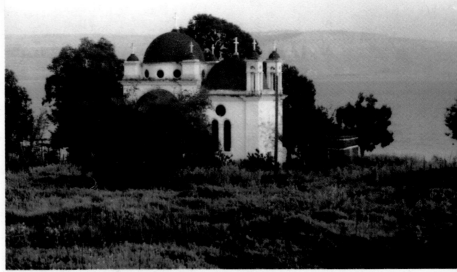

▲ *The Greek Orthodox Monastery, Capernaum*

eight stained glass windows are fixed and on each window, a part of the text of each of the Beautitudes is written in the Hebrew language.

From the Mount of Beautitudes, there is a good view of the Sea of Galilee. On the floor of this church, mosaics decorated with symbols of the virtues of man referred to in the sermon on mountain, can be seen.

TABGHA

According to Matthew 14:15 to 21, in the evening, the disciples came to Jesus and said, "send the multitude away so that they might buy themselves victuals." But, Jesus said, "they need not depart; give ye them to eat." The disciples said, "we have here but five loaves and two fishes." Jesus blessed them and fed 5000 men besides women and children.

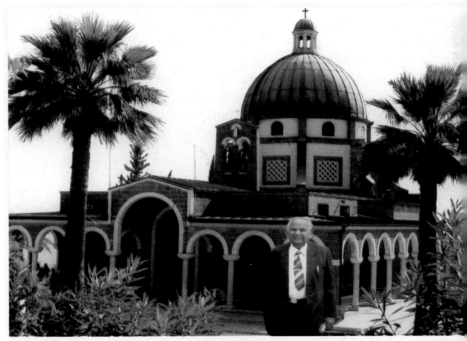

● *The Church of the Beautitudes, Capernaum*

They collected twelve baskets full of remnants.

To commemorate this miracle of 'Feeding the multitude', a church has been constructed.

The name 'Tabgha' is distortion of the Greek word 'Heptapegon', which means, 'seven springs'. In the past, seven springs met here and flowed into the Sea of Galilee. But now there are only five springs.

The table rock on which this miracle took place has been used in this church as altar. The olden days mosaic pavement still remains in this modern church, which was built in 1982. The mosaic in front of the altar symbolizes the five loaves and two fishes.

TIBERIAS

The city of Tiberias is located on the western shore of the Sea of Galilee. This city was built in honour of Emperor Tiberius of Rome in around 20 B.C. by Herod

● *The Church at Tabgha and Church of St. Peter's Primacy*

Antipas, Roman Governor of Galilee and Perea. He declared Tiberias as the capital of Galilee.

Tiberias is located on a rocky cliff at about 19 kilometers (12 miles) south of the place, where River Jordan flows into the Sea of Galilee. Tiberias is 208 meters (682 feet) below the sea level. There is no record of Jesus visiting Tiberias, in the Bible. But, in John 6:23, it is mentioned that, "There came other boats from Tiberias, as near unto the place, where they did eat bread, after that the Lord had given thanks". This city has a good view of the Sea of Galilee. There are many hot springs in the southern part of Tiberias. Hence, in the earlier days, this city was a popular resort for Romans. Even today, there are many health resorts in Tiberias. In 1838, Ibrahim Pasha constructed circular apartments, with marble pavement for private bathing. There are four hot water springs with water at 144 °F temperature, but with saltish and bitter water with strong odour of sulphur. This water is considered to be good for rheumatic ailments.

KENNERET (GENNESARET)

The Sea of Galilee is also known as the 'Lake of Gennesaret' (Luke 5:1), as the city of Gennesaret or Kenneret is located on the shore

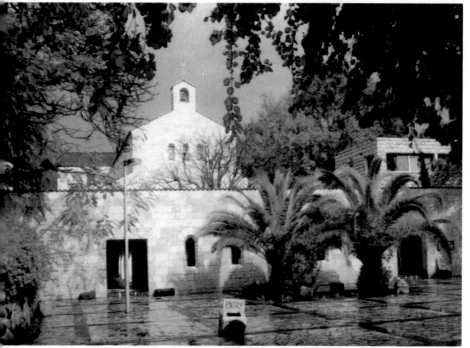

▲ *The Church at Tabgha*

of the sea (lake). This city was fortified city of Naphtali (Josh 19:35), commonly referred to as 'Chinnereth'. In the Bible, Gennesaret is identified as 'The Land of Gennesaret' (Mark 6:53). This city is a plain extending two kilometers from the Sea of Galilee along a five kilometers section of the Galilee's north shore. As the soil of Gennesaret is rich loamy soil, a variety of fruits like figs, olives, palms and a variety of trees are grown here.

YARDINIT

Yardinit is a very important place for all Christians, as it is at this place, Jesus was baptised by John the Baptist in River Jordan. Jesus was 30 years of age at the time of his baptism.

Mark 1:6 to 11 and Matt. 3:1 to 17, says that John did baptise in the wildernesses. Then came Jesus from Galilee to Jordan unto John to be baptised of him. After baptism, when Jesus went up straight away out of the water, and Lo, the heavens were opened unto him, and he saw the Spirit of God descending like a dove, and lighting upon him and Lo, a voice from heaven, saying "This is my beloved Son, in whom, I am well pleased."

Yardinit is just 100 meters from the spot, where River Jordan comes out of the Sea of Galilee at its southern tip. At this place, river Jordan is about 40 feet wide and 10 to 15 feet deep. But, as the

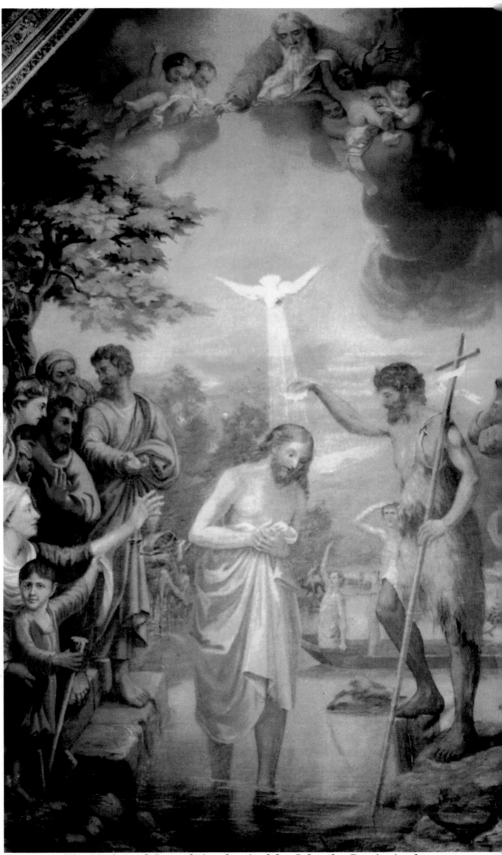

A painting of Jesus being baptised by John the Baptist in the Church of St. John the Baptist, Ein Karem

water, as precious gift from the Holy Land.

KURSI

Matthew 8:28 to 34 says, that when Jesus came to the other side of the Sea of Galilee to a place known as Gerge-senes, there met him two possessed with devils, coming out of the tombs, exceeding fierce, so that no man might pass that way. They cried out saying "What have we to do with thee, Jesus, thou son of God? Art thou come hither to torment us before the time?" There was a herd of swine far away and the devils besought him saying, "If thou cast us out, suffer us to go away into the herd of swine." Jesus allowed so, and the devils went into the herd of swine, which ran violently down a steep place into the sea and perished in the waters. The two men were healed.

On the eastern shore of the Sea of Galilee is located a place known as Kursi, which is the same as Gergesenes. The actual site of this

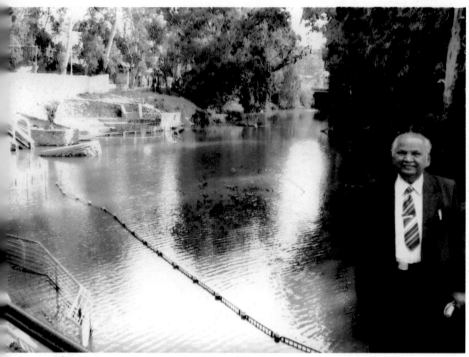

▲ *Baptismal site at Yardinit on River Jordan*

gradient is more, the flow of water is rather rapid. On both sides of this river, trees spread their shady branches over the river.

In recent years, for the convenience of the millions of pilgrims, who visit the baptism site, cemented sloping floor into the river alongwith a fencing has been constructed. A fencing to protect the pilgrims from entering into deep water is also constructed. Hand rails are fixed at many places so that, the pilgrims can hold them while entering the river water. All precautions and protective measures have been taken for the safety of the pilgrims.

Many pilgrims hire baptismal white gowns available at this site and take baptism in River Jordan by a priest. Some pilgrims simply have a dip in the river or atleast sprinkle Jordan River water on their head and pray for blessings.

Almost all the pilgrims fill up

small bottles with the Holy Water of River Jordan and take to their countries for distribution to friends and relatives as "Souvenirs" from the Holy Land. This water is considered to have healing power on sick people and hence, cherished by all recipients of this

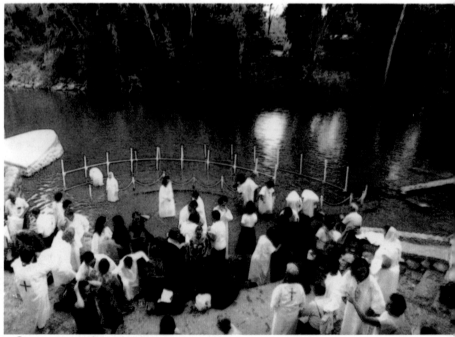

● *Pilgrims being baptised in River Jordan*

miracle was not very well known until the late 1960's, when the ruins of a Byzantine basilica with mosaics floor were by chance discovered to prove that Kursi was the exact place, where this miracle took place.

KORAZIN

Korazin is located on the eastern shore of the Sea of Galilee.

According to Luke 10:13 and 14, when the Jews of Korazin refused to allow Jesus to preach there, Jesus cursed Korazin by saying "Woe unto thee Chorazin (same as Korazin) woe unto thee, Bethsaida, for if the mighty works had been done in Tyre and Sidon, which have been done in you, they had a great while ago repented, sitting in sack cloths and ashes."

At present, all the ruins of Korazin are nothing but, black rubble of a synagogue of second century A.D. Korazin seems to have been destroyed by an earthquake in the third century and it was never rebuilt.

TEL-HADAR (DODEKATHRONON)

Not far from Kursi, there is a place known as Tel-Hadar, which is also known as Dodekathronon. This means, twelve tables. This place had been identified as the site of the second miracle of blessing and multiplication of loaves and fishes to feed 4000 people (Mark 8:1 to 9).

DALMANUTHA

After blessing and multiplying five loaves and two fishes to feed 5000 people at Tabgha, Jesus Christ entered into a ship with his disciples and reached the parts of Dalmanutha. (Mark 8:10-12). The

Cross facing the Sea of Galilee at Dalmanutha

Pharisees came forth and began to question with him, seeking of him a sign from heaven, tempting him. Jesus sighed deeply in his spirit, and saith "Why doth this generation seek after a sign? Verily, I say unto you; There shalt be no sign be given unto this generation."

This site is known as the place, where Jesus sighed for mankind. On the west side of the Sea of Galilee and near Magdala, a place is believed as the site of meditation. This site is marked by a Great Cross facing the peaceful waters of the Sea of Galilee.

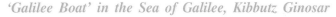

'Galilee Boat' in the Sea of Galilee, Kibbutz Ginosar

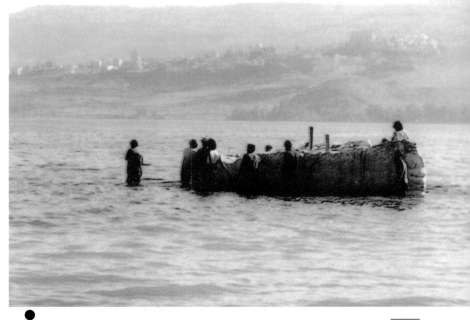

MAGDALA

A place known as Magdala is not far from the Sea of Galilee. Magdala is the birth place of Mary Magdalene.

KIBBUTZ GINOSAR

At a place known as Kibbutz Ginosar in the neighbourhood of the Sea of Galilee, the remains of a first century wooden boat are on display. This was discovered in the mud banks of the Sea of Galilee, when the sea water receded during the drought (no rains) of 1986. It is believed that it is from this boat that Jesus Christ preached to the people, who stood on the shore of the Sea of Galilee. (Matt.13:1 and 2).

This boat was made of different types of wood, meaning that it was a poor man's boat and Jesus himself might have sailed in this boat many times, on the Sea of Galilee.

BETHSAIDA (JORDAN PARK)

Bethsaida is located within Jordan Park in the lower Golan heights. It is on the north of the Sea of Galilee. It is at this spot that River Jordan enters the Sea of Galilee.

According to John 12:21, Bethsaida is the native place of Philip, Andrew and Peter. Mark 8:22 to 26 says that Jesus visited Bethsaida and gave sight to a blind man. Bethsaida is also mentioned as part of the 'Jewish Triangle' in Jesus' time, along with Capernaum and Korazin, the focus of the Jewish life and culture of which Jesus said "Woe unto thee Korazin and woe unto thee Bethsaida, for if the mighty works, which were done in you had been done in Tyre and Sidon, they would have repented long ago in sack cloth and ashes (Matt. 11:21).

The location of this place, where Philip, Andrew and Peter lived as fishermen shows the way in which they lived and carried out their day to day duties.

The pilgrims can now realise that there are many places of biblical importance around the Sea of Galilee, as Jesus Christ spent most of his time in this area. But, unfortunately, due to so many rulers changing in Israel during the last 2006 years, many biblical spots had been destroyed and only ruins can be found in these spots. Recent excavations being carried out in these areas had been revealing many other spots of biblical importance.

While the pilgrims are in the area of the Sea of Galilee, it is convenient for them to visit the northern part of the sea, where there are important places like, Mount Hermon, Caesaria Philippi and later on southern parts of the Sea of Galilee, where there are important places, like Masada, Qumran, Sodon and Gomorrah,

Mount Hermon, Northern Border of Israel

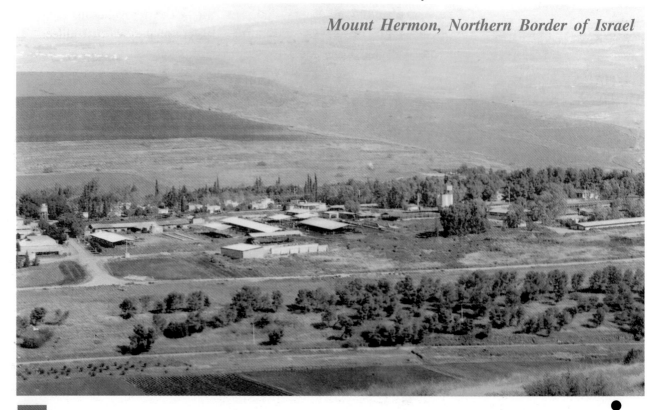

Ein Gedi etc., in the Dead Sea area. Then, the pilgrims can move to central region of Israel, to visit Jerusalem etc.

MOUNT HERMON

Mount Hermon is in the northern border between the country of Israel and its neighbouring countries of Syria and Lebanon. This mountain range extends for a distance of about 18 miles along the border with a width of 5 miles and its height is about 9,220 feet above the sea level.

On a clear day, this mountain can be seen from a distance. In Arabic language, this mountain is known as 'Jabel esh-Sheik' or 'Jabel et-Talg', meaning, the mountain of snow. In winter, lot of snow falls on Mount Hermon and during summer, the snow melts and the cold water flows into the three mountain springs, Banias, Dan and Hazbani, which feed River Jordan with plenty of water. In the early days, Mount Hermon was the seat of the ancient god 'Baal'.

CAESAREA PHILLIPPI

Matthew 16:13 to 19 say, When Jesus came to the coasts of Caesarea Phillippi, he asked his disciples saying, "Whom do men say that I the son of man am?" Simon Peter answered and said unto him "Thou art the Christ, the son of the living God". Jesus answered and said "Blessed art thou, Simon Barjona: for flesh and blood hath not revealed it unto thee, but my Father which is in heaven. I say unto thee that thou art Peter, and upon this rock I will build my church: and the gates of hell shall not prevail against it. I will give unto thee the keys of the

kingdom of heaven and what soever thou shalt bind on earth shall be bound in heaven: and whatsoever thou shalt loose on earth shall be loosed in heaven."

In those days, this city was full of greenery, as the mountain spring Banias was flowing through it, supplying lot of water. This city was given to King Herod by the then Roman Emperor, Augustus. As a token of his gratitude, King Herod built a palace for Caesar Augustus. After the death of King Herod, his son Philip made this city as his capital and renamed it as 'Caesaria Philippi'. The events that took place in this region are:

- Jesus, while walking along the shores of the Sea of Galilee, chose fishermen like, Simon Peter, Andrew, James and John, Philip and Nathaniel as his disciples.(Matt. 4:18 to 21).

- Jesus healed many sick people near the Sea of Galilee. (Matt. 5:29 to 31).

- Jesus fed 4000 men with seven loaves and a few small fishes on the shore of the Sea of Galilee and seven baskets full of remnants were collected. (Matt. 15:32 to 39).

- Jesus walked on the waters of the Sea of Galilee. (Matt. 14:22-33 Mark 6:45 to 52 and John 6:15 to 20).

- From Sycar in Samaria, Jesus came to Galilee and all the people received him joyfully. (John 4:45).

- Jesus went over from the Sea of Galilee to a desert place and preached there and in the evening, he fed 5000 men with five loaves and two fishes and twelve baskets full of remnants were collected. (Matt. 14:13 to 21; Mark 6:33 to 44, Luke 9:11 to 17 and John 6:1 to 14).

- After resurrection, Jesus appeared for the third time to his disciples, who were fishing in the Sea of Galilee and he ate with them. (John 21:1-14).

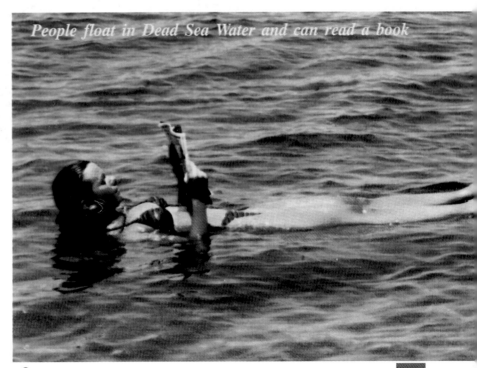

People float in Dead Sea Water and can read a book

DEAD SEA

In the earlier days, Dead Sea was known as 'Salt Sea'. In the Old Testament, the name Salt Sea is mentioned (Gen 14:3; Deut 3:17; Joshua 3:16; 12:3; 15:2 and 15:5).

Due to very high concentration of salts in the Dead Sea water, no aquatic life can survive in this sea water. Due to the salty nature of the water in this sea, it is known as Salt Sea. In Greco-Roman times, this sea was known as 'Pitch Sea', because bitumen was being extracted from the black mud settled at the bottom of this sea. This sea was also called as 'Marbah Sea' or 'Eastern Sea' to distinguish it from the 'West Sea' or 'Mediterrinean Sea' in the west coast of Israel.

As the Dead Sea is the lowest point on earth and all its surroundings are at a higher level, the water from the Dead Sea cannot flow anywhere and it gets dried up there itself by solar evaporation.

Dead Sea is about 96 kilometers (60 miles) from north to south and 20 kilometers (13 miles) from west to east. Thus, Dead Sea has an area of 780 square miles or 1920 square kilometers. Dead Sea is 60 meters (200 feet) deep at its middle and 30 feet deep at its south end. Due to acute shortage of water in the southern parts of Israel, the Government had not been allowing the water from river Jordan to get into the Dead Sea from the year 1967 onwards, but diverting the water for irrigation of crops.

Scientists feel that at this rate, there may not be any water in Dead Sea after a few years and there may be heaps of different types of salts in the sea bed.

The peculiarities of Dead Sea are the air above the Dead Sea, the water in the Dead Sea and the mud at the bottom of the Dead Sea.

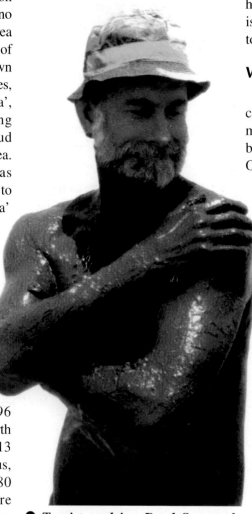

● *Tourist applying Dead Sea mud*

The Air above the Dead Sea

The air above the Dead Sea is miraculously dry, unpolluted and has low humidity. Due to constant evaporation of the water in the Dead Sea by solar heat, the air above the Dead Sea has some chemicals like bromine and sulphur fumes. Bromine is reported to give a relaxing feeling to the people, who visit Dead Sea area. As the Dead Sea is 398 meters below sea level, the barometric pressure there is slightly different than the normal. The oxygen content of the air above Dead Sea is 8% more than anywhere else on the earth and hence, breathing by human beings is easy there. Therefore, all visitors to Dead Sea area feel relaxed.

Water in the Dead Sea

The water in the Dead Sea contains 21 minerals including magnesium, calcium, potassium, bromine salts and sulphur salts etc. Out of these 21 minerals, 12 minerals are reported to be unavailable in any other sea water. The water of Dead Sea is reported to nourish the skin, activating circulation of blood in human body. By this, any rheumatic discomfort and metabolic disorders are reduced.

As the water of Dead Sea contains 10 times more salt and minerals than the water in the Meditarranean sea or any other sea, the density of water of the Dead Sea is more than ordinary water or any other sea water and density of human body. Hence, it enables people to float, even if one lies flat on the water.

There are many thermo-mineral springs along the Dead Sea shores. These spring waters are hot (55 °C temperature) and contain lot of sulphur compounds. Therefore, taking a bath in these sulphur containing water activates blood circulation in the human body and increases oxygen supply to the body.

Natural spring water flows from the Judean hills into lower areas facing the Dead Sea. Usually, tourists splash in the waterfalls and cool stream, when they are walking along dry river beds and oasis near the Dead Sea. Natural mineral spring water is usually bottled by the natives and sold to the tourists, as souveniers.

Dead Sea is the only place in the world, where people can sit in the sun for a long time without getting any sunburns, as the harmful ultra violet rays of the sun are filtered through 3 natural layers – an extra atmospheric layer, an evaporative layer that exists above Dead Sea and a thick ozone layer above the Dead Sea. However, tourists are medically advised to maintain careful and progressive exposure to the sun, after visiting the Dead Sea area.

Mud at the Bottom of the Dead Sea

The mud at the bottom of the Dead Sea is very black in color and slimy. It contains all the minerals of the Dead Sea Water. It has a medicinal smell. As it contains many minerals, particularly bromine and sulphur compounds, this mud has some medicinal effects. So, the locals collect this mud by diving to the sea bed and store it. As soon as the tourists visit the Dead Sea, the locals apply this mud throughout the body and make them sit in the sun for a few hours. Later on, they can take a fresh water bath in the

nearby bath rooms. It is believed that this mud cleanses and stimulates the skin, thereby relieving muscles and emotional tensions, improving blood circulation and easing rheumatic pains.

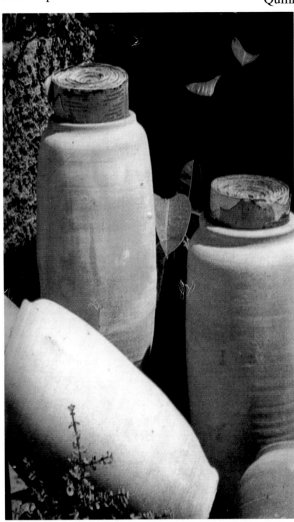

Clay jars found in Qumran caves

It is learnt that in the earlier years, Queen Cleopatra of Egypt obtained exclusive rights to build cosmetic and pharmaceutical factories around Dead Sea area to make use of this black mud in preparing many cosmetic creams and lotions and also for using this mud in beauty parlours.

Many medicinal preparations, particularly skin lotions with the

brand name of 'Ahava' made from Dead Sea chemicals are sold in all souveniers shops in Israel.

On the western shore of the Dead Sea, there are a few places of biblical importance. They are Qumran, Ein Gedi and Masada. A little more to the south of the Dead Sea is Sodom.

QUMRAN

Qumran is a desert located on the western side of the Dead Sea. There are number of caves in Qumran. In these caves, ancient documents, mainly some books of the Old Testament written in Hebrew, Aramaic and Greek languages on rolls of leather, copper and papyrus or paper were found. They are known as 'Dead Sea Scrolls'. The word 'Scroll' means a roll of papers or documents. These scrolls are preserved in many museums, seminaries etc. in Israel for translation.

There is an interesting story behind the discovery of Dead Sea Scrolls. The story goes to say that in the year 1947, two Arab shepherd boys while tending their goats, one of the goats went into a nearby cave and did not return for a long time. One of the shepherd boys threw a stone into the cave in order to drive out his goat. To his great surprise, he heard the sound of breaking of pottery or earthern vessels. He was curious to know how was pottery there in a cave and reason for such a sound. He called his co-shepherd boy and both of them dared

to enter the cave for the first time. To their surprise, they found in the cave, some clay jars of about 30 inches high and 10 inches wide. In these jars, they found leather scrolls wrapped in cloth and the lids of the jars were fixed with a pitch like substance (possibly derived from the nearby Dead Sea mud).

Both the shepherd boys could guess that these jars with scrolls in them could fetch them some money. So, they took seven jars and went to Bethlehem to sell them. There, they located a dealer of antiques (ancient materials) and asked him to pay twenty pounds for all the seven jars. The dealer could not pay that much amount to the shepherd boys. Then, the boys went to Jerusalem and for a few weeks, they bargained with many dealers. Atlast, the boys could sell four jars to Archbishop Athanasius Samuel of St. Mark's Orthodox Syrian Monasrey and three scrolls (jars) to E.L. Sukenik, Professor of Archaeology at the Hebrew University in Jerusalem. The boys agreed with them to show the cave in which they found these seven jars.

The Archbishop and Professor consulted many archaeologists and scholars to find out what was written on the scrolls. Atlast, Dr. W.F. Albright of John Hopkins University, revealed that these scrolls were 'Amazing Discovery', as they were the oldest biblical documents available at that time (1947 to 1950). They were found to be documents of 100 B.C. and were portion of the Bible (Old Testament).

The two shepherd boys showed them the cave in which they found these jars with scrolls in them. From that time onwards, many archaeologists started excavation of many caves in Qumran area and found many such jars with scrolls, Roman lamps, potteries etc. During their excavations, they found ruins of an elaborate central building complex, the main floor of which comprised of 15,000 square feet area. It should have been a community center or monastery with a massive tower for defence, dining hall, pantry, laundry, store rooms, pipes to bring water from a nearby water falls etc. There were also pottery workshops, pools for bathing and baptism and three cemeteries with more than thousand graves. The most impressive discovery in these caves was a Scriptorum, a writing room of 43 feet long and 13 feet wide with ruins of a narrow masonary table of 16 feet long and a long bench in its front. There were also three ink pots (two of clay and one of bronze metal) with dried up ink made of black carbon and gum.

There is a long story of these discoveries. But, in brief, these scrolls were found to be manuscripts of every book of the Old Testament, except the book of Esther. The books of Isaiah, Psalms and Deuteronomy and Genesis were found in many numbers by which the scholars who could read these manuscripts in 1950's felt that these books were perhaps more in use. They were written on leather. These scholars gradually translated these documents from Hebrew, Aramaic and Greek languages into English and published the present day versions of the Bibles. The language used in these scrolls more or less tallied with the style in the present day King James version of the Bible. All these scrolls in original form and bits of these scrolls are now being preserved by the Government in the Great Palestine Archaelogical Museum in Jerusalem. Some are preserved in the 'Shrine of the Book' at Israel Museum in Jerusalem. An international group of scholars are kept busy in Jerusalem to translate these documents and publish them in English.

EIN GEDI

Ein Gedi is on the western shore of the Dead Sea, just a little north of Masada. This place is like an oasis in the Judean desert. According to I Samuel 23:29 David went up from thence and dwelt in strong holds at Ein-Gedi", in a cave Adullam. I Samuel 24:1 to 6 says that King Saul took 3000 chosen men and went to seek David and his men upon the rocks of the wild goats (Ein Gedi). King Saul went into a cave (Sheepcotes) and David and his men were staying by the side of the same cave. David arose and cut off the skirt of Saul's robe privily, but did not kill King Saul, seeing that he was the anointed of the Lord.

Ein Gedi is an ancient settlement near the western shore of the Dead Sea. The term 'Ein Gedi' means, 'Spring of the young goat'. Many ibexes (mountain goats) are found in the caves and cliffs of Ein Gedi. This place is also noted for its springs and water falls, like David's Spring.

MASADA

Masada is a mountain located about ten miles south of Ein Gedi

and two and half miles off the west shore of the Dead Sea. Masada is shaped like a big ship of 200 feet long and 100 feet wide in the middle and tapers to narrow promontories (an area of high land that extends out into the sea) at the northern and southern tips. Its sides are composed of almost sheer rock cliffs, a thousand feet above the barren wilderness of Judea and 1300 feet above the waters of the Dead Sea.

Masada is the world's most startling natural fortification and is a majestic twenty three acres flat top mesa. (a hill with flat top and steep sides). This mountain 'Masada' is a symbol of Jewish freedom.

In 40 B.C., King Herod chose Masada as his place of retreat and refuge in the event of any possible attack by Queen Cleopatra of Egypt, who desired to extend her kingdom of Egypt to Judea. Herod got a big wall of 4,590 feet long 20 feet high and 13 feet wide with three gates and thirty defence towers constructed. Within this wall, Herod got his three-tiered hanging palace constructed. The hanging palace is three-tiered with upper terrace and 60 feet below it is middle terrace and 50 feet below it is the lower terrace. On each terrace, there are palatial buildings. In addition to the three-tiered palace, Herod got constructed a main official ceremonial palace, known as the 'Palace of the King' on the western side of Masada mountain. This is the largest building on this summit and covers an area of 36,000 square feet. There are a number of highly decorated rooms, bath houses etc. The only approach road to the top of this

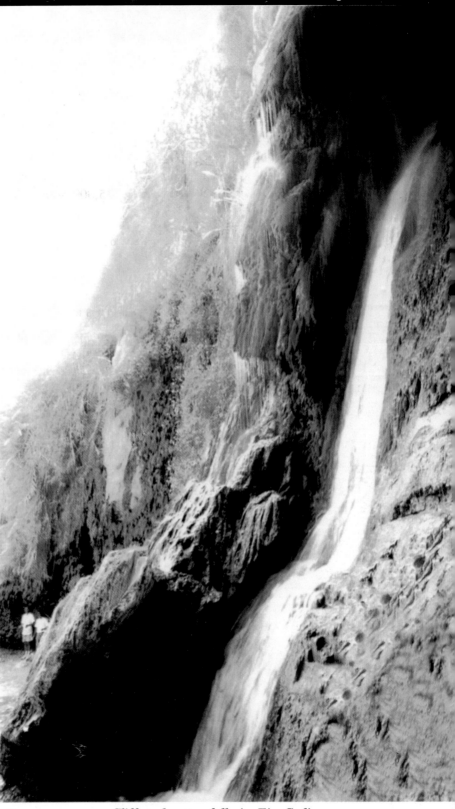

Cliff and water falls in Ein Gedi

mountain was a narrow snake path winding up to the top on the eastern slopes of this mountain.

Masada was the site of most pathetic and dramatic episodes in the history. 19 centuries ago, 967

Three tiered palaces of King Herod on Masada Mountain

Jews (men, women and children) gathered on the summit of Masada to escape killing by Roman soldiers. In the year 72 B.C. Roman Governor, Flavius Silva moved 15,000 Roman soldiers upto Masada mountain and for three years, he got a massive wall constructed around Masada summit, so that these Jews could not escape when attacked.

Eleazar ben Yair, leader of the Jews that gathered on the summit watched all the efforts of the Roman soldiers in building the massive wall for three years and realised that their end was near. He bade his followers to remain true to the cause for which they had fought so long and so valiantly. He cried out "Let us rather die than be enslaved by our enemies (Romans). Let us leave this world in freedom". With these words, nine hundred and sixty seven Jews (men, women and children) had a pathetic death with their own swords. The men embraced their wives and children and killed them with their own swords. Then, lots were cast and ten men were chosen to take the lives of their comrades. Finally, the last surviving warrior set fire to the palace on the summit of Masada mountain and fell on his own sword and died. These Jews left behind abundant supplies of food materials and water, so that, the Roman soldiers might realise that the Jews preferred death rather than enslavement.

For many generations, this incident of Masada was considered as a semi-legendry tale. But, in the year 1963, Masada mountain was excavated by international archaeologists, which proved this 'Legend' to be history. Masada has become a symbol of the determination of the Jews to be free in their own land. The sacrifice of Eleazar ben Yair and his comrades remain as a reminder of love for freedom, which is important to the Jewish nation today, as it was in the earlier year.

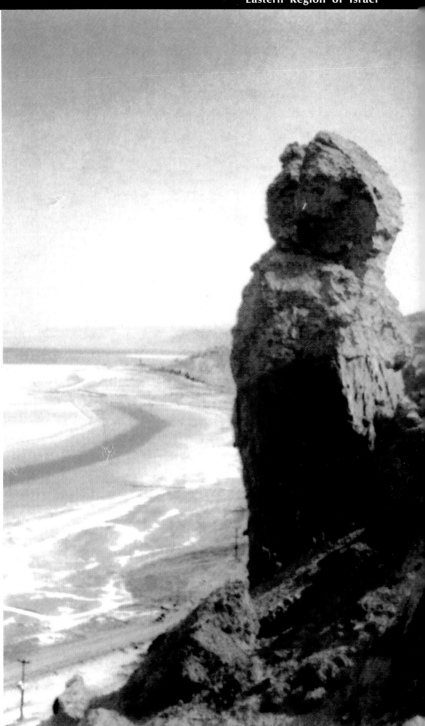

● *Rock pillar of Lot's wife.*

SODOM AND GOMORRAH

According to Genesis 19:1 to 26, two angels came to Sodom and told Lot to escape with his wife and two daughters for their life but not look back. Lot entered a place known as Zoar. Then the Lord rained upon Sodom and Gomorrah brimstone and fire from heaven, and destroyed the cities. But, Lot's wife looked back from behind him and she became a pillar of salt. Sodom is 10 miles south of Masada.

8. Central Region of Israel
JUDEAN REGION

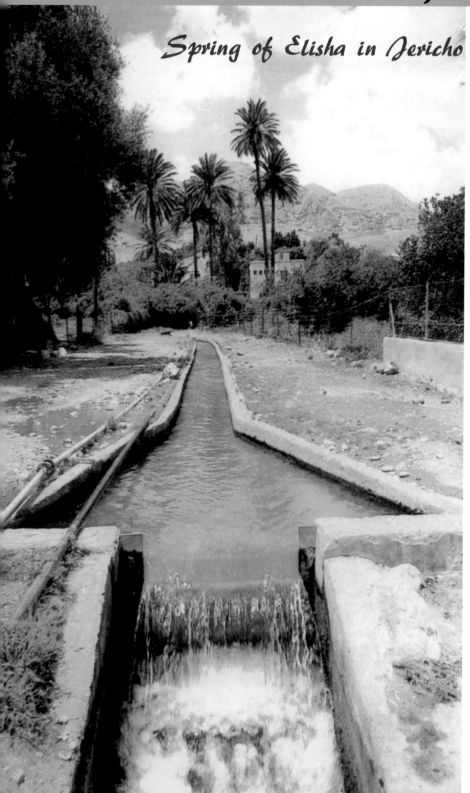

Spring of Elisha in Jericho

The central region of Israel (Judean Region), consists of some of the most important places of biblical importance and many events took place in this region.

- Jericho
- Bethany/Bethphage
- Jerusalem
- Emmaus
- King Solomon's Pools
- Herodion
- Hebron
- Sycar in Samaria
- Cana
- Meddigo
- Sepporis
- Nain
- Mount Tabor

JERICHO

Jericho is the oldest walled city in the world. It has a history from 7000 B.C., onwards. Excavations are still going on to locate the correct place of Jericho. Old Testament (Joshua 6:20) shows that Jericho was conquered by Joshua. Jericho was the first place in Israel, where men settled permanently at one place, abandoning their earlier wondering life style of herdsmen. Throughout the early Bronze Age (300 to 2100 B.C.) Jericho was defended by a series of mud brick walls. In 1259 B.C., the children of Israel crossed River Jordan at a place near Jericho. Elijah was taken to heaven from Jericho. Elisha purified the water by sprinking salt into water. A

Greek Orthodox Church has been constructed by the name of St. Elisha Church to commemorate this miracle.

The city of Jericho is also known as 'City of Palms' or 'City of Dates', as there are plenty of date palm trees in and around Jericho. Deuteronomy 34:3 says that when Moses went upto Mount Nebo, the Lord showed him the 'Promised Land' including the plain of the valley of Jericho, the city of Palm Trees.

As plenty of water is available for irrigation in Jericho area, many types of fruits and vegetables are grown in this area and marketed here. All the pilgrims make purchases of different types of fruits in Jericho. Of all the fruits, fresh and delicious dates plucked from the date palms are sold in the fruit stalls. Fresh dates are also served in restaurants.

▲ *Date Palm trees in Jericho*

Jesus' visit to Zacchaeus' House

According to Luke 19:1 to 10, Jesus entered and passed through Jericho. A rich man named, Zacchaeus, who was a chief among the publicans sought to see Jesus but could not due to many people surrounding Jesus and his little stature. When he heard that Jesus was passing by, he ran before and climbed up a Sycamore tree to see Jesus.

When Jesus came to that place where the Sycamore tree was located, he looked up and saw him

▲ *Sycamore Tree in Jericho*

▲ *Fresh fruit stalls in Jericho*

and said unto him, "Zacchaeus, make haste and come down, for to day I must abide at thy house." And Zacchaeus came down the tree quickly and received Jesus joyfully.

Jesus healed a blind man

Luke 18:35 to 43 says that as Jesus came near Jericho, a certain blind man, Barthemaus sat by the way side begging. When the blind man knew that Jesus of Nazareth was passing by, he cried saying "Jesus, thou son of David, have mercy on me." Jesus stood and commanded him to be brought unto him. Jesus said unto him "receive thy sight thy faith hath saved thee." Immediately, the blind man received his sight.

Good Samaritan Inn

Jesus Christ wanted to explain to the people as to who is their neighbour. According to Luke 10:30 to 37 Jesus narrated to them the parable of a man going from Jerusalem to Jericho (24 kilometers) and fell among thieves, who stripped him off his raiment, wounded him and departed, leaving him half dead. A priest and a levite passed by and went away. But, a certain Samaritan came that way, saw him and had compassion on him. He bound up the wounds, pouring in oil and wine, made him sit on his donkey and admitted him into an inn to be taken care of and paid for it. Jesus asked the people, which of these three was a neighbour? They all said that the Samaritan, who showed pity on him

THE MOUNT OF TEMPTATION OR THE QUARANTEL MONASTERY

Just 1.5 kilometers north-west of Jericho and above Jericho basin, there is a steep ridge and on its side is the Greek Orthodox Monastery called 'Monastery of Quarantel'. In Latin, 'Quarantel'

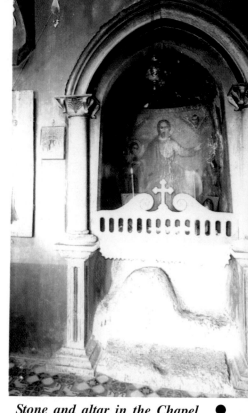

Stone and altar in the Chapel of Temptation, Jericho

means forty days, meaning that Jesus was tempted for forty days. This is also known as 'Monastery of Temptation' or 'The Mount of Temptation'.

According to Mark 1:12 and 13, immediately after the baptism of Jesus by John the Baptist in River Jordan, the spirit driveth him into the wilderness. And he was there in the wilderness forty days, tempted of Satan and was with wild beasts and the angels ministered unto him.

A new monastery was constructed in 1895 at a height of 170 meters above the ground level and above 25 caves and the monastery faces Jericho. At the southern end of the church is a staircase leading to the Chapel of Temptations, wherein there is a stone upon which Jesus sat, when Satan tried to tempt him for the

Good Samaritan Inn between Jericho and Jerusalem.

first time. This stone is part of the apse above which is the altar.

From the entrance to the monastery, another winding path leads unto the top of the mountain. From here is a bird's eye view of Jericho, Jordan valley and mountain Moab.

Now a days, there are cable cars running from Jericho (near the Temptation Restaurant) to the top of the Mountain of Temptations. These operate from 8 o'clock in the morning to 8 o'clock in the night for the convenience of the pilgrims.

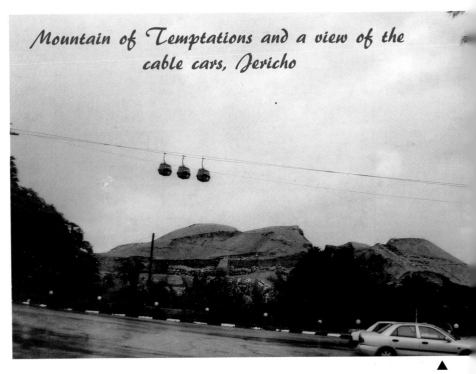

Mountain of Temptations and a view of the cable cars, Jericho

JESUS CHRIST'S LAST JOURNEY TOWARDS JERUSALEM

Jesus Christ's last journey was towards Jerusalem through Bethany and Bethapage.

BETHANY

Bethany, which was a small village in Jesus' days is located on the south-eastern slopes of the Mount of Olives. Bethany is just 2 miles (3 kilometers) east of Jerusalem. Bethany was an Arab village, with the name of 'El Azaryia', meaning, 'The place of Lazarus'. Jesus Christ used to stop at Bethany on his way from Jericho to Jerusalem. Whenever Jesus visited Jerusalem with his disciples, he spent the night at Bethany with his disciples.

Jesus Christ cursed a Fig Tree

Mark 11:11 to 14 and 20 to 22 says that Jesus entered Jerusalem and at even tide, he went out into Bethany with his twelve disciples. And on the morrow, when they were come from Bethany, he was

hungry: and seeing a fig tree afar off having leaves, he came, if he might find anything thereon: and when he came to it, he found nothing but leaves, for the time of the figs was not yet. And Jesus answered and said to it "No man will eat fruit of thee hereafter for

ever". His disciples heard it.

Verses 20 to 22 say that in the morning, as they passed by, they saw the fig tree dried up from the roots. And Peter calling to remembrance saith unto him "Master, behold, the fig free which

Fig tree cursed by Jesus Christ, Bethany

57

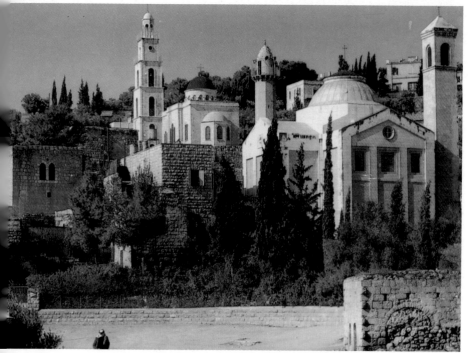

St. Lazarus Church in Bethany

tower, which are said to be the site of the house of Simon the leper.

According the Matthew 26:6 to 13, when Jesus Christ was in Bethany in the house of Simon the leper, there came unto him a woman having an alabaster box of very precious ointment and poured it on Jesus' head, as he sat at meat (meal). His disciples had indignation, saying "To what purpose is this waste?" But, Jesus said that she hath wrought a good work, as she did it for his burial. He further said that "Wheresoever this gospel shall be preached in the whole world, there shall also this, what the woman has done be told for a memorial of her". (Mark 14:3 to 9)

thou cursedst is withered away." Jesus answering saith unto them "Have faith in God".

Raising Lazarus who was Dead

According to John 11:1-4, Lazarus, the brother of Mary and Martha, who were all staying in Bethany and whom Jesus visited often was sick and died. They sent word to Jesus about his sickness. Jesus came four days after his death. Mary, Martha and many Jews were weeping. Jesus wept. Jesus prayed and cried with a loud voice "Lazarus come forth." Lazarus rose and many, who saw this miracle believed on Jesus.

In 1954, an Italian architect, Barluzzi built a Sanctuary of St. Lazarus on the ruins of a previous church at the site of Lazarus tomb.

Inside the church, there are many paintings depicting Mary and Martha discussing with Jesus Christ, Jesus raising Lazarus who was dead, Jesus Christ eating in Simon the leper's house etc.

Jesus in the House of Simon the Leper

Just above the Church of St. Lazarus, there are ruins of a twin

Ascension of Jesus Christ to Heaven near Bethany

After resurrection, Jesus Christ appeared to his disciples three times and finally ascended to heaven in the presence of his disciples near Bethany.

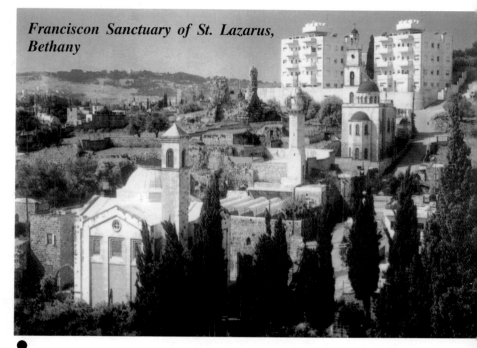

Franciscon Sanctuary of St. Lazarus, Bethany

BETHPHAGE

Bethphage is by the side of Bethany on the slopes of Mount of Olives. Bethphage is about 2 miles (3 kilometers) to the east of Jerusalem. Bethphage is the beginning of the descent from the Mount of Olives.

According to Mark 11:1 to 10, when Jesus along with his disciples came nigh to Jerusalem, unto Bethphage and Bethany, at the Mount of Olives, Jesus sent forth two of his disciples and said unto them, "Go your way into the village over against you: and as soon as ye be entered into it, ye shall find a colt tied, whereon never man sat: loose him and bring him." They brought the colt to Jesus and cast their garments on it and Jesus sat upon it. They that went before and they that followed cried saying "Hosanna, Blessed is he that cometh in the name of the Lord. Blessed be the kingdom of our father David, that cometh in the name of our Lord: Hosanna in the highest."

There is a church at Bethphage to commemorate this incident of Jesus sitting on a colt and entering Jerusalem, starting at Bethphage.

In the same church, there is a stone said to bear the imprint of the foot of Jesus, as he mounted the colt stepping on this stone.

Every Palm Sunday, a holy procession of clergy and people starts from this church in Bethphage, people holding palm and olive leaves in their hands and singing. This procession ends at the Church of St. Anne in the old city of Jerusalem, after passing through St. Stephen's gate of

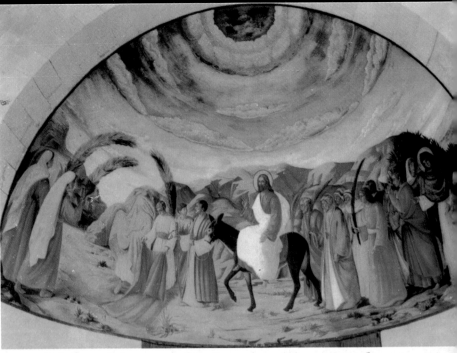

● *Painting of Jesus entering Jerusalem sitting on a colt*

Jerusalem walls.

Jesus Christ entered Jerusalem in a triumphant manner but also, to spend only his last 6 days of his life on earth, before he was mocked, tortured and finally crucified.

JERUSALEM

Jerusalem is known as 'Yerushalayim' in Hebrew language and as 'Beit Mak des' in Arabic language.

In the panoramic view of Jerusalem, the Mount of Olives, is located on the east of Jerusalem. By the side of the Mount of Olives is the Kidron Valley with short pruned olive trees by the side of tall pine trees. Behind Kidron Valley is the eastern city wall of Jerusalem. Just behind the wall to the right is the 'Dome of the Rock',

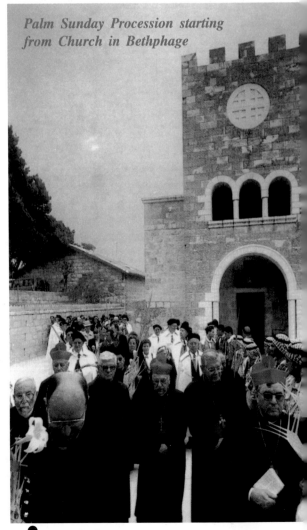

Palm Sunday Procession starting from Church in Bethphage

important mosques like the Dome of the Rock and El Aqsa.

Brief History of Jerusalem

Jerusalem has a very long history.

When King David was just 30 years old, he ruled all over Israel and Judea. (II Samuel 5:4 and 5) nearly 3000 years ago. King David made Jerusalem as the capital of Israel Nation. He transferred the 'Ark of the Covenant' to Jerusalem. (II Samuel 6:3). From that time onwards, Jerusalem became the religious as well as, political centre of David's kingdom.

First Temple by King Solomon

After the death of King David, his son Solomon became the king. He constructed the first magnificent temple in Jerusalem for the Jews during the years 961 to 922 B.C. It goes to say that "in this House and in Jerusalem I will establish my name for ever" (II Chronicles 33:7). During the regime of King Solomon, Jerusalem expanded greatly. (I Kings chapters 5-7).

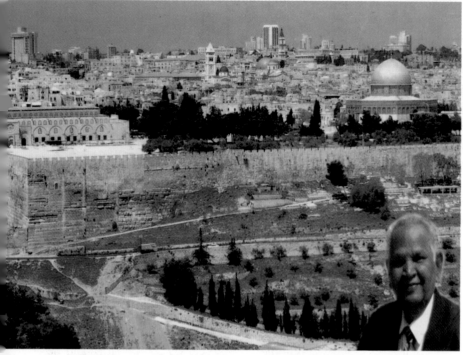

● *Panoramic view of Jerusalem city from Mount of Olives*

which is a Muslim mosque. It has a golden dome, which can be seen from a distance. In the earlier days, Jerusalem temple was just by the side of the Dome of the Rock, but now there is no temple at this site. On the left is the El-Aqsa mosque of the Muslims, with a silver dome. In the middle, with a silver dome is the Church of Holy Sepulchure. The other tall buildings in the background are the present days Five Star Hotels, offices etc.

Jerusalem is in the midst of Judean hills, surrounded by five mountain ranges.

- Mount Calvary, in the north of Jerusalem
- Mount Scopus, in the north-east of Jerusalem
- Mount of Olives, in the east of Jerusalem
- Mount Moria, in the north-east of the city
- Mount Zion in the south west of the city.

Under Mount Scopus, there is a long tunnel to enter Jerusalem from Jericho side.

Jerusalem is known as the 'Holy City' in the Holy Land of Israel. No other city in the entire world is described with so much love and devotion. The magnetism of Jerusalem has not diminished in the last 2006 years after the death of Jesus Christ and long lines of piligrims from different countries continue to visit Jerusalem throughout the year.

Jerusalem, the capital and largest city in Israel is considered as a Holy City by Christians, Jews and Muslims. For Christians and Jews, Jerusalem contains many churches, synagogues, shrines, holy sites and places of worship. For Jews, the whole city of Jerusalem itself is holy and is the focal point of Jewish history, the symbol of ancient glory, spiritual fulfilment and modern renual. For Muslims, there are

According to II Chronicles 2:1 to 18, King Solomon was determined to build a house in the name of the Lord and a house for his Kingdom. Solomon sent to Huram, the king of Tyre, saying "As thou didst deal with David my father and didst sent him cedars to build him a house to dwell therein even so deal with me. The house, which I build is great: for great is our God above all Gods. Send me a man to work in gold, silver, brass, iron and in all colours. Send me also cedar trees, fir trees and algum trees out of Lebanon. I will give to the hewers that cut the

timber, twenty thousand measures of wheat, twenty thousand measures of barley, twenty thousand baths of wine and twenty thousand baths of oil.'' Then Huram agreed to do all this in writing and said all the wood would reach Joppa port from where Solomon could take them to Jerusalem. King Solomon sent thousands of workers to cut wood in Lebanon.

According to II Chronicles 3:1 -17, King Solomon began to build the house of the Lord at Jerusalem on Mount Moriah, where the Lord appeared unto David, his father. The length and breadth of the temple and the porch were determined by King Solomon himself and he used gold and precious stones for beauty. In the most holy house, he made two cherubims of image work and over laid them with gold. The wings of the cherubims were twenty cubits long: one wing of the one cherub was five cubits reaching the wall of the house and the other wing was likewise five cubits reaching the wing of the other cherub.

II Chronicles Chapter 4 also explains the furnishing of this magnificent temple by King Solomon. After the construction of the temple was completed, King Solomon made all the elders of Israel and Heads of all tribes and all people to assemble. The Levites brought the Ark of the Covenant of the Lord out of the city of David, which is Zion. King Solomon made long prayers before all people in the house of the Lord. When he made an end of his prayer, fire came down from heaven and consumed the burnt offering and the sacrifices. The house of the Lord was thus dedicated in a very grand manner.

According to II Chronicles 36:5 to 23, Jehoiakim was king over Judah and Jerusalem. He did that which was evil in the sight of the Lord his God. Against him came up Nebuchadnezzar, king of Babylon and bound him in fetters to carry him to Babylon. Nebuchadnezzar also carried the vessels of the house of the Lord to Babylon and put them in his temple at Babylon. Nebuchadnezzar made Zedekiah (brother of Jehoiakim) as the king of Judah and Jerusalem. Zedekiah also did that which was evil in the sight of the Lord, his God and also repelled against King Nebuchadnezzar. The king of the Chaldees raided Jerusalem and slew all young and old people mercilessly. All the vessels of the house of the Lord and treasures were taken by him to Babylon. They burnt the house of God and broke down the walls of Jerusalem. The people who escaped his sword were carried to Babylon, where they were servants to him and his sons until the reign of the kingdom of Persia. After Babylon fell to Persia 50 years later, the Jews who were taken to Babylon as servants returned to Jerusalem in 537 B.C.

Second Temple by King Cyrus of Persia

According to Ezra 1:1-11 Cyrus, the King of Persia made a proclamation throughout his kingdom saying that "the Lord God of heaven hath given me all the kingdom of the earth: and he hath charged me to build him an house at Jerusalem. Let us go to Jerusalem with all our precious things and build the house of the Lord." Cyrus, the king of Persia brought forth the vessels of the house of the Lord, which King Nebuchadnezzar brought from

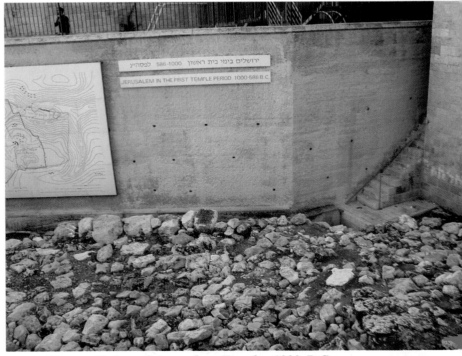

■ *Ruins of Jerusalem Temple, 1000 B.C.*

Jerusalem to Babylon and put them back in the house of the Lord. According to Ezra 3:10, when the builders laid the foundation of the temple, they set the priests in their apparel with trumpets and the Levites with cymbals to praise the lord. Thus, the second temple was constructed and completed in 517 B.C. The temple complex was enlarged and adorned over the years and it became a splendid holy site and was considered as one of the wonders of the world at that time.

However, this temple was inferior to the earlier temple constructed by King Solomon. (Ezra 3:12).

The Ark of the Covenant, which disappeared at the time when Nebuchadnezzar looted the temple was never replaced in this second temple. Only ten lampstands and one seven branched candle stand were placed in the Holy Place. But, later on, these were also taken by Antiochus

IV Epiphanes during 175 to 163 B.C. They made it a pagan altar or statue in 167 B.C.

The triumphant Maccabees cleansed the temple from this pollution and replaced the furniture late in 164 B.C. They also turned the enclosure into a fortress so strong that it resisted the siege of Pompey for three months in 63 B.C. Thus, this second temple built by King Cyrus of Persia stood for almost 500 years (from 537 B.C. to 63 B.C.), longer than the first temple constructed by King Solomon or the third temple constructed later on by King Herod during the period 19 to 9 B.C.

Third Temple by King Herod

King Herod wanted to please the Jews. So, he started construction of a new temple, in 19 B.C., just to please the Jews, rather than worshipping God.

King Herod took great care to respect the sacred area, during the

work. He even trained 1000 priests as masons to build the shrine. The main structure of the temple was completed in 10 years time, that is, by 9 B.C. But, construction work of the temple continued for 73 years, that is, upto A.D. 64.

But, the Ark of the Covenant could not be placed even in this temple, like in the second temple built by King Cyrus of Persia. At the North-West corner, the fortress of Antonia dominated the enclosure. This was the residence of the Procurators (administrators of law and order), when they were in Jerusalem. Their soldiers were always at hand to subdue any unrest in the temple. (Luke 13:1 and Acts 21:31 to 35). The robes of the High Priest were stored therein, as a token of subjection.

The entire structure of the temple was with white shining stones and as a result, it was difficult to look at it during the sunshine time, due to its glare.

The construction of the temple was barely complete in 64 A.D., when the soldiers of the Roman Tenth Legion invaded Jerusalem in 70 A.D., and destroyed everything, including this magnificent temple. It is perhaps, in this temple built by King Herod that Jesus Christ preached many times, as this temple existed from 9 B.C. to 64 A.D. which coincided with the life and mission of Jesus Christ.

Struggle to save the Holy Land

From 132 to 135 A.D., the Jews made an attempt to fight against the Romans, but they could not stand before the Roman soldiers. In 135 A.D., 'Aelia Capitolina' was

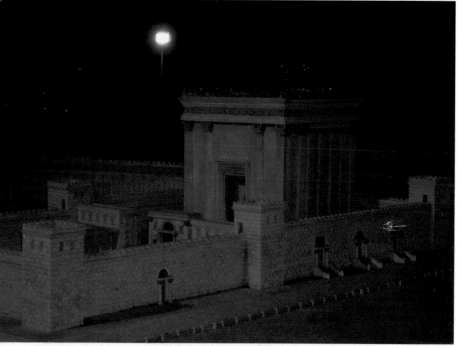

■ *Temple Model in Jerusalem by night*

built in place of Jerusalem and ruled as a Roman colony. Till the year 324 A.D., Jerusalem was not a conspicuous city.

In the year 326 A.D., Emperor Constantine of Rome and his mother Queen Helena were converted to Christianity, as the Emperor flourished very much by believing in the cross, which he saw in a vision. Both of them visited the Holy land and to show gratitude to Jesus Christ and Christianity, they constructed many churches, shrines etc., in the Holy land. Under the Byzantine (Roman) rule, Jerusalem flourished till the year 614. In 614, Persians invaded the Holy land. In 637, Jerusalem was conquered by the Muslims. Thus, from 634 to 1099 A.D., Jerusalem was under Muslim rule and during that period, no development of Christian churches and shrines could take place. When Caliph Omar Ibn Alr Khattab rose to power, he was responsible for the construction of the 'Dome of the Rock'.

In November 1095, Pope Urba II of Rome appealed to the noble men of Europe and their knights to embark on a 'crusade' to save the Holy Land. According to Papal advice, two centers in France, one in the Netherlands and one in Germany were set up to start attack on the Holy land. In June 1099, the Crusaders entered Jerusalem by climbing over its walls and in a fierce battle, many were killed. Thus, the Crusaders occupied Jerusalem and the entire European Christian community rejoiced. The Crusaders started renovating the destroyed churches, synagogues and shrines and started

■ *Manger Square, Bethlehem*

constructing new ones also. In 1110, they thoroughly renovated the Church of Nativity in Bethlehem.

The Second Crusade started by the forces of Louis VII, the French King was not successful and they had to retreat. In 1149, the Crusaders renovated the Church of Holy Sepulchure and made it a magnificent church.

In 1187, Sultan Saladin shattered the bells of the tower and crushed its cross. There was a fierce battle, but the Crusaders were defeated. They entered into a treaty with Saladin according to which, Christians were required to pay a ransom within 40 days, failing which they would be sold as slaves.

In 1187, three kings of Europe- Richard I (Richard the Lion Hearted) of England, Philip II of France and Friedrich I (Barbarosa), Emperor of Germany responded to the advice of Pope Gregory VIII

to set out on a new Third crusade to liberate Jerusalem from Saladin. Crusaders had success at Acre, and Jaffa. Like this, there were six Crusades and the Crusaders kingdom was from 1187 to 1270. In 1260, a cavalry from Mongolia raided Jerusalem, simply to plunder and they returned after plundering.

Jerusalem was under the rule of Mameluke Sultan from 1260 to 1516. Then, from 1516 to 1798, Jerusalem was under the rule of Ottomans (Turks). Sultan Suleiman II, The Magnificient came into power in 1520. His rule was known as the 'Golden Age', as he was responsible for rebuilding of the Jerusalem walls and other projects. In his time, Jerusalem was a vibrant and active commercial center.

In 1335, under pressure from Catholic Nations of Europe, the sultan allowed the Franciscons to settle on Mount Zion and take

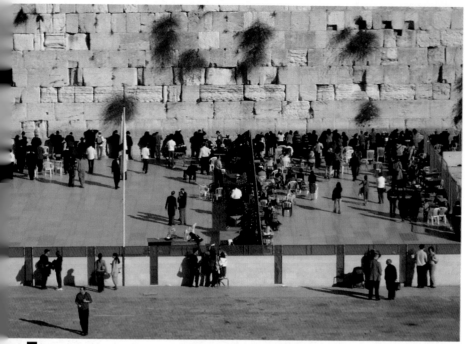

Wailing Wall, Jerusalem

charge of Cenacle (Upper Room), the chapel of the Holy Spirit and the chapel of St. Thomas on the mount. In 1332, Franciscon brothers were officially appointed by the Pope as custodians of Christian institutions in the Holy Land. But, the Mamelukes confiscated two of the above sites and made the Franciscons stay in the Monastery and in the church on Mount Zion. Later on, when war broke out between Turkey and Venice, the Franciscons on Mount Zion were considered as hostile elements and were arrested and their property confiscated.

In the 17th and 18th centuries, the Franciscons and the Greek Orthodox fought for the control of the holy sites in Jerusalem and Bethlehem. During 1605 to 1650, the Greek Orthodox Church took control over many holy places.

In 1799, Napolean Bonaparte travelled to the Holy Land and had a fierce fight with the Turks and Arabs in Jaffa, Acre, Tabor and

defeated them. He offered a thanks giving prayer in Nazareth on 17th and 18th April 1799. But, in May and June 1799, Napolean returned to France, leaving his army in Egypt.

In October 1808, a fire broke out in the Church of Holy Sepulchure. The Catholics blamed the Greek Orthodox and Armenians for this fire accident and vice versa. Ultimately, the Greek Orthodox got permission to repair this church. The Greek Orthodox started repairs in 1820 and took revenge on Catholics by destroying the tombs of the Crusader kings buried beneath Golgotha. The Ottoman rule came to an end in 1917.

Towards the end of the First World War in 1917, Britain's General Allenby accepted Jerusalem's surrender from the Mayor of Jerusalem. For the next 30 years, till 1947, the British developed Jerusalem to a great extent, as it is their Holy Land.

Later on, with the establishment of the State of Israel in the year 1948, Jerusalem once again became the capital of the sovereign Jewish State. From that time onwards, Jerusalem was developed in many ways, which is responsible for the present days importance of Jerusalem. Thus, during the last 3000 years, Jerusalem was captured or destroyed partially or completely for more than 40 times.

Biblical Importance of Jerusalem

As many rulers over Israel changed during these 3000 years, the name of Jerusalem (the main city of Israel) changed many times. About 70 different names were given to Jerusalem, many of them originating in the Bible. Out of these 70 names, some names are given below:-

- Ariel – Lion of God. (Isaiah 29:1).
- Beloved City. (Revelations 20:9).
- City of God. (Psalms 46:4 and 87:3).
- City of Gold. (Revelations 21:18).
- City of Righteousness. (Isaiah 1:21).
- Faithful City. (Isaiah 1:21).
- Heavenly City. (Hebrews 12:22).
- Holy City. (Isaiah 52:1; Nehe 11:1; Joel 3:17; Matt. 4:5).
- Joy of all the Earth. (Lamentations 2:15).
- Joyous City. (Isaiah 22:2).
- Throne of the Lord. (Jeremiah 3:17).

- City of David. (II Sam 5:7 and Isaiah 22:9).

- City of the Great King. (Psalms 48:2).

- City of Judah. (II Chro 25:28).

- City of Truth. (Zecharia 8:3).

- Holy Mountain. (Daniel 9:16).

- Jebusi. (Joshua 18:28 and Judges 19:10).

- Perfection of Beauty. (Lamentations 2:15).

- Salem. (Gene 14:18 and Psalms 76:2).

- Zion. (1 Kings 8:1 and Zech 9:13).

Jerusalem has been a very important biblical city and hence, it is mentioned in as many as 40 books of the Holy Bible, out of a total of 66 books in the Old Testament and New Testament, put together. In the serial order of these books in the Bible. Jerusalem is mentioned right from the Book of Isaiah in the Old Testament upto the Book of Revelations in the New Testament.

It is rather difficult to narrate all these 40 references here, but the readers are advised to go through these following references (arranged in a serial order) to know how important is Jerusalem from the olden days onwards.

OLD TESTAMENT

Isaiah 2:3
Isaiah 24:23
Isaiah 40:9
Isaiah 52:1
Isaiah 62:1
Isaiah 65:18
Isaiah 66:10
Jeremiah 3:17

Joel 2:32
Joel 3:17
II Kings 23:27
II Chronicles 6:6
Nehemiah 2:17
Psalms 122:2, 3 and 6
Psalms 125:2
Psalms 137:5, 6 and 7
Zechariah 2:14
Zechariah 8:4 and 5
Zechariah 8: 8
Zechariah 8:22
Zechariah 12:10
Zechariah 14:8
Zephaniah 3:16

NEW TESTAMENT

St. Matthew 23:37 to 39
St. Luke 13:34
St. Luke 19:28 to 40
St. Luke 19:41 to 44
St. Luke 21:24
St. John 4:20
Galatians 4:25 and 26
Hebrews 12:22
Acts 1:8
Revelations 3:12
Revelations 21:2

Three Walls and Eight Gates of Jerusalem City

In ancient times, high, wide and strong walls with gates were constructed around important cities to protect them from enemies. In those days, war or battle meant the enemy soldiers entering on horsebacks, infantry etc., and not like the present days aerial attacks. So, entry of enemies could be arrested only by high and wide walls.

Early history shows that Jerusalem being an important city in the Holy Land, many battles were fought in and around Jerusalem, most probably, more than 40 battles from the days of

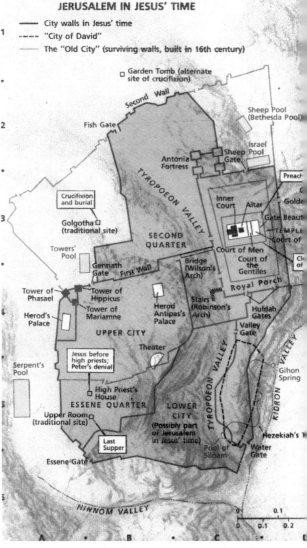

Jerusalem city and its walls, as in Jesus' time

King David and King Solomon onwards.

According to ancient history, the first wall around Jerusalem was constructed by King David and King Solomon, nearly 3000 years ago (960 to 922 B.C.). This first wall enclosed the Upper Room (Last supper place in the south of the city), Palaces of Herod, high priest, and temple complex in the north of the city. This first wall had a few gates, whose names were changed later on.

As the city expanded, a second

Golden Gate of Jerusalem

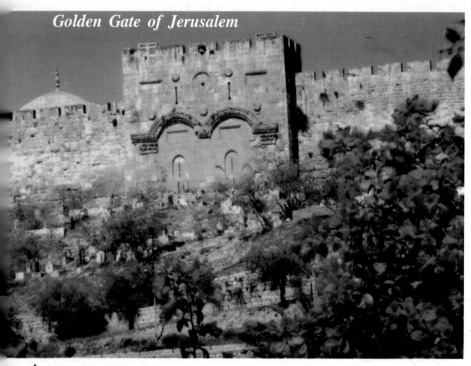

was through this Golden Gate that Jesus sitting on a colt entered Jerusalem with people holding palm and olive leaves in their hands.

The Jews believe that when the Messiah comes the second time, he would come through Kidron valley and enter Jerusalem through the Golden Gate.

In early 1500's, the Ottoman kings closed this gate permanently. This gate is also known as 'Gate of Mercy'.

DAMASCUS GATE

This gate is known as 'Bab-Al-Amud' in Arabic. Of all the gates of Jerusalem, Damascus Gate is considered to be the most beautiful gate. The original gate was a Herodion structure of 135 A.D., as an entrance to Haddrian's Aelia Capitolina. In the earlier days, the road to Damascus began at this gate and hence, it was known as Damascus Gate.

Now, this gate is just by the side of 'Garden Tomb' where Jesus Christ was crucified and placed in a tomb. (According to the belief of Protestant Christians). Opposite to Damascus Gate, now a days there is busy market place and Arab Bazar, where pilgrims purchase souvenirs etc.

ST. STEPHEN'S GATE OR LIONS GATE

This gate is known as 'Bab-el-Asbat' in Arabic. This gate is located on the eastern wall. This gate is also known as 'Lions Gate', as figures of two lions on each side, guard this gate.

It is believed that near this gate, in ancient days St. Stephen was stoned to death and martyred

wall was constructed by King Hezekiah enclosing some more areas of Jerusalem. Excavations carried out in the recent years show that in the years 1536 to 1542, the walls of Jerusalem were built by Sultan Sulaiman (The Magnificant) on the ruins of the earlier walls constructed by King David, King Solomon and King Hezikiah. One of the archaelogist found in 1865 that even a third wall was there around Jerusalem city and it was constructed by Herod Agrippa.

The original walls of Jerusalem were built with huge blocks of stones. These walls measured 2.5 miles in circumference. The height of the walls depend on the topography of the land on which they are constructed. But, in general the height varied from 20 feet to 50 feet. These walls have a broad walk path along the top of the walls. As such, the width of the walls is about 15 feet. There are steps to climb up to the walk

paths. These walls have observation towers here and there to watch the movement of any enemies. There are battlements also in the walls, to shoot enemies, when sighted. Due to the height and width of these walls, it was very difficult for enemies to enter the city, while receiving arrows and spears from the battlements and the top of the walls.

The names of the different gates constructed in the walls of Jerusalem are mentioned in Nehemiah 2 to 7 chapters. The names of the gates of Jerusalem walls at present, are:

GOLDEN GATE

This gate is called 'Bab-Dahiriyeh' in Arabic. Golden Gate is mentioned in the book of Nehemiah as the place of the last judgement by Messiah. This is located on the eastern side of the temple complex and is opposite to the Mount of Olives.

The Christians believe that it

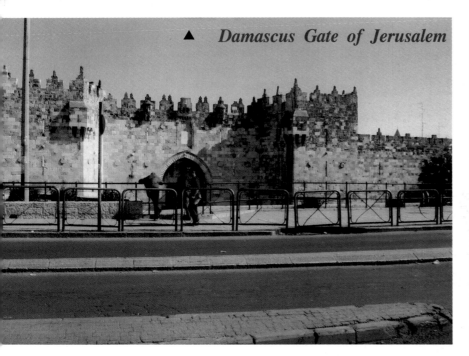

▲ *Damascus Gate of Jerusalem*

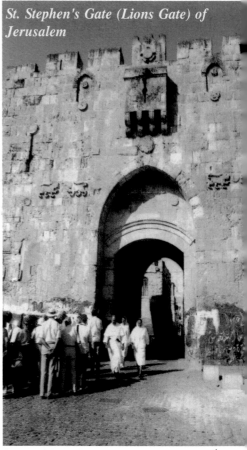

St. Stephen's Gate (Lions Gate) of Jerusalem

and hence, this gate is known as St. Stephen's Gate.

The Palm Sunday procession starting from the Chapel of Bethphage, enters the city of Jerusalem through this Stephen's Gate and terminates at St. Anne's Church in the city. 'Via Dolorosa', which means the 'Way of the Cross' on which Jesus Christ carried the cross, starts at St. Stephen's gate.

HEROD'S GATE

This is known as 'Bab-es-Sahira' in Arabic. This gate was named by error, mistaking a church near this gate as the Palace of Herod Antipas and hence called it Herod's Gate.

Just above the entrance, there is a rose like structure on the wall of this gate. Hence, in Hebrew language, it is known as 'Gate of the Flowers'.

DUNG GATE

This gate is known as 'Bab-el-Magharebeb' in Arabic. Dung Gate

is located in the southern side.

This gate is the nearest gate to the Western wall or "Wailing Wall", a sacred place for Jews. This gate is narrow and low. In the ancient days, much of the city's refuse was being taken to be

Herod's Gate or Gate of the Flowers, Jerusalem

dumped in Kidron valley, through ▲ a sewer, which was running under this gate.

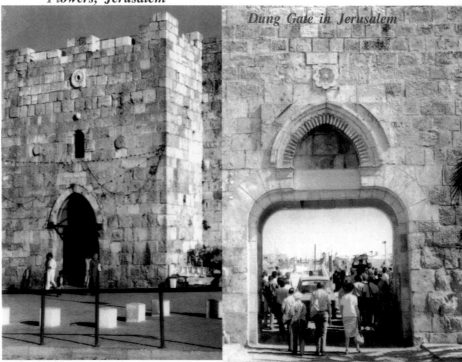

Dung Gate in Jerusalem

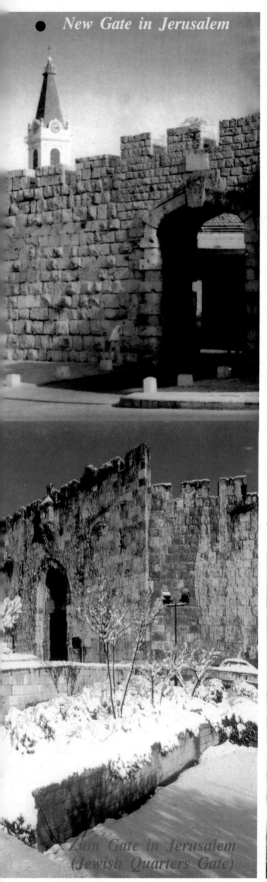

● *New Gate in Jerusalem*

*Zion Gate in Jerusalem
(Jewish Quarters Gate)*

NEW GATE

This is known as 'Bab-al-Jadid' in Arabic. This gate was opened in 1889 to facilitate passage from Christian quarters in Jerusalem to the Catholic Institutions located outside the wall of Jerusalem.

ZION GATE

This is known as 'Bab-en-Neby Daoud' in Arabic. This gate is located in the southern wall. It was damaged in a fighting between Jordanians and Israelis.

This gate connects the Armenian quarters in Jerusalem with Mount Zion. This gate is also called 'The Jewish Quarter Gate', as it is located very near the Jewish quarters in Jerusalem.

JAFFA GATE

This is also known as 'Bab-al-Khalil' in Arabic.

In the earlier days, this gate was the starting point of the road leading to the city of Jaffa or Joppa, which was an important sea port of Israel on the Meditarranean sea coast in the west. Hence, this gate was important for trade through Jaffa port.

Jaffa gate adjoins David's Citadel in Jerusalem, which is a land mark.

The following places of biblical importance must be visited by the pilgrims, while they are in Jerusalem.

● Sheep Pool (Bethesda pool, where Jesus healed a blind man).

● Mount of Olives (Where Jesus went to pray for the last time after supper).

● Garden of Gethsemane (Where Jesus prayed for the last time and was arrested).

● Jerusalem Temple (Where Jesus preached many times).

● Golgotha (where Jesus was crucified).

● Herod Antipas' palace (Herod judged Jesus and mocked him).

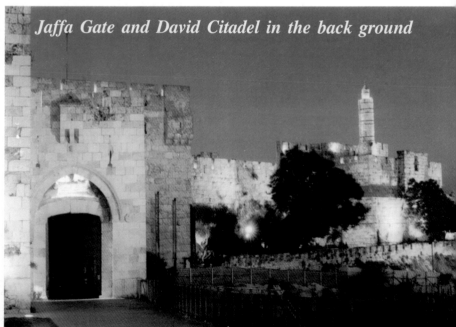

Jaffa Gate and David Citadel in the back ground

- High Priest's house (where Jesus was judged by Pontius Pilate and Peter denied Jesus thrice).

- Upper Room (Where Jesus had last supper with disciples)

- Pool of Siloam (Where a blind man washed his eyes as commanded by Jesus and gained sight).

Explanation in the following paragraphs is in the order of events that took place, as Jesus Christ entered Jerusalem sitting on a colt from Bethphage, and his final crucifixion at Golgotha.

Kidron Valley (Valley of Jehoshapat)

This valley is also known as the valley of Jehoshapat. Kidron valley is located between the Mount of Olives and eastern wall of the city of Jerusalem. Kidron valley starts at north of Jerusalem with a low depression known as 'Wadi el Joz'. The valley extends eastward for half a mile and then takes a southwards bend till it reaches the valley of 'Hinnom'. A brook known as 'Kidron' flows through this valley.

Jewish Tombs in Kidron Valley

The Jews believe that when Messiah comes, trumpets will sound and the last judgement will take place in Kidron valley. For this reason, Kidron valley was used by the Jews as the burial place, since a very long time. As the pilgrims enter the Kidron valley, they will find a few thousands of tombs of the Jews in many rows. After the tombs of the Jews, there are rows of Christian tombs. After these, there are rows of Muslim tombs. Thus, there are rows of tombs of Jews, then Christians and then towards the gates of Jerusalem wall, there are rows of Muslim tombs.

The gate nearest to these tombs is the Golden Gate of the Jerusalem eastern wall. The Jews believe that during the second coming of Messiah, he would come from the Mount of Olives and then Kidron valley before entering Jerusalem through the Golden Gate. As the Messiah is supposed to pass through the rows of the tombs of the Jews first, the Jews will be the first to have resurrection and accompany the Messiah into Jerusalem.

A peculiar practice of the Jews is that whenever they visit a tomb of relative or friend, they place a small stone on the tomb, before they leave the cemetery and not flowers as done by other Christians. The picture of tombs shows these stones on all the tombs. The number of such stones on each tomb shows the number of visitors to that tomb.

TOMBS IN KIDRON VALLEY

The most striking feature in the Kidron valley is a group of 4 tombs of Absalom, Zechariah Jehoshaphat and St. James. The tombs of Jehoshaphat and St.

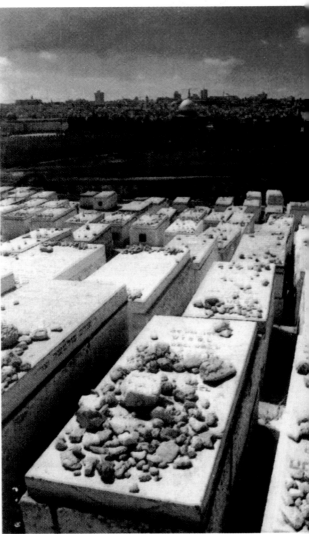

Jewish tombs in Kidron Valley, Jerusalem ▲

James are only excavated tombs with ornamented portals. But, the tombs of Absalom and Zechariah are real monuments of rocks.

Absalom's Tomb

Also known as 'Absalom Pillar' as the tomb is in the shape of a pillar.

According to II Samuel 18:6 to 33, David sent his people into the field against Israel and the battle was in the wood of Ephraim. Twenty thousand Israelis were slaughtered in this battle. Absalom met the servants of David.

Absalom rode upon a mule and the mule went under the thick branches of a great oak and his long hair caught hold of the oak and he was taken up between the heaven and the earth: and the mule that was under him went away. On hearing this from a soldier, Joab, the commander of David went to this place and thrust three darts through the heart of Absalom, while he was still alive in the midst of the oak tree. They took Absalom's body and cast it into a great pit in the wood and covered it with a very great heap of stones. Absolom, in his lifetime had taken and reared up for himself a pillar, which is in the king's dale (valley): for he said, "I have no son to keep my name in remembrance: and he called the pillar after his own name: and it is called unto this day, "Absalom's Pillar" or "Absalom's Place". (II Sam 18:18)

Absalom's Pillar stands close to the lower bridge over the Kidron Brook. This pillar is a square isolated block hewn out of the rocky ledge. The total height of Absalom's pillar is about 40 feet. It is in the shape of an inverted flower or bottle with a long neck and is visible from many places in the Kidron Valley.

Tomb of Zechariah

In Kidron valley, just a few meters away from the Absalom Pillar is the tomb of Zechariah. It is a square block of above 20 feet on each side. The rock being cut away round it, so that this block stands isolated. The body of the tomb is about 20 feet high. The dome is in the shape of a pyramid of 12 feet high. Thus, the whole monument is about 32 feet high.

Tombs of Jehosaphat and St. James

The tombs of Jehoshaphat and St. James are also located near the tombs of Absalom and Zechariah in Kidron valley. But, they are only excavated tombs with ornamental portals.

Mount of Olives or Jebel-Et-Tur

Mount of Olives (Jebel-et-Tur) is on the eastern side of the city of Jerusalem. In between

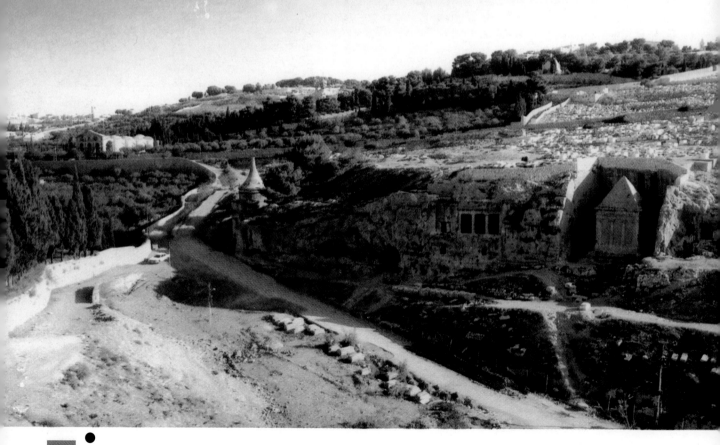

Tombs of Absalom, Zechariah in Kidron Valley

Jerusalem's east wall and Mount of Olives is the Kidron valley, which is about half a mile in width. From any part of the Mount of Olives, one can have a good view of the city of Jerusalem. In fact, the city of Jerusalem is surrounded by three mountains on one side. That is, Mount Scopus in the north, Mount of Offences in the south and in the middle, Mount of Olives. The Mount of Olives is 2,680 feet above the sea level, which means, it is 200 feet above the temple area in Jerusalem city.

As the pilgrims come to Jerusalem from Jericho, they have to pass through Bethany and Bethphage and from here, the pilgrims descend the Mount of Olives. At the summit of this mountain, there is a small chapel built by the Crusaders. This chapel marks the end of Jesus Christ's life on earth, as it is at this place, Jesus Christ ascended to heaven in the presence of his disciples. This place is near Bethany and is known as the 'Chapel of Ascension'.

Down the road, from the Chapel of Ascension, there is a church known as 'Church of Pater Noster', where Jesus Christ taught his disciples 'The Lord's Prayer'.

Further down the Mount of Olives is the Church of 'Dominus Flevit', which was built to commemorate the place, where Jesus Christ wept looking at Jerusalem, as soon as he entered Jerusalem sitting on a colt.

Further down the Mount of Olives is the Church of Mary Magdalene, a part of a Roman Orthodox Convent.

From the entrance to this church, it is a short walk to the Garden of Gethsemane, Chapel of Ascension, Church of Pater Noster, Church of Dominus Flevit and Church of Mary Magdalene, all of which are located on the Mount of Olives.

GARDEN OF GETHSEMANE

In Aramaic language (the language spoken by Jesus Christ), the word 'Gat-Shamane', means 'Olive Press'. As there were many olive trees in the Garden of Gethsemane, as well as in the nearby Kidron valley and Mount of Olives, it is learnt, that there were many olive presses in this area. In those days, the olive presses were stone crushers like the present day 'edge runners'. Hence, the Garden of Gethsemane was known as the place of olive presses, and in Aramaic language 'Gat-Samane'. It is learnt that when an olive tree's branches are cut or pruned, the tree again grows rapidly, giving more olives. That is why the country of Israel is usually compared to an olive tree, as the country is rebuilt rapidly, even if it is destroyed.

Garden of Gethsemane is the place on the Mount of Olives, where Jesus Christ went with his disciples in the last night after supper, to pray there.

At present, there are only 8 olive trees in this small garden which has a metal fencing around. These 8 olive trees are considered to be one of the original things existing from the days of Jesus Christ. As such, these 8 trees have very large trunks and less branches and leaves. The normal olive trees, which are grown for reaping olives are short trees. In between the 8 trees in the present day Garden of Gethsemane, there are small flower plants. The pilgrims gather round this fence to see the ancient olive trees, which are about 3000 years old.

According to Matthew 26:36

Present status of the Garden of Gethsemane on Mount of Olives ▲

to 46, Jesus Christ went to the Garden of Gethsemane along with his 11 disciples and said "Sit ye here, while I go and pray yonder." He took with him Peter and the two sons of Zebedee and began to be sorrowful and very heavy. Then he said unto them "Tarry ye here and watch with me". He went a little further, and fell on his face and prayed, saying, "O my Father, if it is possible, let this cup pass from me, nevertheless not as I will, but as thou will." Jesus Christ went there three times to pray, repeating the same words and in between, he came to see his three disciples but, found them sleeping all the while.

The rock on which Jesus Christ fell with his face down in the Garden of Gethsemane for praying three times, is now known as 'The Rock of Agony'.

The Church of All Nations or The Church of Agony

Just by the side of the fencing of the Garden of Gethsemane is the 'Church of All Nations' or 'Church of Agony' or 'Church of Gethsemane'. This is one of the most beautiful churches built in Jerusalem.

Behind this church, there are many trees and amongst these trees is the Church of Mary Magdalene with onion shaped golden domes and crosses on each dome.

The present Church of All Nations was constructed in the year 1924 on the ruins of the earlier two churches constructed here by Byzantines

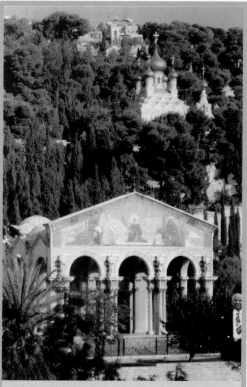

▲ *The Church of All Nations or the Church of Agony in the Garden of Gethsemane*

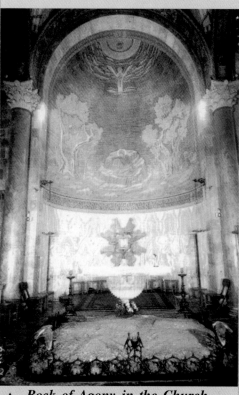

▲ *Rock of Agony in the Church of All Nations*

and Crusaders. The present church was constructed making use of the funds received from twelve Catholic Nations. Hence, it is known as the "Church of All Nations". On the top of this church, there are twelve white domes to depict the twelve Catholic Nations which contributed funds for the construction of this church. The top of the front wall is in the shape of a triangle, supported by four sets of huge pillars and in between the four sets of pillars, three arches are formed. There are steps in front before the compound fencing. The beautiful facade depicts four evangelists with Jesus Christ in the middle, offering his sufferings to his Father in heaven. At the top of the pointed roof, a picture of two deer with their heads raising is shown, recalling the Psalm 42:1 which says "As the hart (deer) panteth after the water brooks, so panteth my soul after thee, O God". On each side of this church, there are four arch shaped windows.

An important feature inside this church is 'Rock of Agony' with a metal fencing resembling the 'Crown of Thorns' placed on Jesus Christ's head at the time of judgement before Pontius Pilate. This Rock of Agony is white in colour. (Lime Stone).

The pilgrims kneel down in front of this 'Rock of Agony' pray for a while and kiss this Rock.

Just above the altar in the church, on the walls there are

many mosaics depicting the events associated with Garden of Gethsemane, like betrayal of Jesus Christ by Judas Iscariot, which led to the arrest of Jesus Christ, trial of Jesus Christ before Pontius Pilate etc.

Ancient Steps in the Garden of Gethsemane

After the last supper with his disciples in the Upper Room, Jesus Christ went to the Garden of Gethsemane on the Mount of Olives. The steps on which Jesus Christ and his disciples walked down to reach the spot where Jesus Christ prayed still exists. On the same steps, he walked up without his disciples to Caiaphas' house for trial.

Church of the Pater Noster

'Pater Noster' means 'Our Father'.

According to Luke 11:1 to 4, one of the disciples of Jesus Christ said unto him "Lord, teach us to pray, as John also taught his disciples''. Then, Jesus Christ taught them a short and sweet prayer, which is now known as the 'Lord's Prayer', which is frequently used by all Christians throughout the world.

To commemorate this place, where Jesus Christ taught his disciples this prayer, Queen Helena of Rome constructed a magnificent church at this site. This church was destroyed during the Persian invasion in 614 A.D., but, rebuilt by the Crusaders. But, the enemies again destroyed this church. A French Dutchess bought this area and built a church and a Carmelite Convent. This church is called 'Eleona' in Greek language, which means 'Olives' in English.

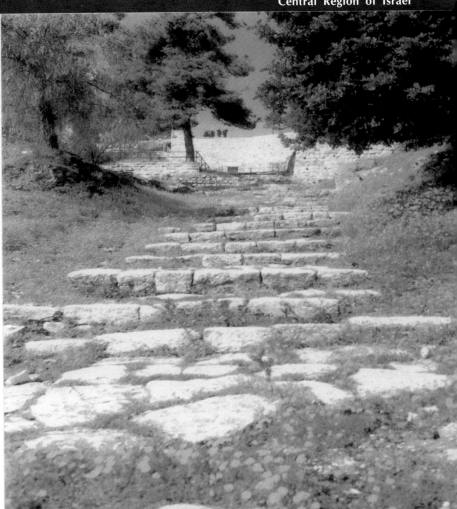

Ancient steps in the Garden of Gethsemane

Lord's Prayer written in different languages on porcelain slabs ▲

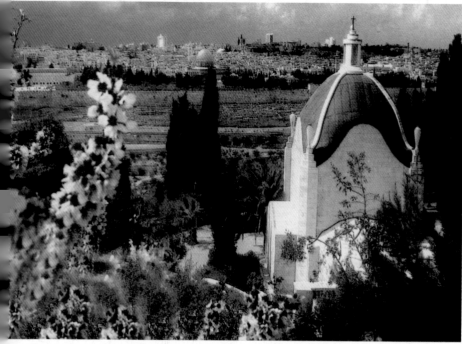

▲ *The Church of Dominus Flevit on Mount of Olives*

John 12:12-14, Jesus Christ in his last journey to the city of Jerusalem, started at Bethphage sitting on a colt and as he came down the Mount of Olives and entered Jerusalem, the whole multitude following him with palm and olive leaves in their hands were praising him saying, "Hosanna to the son of David. Hosanna in the highest". According to Luke 19:41, when Jesus Christ came near to Jerusalem, he beheld the city and wept over it.

To commemorate this event, a church had been constructed at this site, where Jesus wept. The present church was constructed over the ruins of earlier church.

This Church is in a peculiar shape, depicting the tear drop of Jesus Christ, when he wept here. This church is located at such a spot on the Mount of Olives from which the pilgrims can have a full view of the city of Jerusalem.

The cavern (cave), where Jesus Christ taught a prayer to his disciples is a now a chapel. The Carmelite cloister (covered passage) is lined with glazed tiles on which the text of the 'Lord's Prayer' is written in more than 80 languages, including Braille. (Script of the blind people).

Church of Dominus Flevit

Further down the Mount of Olives after the Church of Pater Noster is the Church of Dominus Flevit. 'Dominus Flevit' is a Latin term, meaning 'Jesus Wept'.

According to Matt. 21:1-9; Mark 11:1-10; Luke 19:29-40 and

The mosaic under the altar of the Church of Dominus Flevit

Mosaic under the altar of the Church of Dominus Flevit

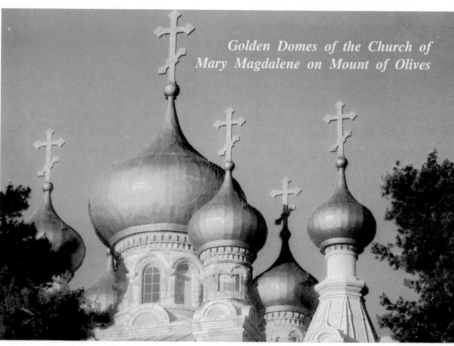

Golden Domes of the Church of Mary Magdalene on Mount of Olives

shows a picture of a hen gathering her brood under her wings to depict the saying "O Jerusalem, Jerusalem, which killest the prophets and stoned them that are sent unto thee; how often would I have gathered thy children as a hen doth gather here brood under her wings, and ye would not". (Luke 13:34).

The Church of Mary Magdalene

Further down the slope of Mount of Olives, there is the most beautiful Church of Mary Magdalene. This church is conspicuous due to its onion shaped golden domes with a cross on each dome. As such, this church is visible from a distance, though a part of it is covered by the trees.

This church was built by Tsar Alexander III of Russia in 1888 in a typical Muscovite style, in memory of his mother, the Empress Maria Alexandrova.

A full view of the Mount of Olives with all these biblical spots can be seen above right. This picture has been taken from the temple mount in Jerusalem.

The extreme left is the Church of all Nations just behind the eastern wall of Jerusalem. Behind it in the midst of trees is the Church of Mary Magdalene with golden domes. Behind it towards its right is the Church of Dominus Flevit. In the forefront is the Jerusalem's eastern wall and behind it is the Kidron valley.

At the very top of the picture, there is the Chapel of Ascension, Greek Orthodox Church and Church of Pater Noster, all of

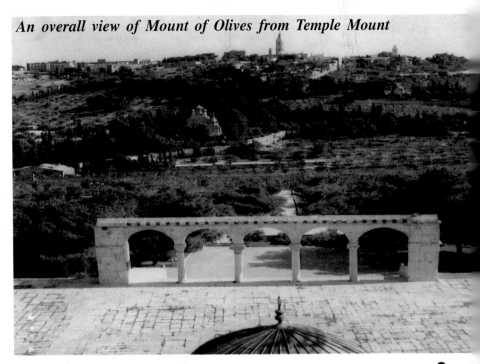

An overall view of Mount of Olives from Temple Mount

which are located on the Mount of Olives.

Jerusalem Temple

The first temple of Jerusalem was built on Mount Moria by King Solomon, as the Lord appeared to his father King David on this mountain. Archaeologists now believe that Mount Moria is under the debris of the temple mount. King David bought this site on Mount Moria from Araunah, the Jebusite. King Solomon built a magnificent temple at this site. He arranged to get cedar, fir and algum wood from Lebanon with the help of King Huram (Hiram)

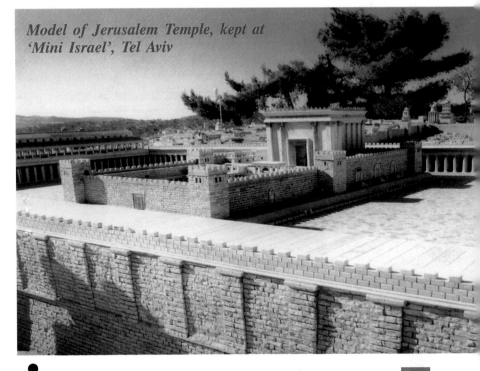

Model of Jerusalem Temple, kept at 'Mini Israel', Tel Aviv

of Tyre. It was adorned with gold, silver and precious stones etc.

Two thousand years ago, King Herod rebuilt this temple, making it an impressive structure in the Roman world. This was the temple in which Jesus Christ and his parents were worshipping every year at the festival of Passover. Jesus Christ visited this temple many more times for preaching and healing the sick people. At one time, Jesus Christ drove out all the people, who were trading in the temple.

This temple consists of Court of the Gentiles, Court of Women, Court of the Priests, Sacred Enclosure, House of God etc.

In 66 A.D., the Jews rose up in revolt against increasing Roman oppression. Their bitter struggle against Romans ended in a catastrophe in the year 7 A.D. The Romans burned the temple to the ground, destroyed everything and took away the inhabitants of Jerusalem as slaves. As a result of this, till today there is no temple of Jerusalem at this site. But other structures have come up and only ruins of the earlier temple can be seen here.

After the destruction of Jerusalem, the Romans established a new city called 'Aelia Capitolina' and banned Jews from entering its gates. By the end of 4th century, the land was part of the Byzantine Empire and Jerusalem had become a Christian city.

The events that took place in the last days of Jesus Christ in Jerusalem start from Mount Zion, where the Upper Room, and other important places of biblical importance are located.

▲ *Upper Room on Mount Zion*

Mount Zion

The name of Mount Zion has been mentioned in the Bible many times. In the Old Testament, the name of Mount Zion was given to the city of King David. II Samuel 5:7 says, David took the strong hold of Zion: the same is the city of David. The tomb of King David was ruined in 133 A.D. But, it was discovered and renovated in 1158. Even today, Christians, Muslims and Jews visit this tomb of King David and worship there. Jews particularly visit this tomb at the feast of Weeks (Shavuot), which is the day of David's death.

Mount Zion is located in the south-west of the city of Jerusalem. There are many places of biblical importance and sacred places of Jews, all located in Mount Zion.

Upper Room (Cenacle or Coenaculum)

According to Matt. 26:17 to 19;

Mark 14:12 to 15 and Luke 22:7 and 12, then came the day of unleavened bread, when the Passover must be killed. He (Jesus) sent Peter and John, saying "Go and prepare us the Passover, that we may eat". And they said unto him, "Where will thou that we prepare?" And he said unto them, "Behold when ye are entered into the city, there shall a man meet you, bearing a pitcher of water. Follow him into the house, where he entereth in. And ye shall say unto the good man of the house. The master saith unto thee, where is the guest chamber, where I shall eat the Passover with my disciples? And he shall show you a large Upper Room furnished; there make ready".

The Upper Room is located in the south-west of the city of Jerusalem and just above the tomb of King David on Mount Zion. The present structure was built in the 14th century with gothic windows and crusader arches in the roof.

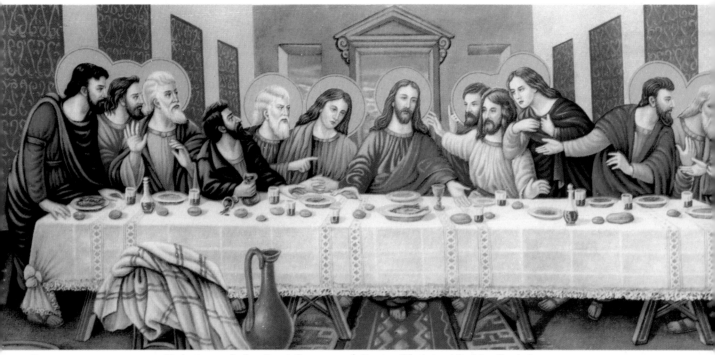

Painting of the Last Supper of Jesus Christ with his disciples

Beneath the Upper Room or Cenacle, there is a hall, where Jesus washed the feet of his disciples. This is a small room leading to a bigger room, where there is the tomb of King David.

According to Matthew 26:26, as they were eating, Jesus took bread and blessed it and broke it and gave it to the disciples and said, "Take; eat: this is my body." And he took the cup and gave thanks and gave it to them saying, "Drink ye all of it. For this is my blood of the New Testament, which is shed for many for the remission of sins".

This is known as 'Last Supper' of Jesus Christ with his disciples in the Upper Room.

The Church of St. Peter in Gallicantu

According to Matthew 26:31 to 35, Jesus saith unto them (disciples), "All ye shall be offended because of me this night:

for it is written, I will smite the shepherd and the sheep of the flock shall be scattered abroad". Peter answered and said unto him, "Though all men shall be offended because of thee, yet will I never be offended". Jesus said unto him

"Verily, I say unto thee, that this night, before the cock crows, thou shalt deny me thrice".

To commemorate this event, a church was constructed and known as the 'Church of St. Peter in Gallicantu'. The word 'Gallicantu'

The Church of St. Peter in Gallicantu, Mount Zion

● *Interior view of the Church of St. Peter in Gallicantu*

The dome of the Church of Flagellation has a mosaic representing the 'Crown of Thorns', placed on Jesus' head. There are three stained glass windows in this church-the one on the left depicts Pontius Pilate washing this hands, (Matt. 27:24) the one in the center depicts the flagellation (condemnation) and the one on the right depicts the liberation of Barabbas, the robber. (Matt. 27:36).

The Chapel of Condemnation

The second chapel in the Franciscon University (Franciscon Stadium Biblicum) commemorates the condemnation of Jesus. On either side of the main altar are two carved statues of the suffering of Jesus Christ.

The stone pavement in the back of this chapel forms part of the Roman Street that extends out to the 'Via Dolorosa', the path on which Jesus Christ carried the cross.

means, 'cock crow'. This church was constructed just above the site of High Priest's house (Caiphas in Jesus' days). The present day church was restored in 1999 by the Assumptionist Fathers. The shrine house had dungeons and pits used by the High Priests in those days for keeping the offenders, particularly in the nights. Perhaps, Jesus Christ was also kept as a prisoner in one of these dungeons, after his condemnation by the 'Sunhedrin' (Jewish court).

The Chapel of the Flagellation

John 19:1 to 3 says, Pontius Pilate therefore took Jesus and scourged him. The soldiers plaited a crown of thorns and put it on Jesus' head and put on him a purple robe. The soldiers said "Hail, King of the Jews" and smote him with their hands.

Parallel to the place of condemnation (Flagellation), of Jesus by Pontius Pilate is the

Franciscon University (Franciscon Stadium Biblicum). There are two chapels in the courtyard of this University. The first one is the chapel to commemorate the condemnation of Jesus by Pontius Pilate.

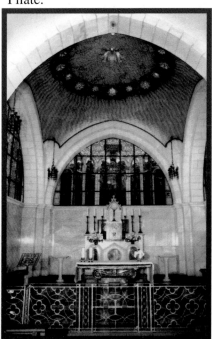

● *Interior view of the Church of Flagellation, Mount Zion*

Ecce Homo Chapel

'Ecce Homo' means 'Behold the Man'.

According to John 19:5, Pilate saith unto them 'Behold the Man'.

To commemorate this event, a Chapel known as 'Ecce Homo' Chapel was constructed on Mount Zion, near the chapel of Flagellation. Ecce homo Chapel is now being administered by the Sisters of Sion (Zion).

The Dormition Abbey (the Church of Hagia Maria Zion) on Mount Zion

Dormition Abbey or Church of the

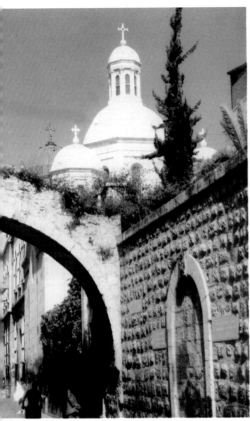

Ecce Homo Chapel on Mount Zion

Hagia Maria Zion located on Mount Zion is the place, where Virgin Mary fell into eternal sleep.

This church was built in the beginning of twentieth century, on the ruins of earlier two churches built during the Byzantine and Crusaders periods.

The beautiful mosaic floor in this church depicts the Holy Trinity, the Apostles and the Zodiac. A staircase leads down from the upper church to the crypt, venerated as Mary's home after resurrection and as the place of her death. In the center of the crypt is a life size statue of Mary in a sleeping position, made of cherry wood and ivory. In the dome above it, there is a mosaic depicting the figure of Jesus Christ welcoming

his mother, surrounded by six famous women of the Old Testament.

Palaces of Pontius Pilate and Herod

It is impossible for archaelogists to say precisely, where exactly the house of the Jewish high priest was located in the days of Jesus Christ. Many scholars and archaelogists think that the exact location was on the south-west of the city of Jerusalem and on the edge of Mount Zion, where there is now the Church of St. Peter in Gallicantu.

At this site, there are many excavated cellars, stables, water cisterns etc., dating from the Herodion period. Excavations have also revealed old steps dating from the first century and Jesus Christ might had been made to climb these steps to reach the Palace of Pontius Pilate. Beneath this church, there are dungeons and cellars. Recent excavations have

revealed a large stretch of Roman pavement, which should have been the 'Gabbatha' in Aramaic language or 'lithostroto' in Greek language, which in English means 'Judgement Hall'.

Jesus Christ's Crucifixion and Tomb

Now, the pilgrims come to the last stage of Jesus Christ's, life on earth. According to Roman Law, a criminal is condemned to death either by stoning or by crucifixion. Jesus Christ was condemned to death by crucifixion along with two other robbers (malefactors). Jesus was made to bear the cross on his shoulders from 'Gabbatha' (Judgement Hall) to 'Golgotha' in Hebrew language, which means the 'Place of Skull', located on Calvary hills.

The exact place of crucifixion and placing the body of Jesus Christ after his death in a tomb is controversial at present. The Protestant Christians believe that

Dormition Abbey on Mount Zion

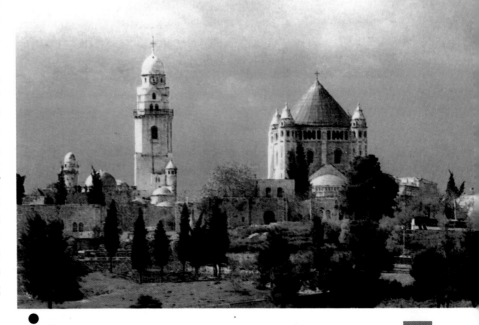

the exact site of crucifixion and tomb are in a garden, which they now call a 'Garden Tomb'.

On the other hand, the Roman Catholic Christians believe that this site is now in the Church of Holy Sepulchure, which was constructed by Queen Helena of Rome bringing the last five stations of the cross within this huge church.

But, all the pilgrims visiting the Holy Land usually visit both these sites, whether they are Protestant Christians or Roman Catholic Christians, as both these sites are considered as holy places.

The Garden Tomb or Gordon's Calvary

Long after the crucifixion of Jesus Christ, many rich and powerful kings of Christian nations took the help of expert archaelogists and scholars to excavate a few sites in Jerusalem to locate the exact place of the crucifixion of Jesus Christ and the tomb in which his body was laid. (Rock tomb of Joseph Arimathia as mentioned in the gospels.)

According to John 19:41 and 42, in the place where he (Jesus Christ) was crucified, there was a garden; and in the garden a new sepulchure, wherein was never man yet laid. There laid they Jesus therefore because of the Jew's preparation day; for the sepulchure was nigh at hand.

The grounds on which the Protestant Christians determined the 'Garden Tomb' as the exact place of crucifixion and tomb are as follows:-

The Garden Tomb is located

'Golgotha' Rock resembling human skull in Garden Tomb ▲

outside the northern wall of Jerusalem and its entrance is a few meters away from the Damascus Gate.

In the year 1883, a British General named Charles Gordon was the Governor of Palestine. General Gordon revealed that he had located a huge rock that resembled the human skull in this garden at a height of about 5 feet above the surrounding area and hence, this rock could be seen from many places. This rock was facing the city of Jerusalem and had a 'Fantastic likeness' of a human skull. There were caverns, (large depressions) to resemble the two human eyes, a protruding rock to resemble human nose, a long slit to resemble human mouth and a lower edge to resemble human chin. General Gordon, therefore believed that this rock resembling the human skull was the real 'Place of Skull' or 'Golgotha' as mentioned in the gospels.

The entire rock is a white

lime stone rock, which are very prevalent in the entire Jerusalem area.

In this garden, very near the skull shaped rock, there is a cave, which was believed to be the rock tomb prepared by Joseph Arimathia for the burial of his family members, but used for laying the body of Jesus Christ, as it was near the place of crucifixion, called Golgotha.

Pilgrims enter this tomb through the narrow opening, one by one and observe inside, a two roomed cave. The front room is supposed to be the mourning room for the relatives of the dead person and the second room is the place, where the body is laid. Another small opening at a height is the window to the second room, where the body is laid.

As there is a skull shaped rock, Golgotha, a tomb near it and these two are located in a garden, all the Protestant Christians believe that this is the exact place of

crucifixion and tomb of Jesus. They now call it 'Garden Tomb', because of the garden there and not to be confused with the name of General Charles Gordon, who discovered this site.

The entire area of about 3 acres had been purchased in 1893, by the Garden Tomb Association, with its Headquarters in London, U.K. The entire area and the garden are now being maintained by this Association. After the Association took over this site, many Easter services were conducted in this Garden Tomb.

Many people preach in this Garden Tomb and pilgrims participate in these meetings. The Garden Tomb Association has selected about 10 spots in this garden, where they arrange benches , chairs and one or two tables at each spot so that, groups of pilgrims coming from different countries can conduct prayer meetings in their own language and even partake in the Holy Communion, after the bread and wine are blessed by an ordained priest maintained by this Association. This Association also provides guides who can speak in different languages to explain groups of pilgrims coming from different countries. They do not charge anything for all these services. Pilgrims from all over the world assemble in this Garden Tomb, throughout the year.

The Church of the Holy Sepulchure

The Roman Catholic Christians believe that the exact place of crucifixion of Jesus Christ and the tomb in which his body was placed

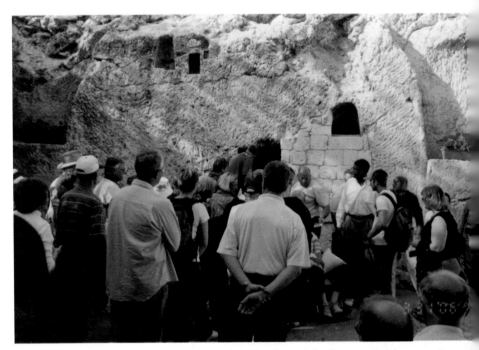

Rock Tomb in the Garden, wherein Jesus' body was laid ▲

are enclosed within the huge church of the Holy Sepulchure, during the construction of this church in 335 A.D., by Queen Helena of Rome.

When Emperor Constantine of Rome sent his mother Queen Helena to the Holy Land to find out the exact place of Jesus Christ's crucifixion and tomb, she came to Jerusalem. With the help of Eusebius, the Bishop of Caesaria and Macarius, the Bishop of Jerusalem, all the debris from a big heap in Calvary was removed and a tomb was discovered. In that tomb, they found three old wooden crosses believed to be the cross on which Jesus Christ was crucified and the other two crosses on which the two robbers (malefactors) were crucified. There were some other evidences also, which made them all believe that this was the exact place of Calvary, Golgotha, where Jesus Christ was crucified along with two robbers, one on each side.

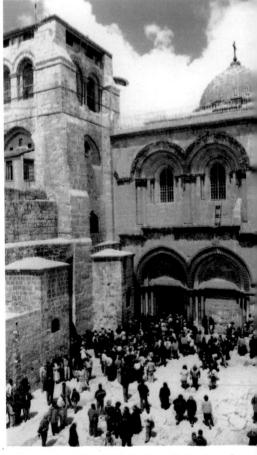

The Church of Holy Sepulchure, ▲
Jerusalem

which means, it covers the place of crucifixion, as well as, the tomb in which Jesus Christ's body was laid after he died on the cross.

Emperor Constantine and his mother Queen Helena planned this church construction in such a way as to enclose the last 5 stations of the cross, out of the 14 stations in all, within this huge church. These five last stations are:-

10th station – Golgotha, where Jesus was stripped off the purple robe and his own clothes were put on (Anrobe).

11th station – Jesus was nailed to the cross.

12th station – Calvary, where Jesus died on the cross.

13th station – Jesus' body was laid on a stone of Unction (Anointing) and anointed with spices, preparing him for burial.

14th station – Jesus' body was placed in the tomb.

All these last five stations of the cross are enclosed in the Church of Holy Sepulchure.

The three different buildings constructed at this site consist of a round church, the Anastasis above the empty grave of Jesus and a Basilica, the Martyrium. The square between the two churches, is a shrine marking the place of crucifixion – Calvarium (Golgotha).

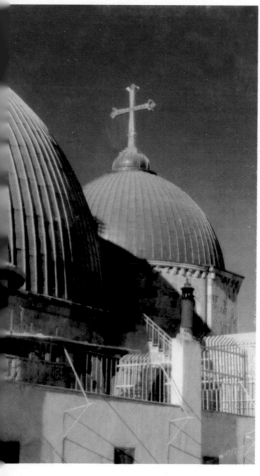

Dome of the Church of Holy Sepulchure

Scholars believe that Queen Helena dreamt of this spot one night during her stay in Jerusalem.

Queen Helena went back to Rome and informed her son, Emperor Constantine and the entire Roman Catholic world about this 'Miraculous Discovery'. Later on, Emperor Constantine of Rome got a magnificent church constructed on the sepulchure or tomb of Jesus and called it 'The Church of Holy Sepulchure'. It was dedicated in 335 A.D. Three different buildings were constructed at this site. This church is considered as a dupliex structure

The last five stations enclosed within this Church of Holy Sepulchure are depicted by beautiful paintings at each station.

The painting of station 10 is not available here. But, it is shown under 'Via Dolorosa' description in the subsequent pages.

11th station shows the nailing of Jesus to the cross.

Painting of 11th station-Jesus being nailed to the Cross

12th station, shows Jesus died on the cross, as existing in the Church of Holy Sepulchure.

13th station, shows laying the body of Jesus on a stone (Stone of anointment) and applying spices, preparing him for burial.

Apart from the painting of this 13th station of the cross, which depicts the placing of the body of Jesus brought down from the cross on a stone for anointing spices etc. before burial, in this church as

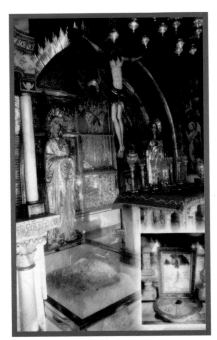

▲ *12th station - Jesus died on the Cross*

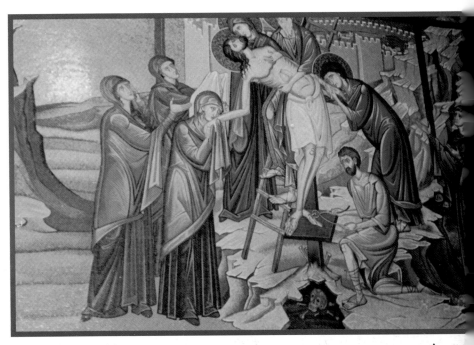

Painting of Jesus being brought from the Cross after he died ▲

soon as one enters, there is the actual 'Stone of Unction' (Anointing). There is an altar which marks the spot, where Mary, the mother of Jesus received the body of Jesus after he was brought down from the cross. Then, the body of Jesus was laid on the 'Stone of Unction', (Stone of Anointing) and anointed with aromatics and spices, which is the usual act, preparing for the burial of the Dead.

This stone is fixed in a rectangular frame, with high candle stands on both sides. From the top of the frame, eight white lamps are hanging on this stone. Right opposite to this Stone of Unction, the painting of the 13th station of the cross, depicting the anointing of Jesus' body by the Women of Jerusalem, including Mary the Mother of Jesus, Mary Magdalene and others can be seen.

14th station, shows Jesus' body being laid in the rock tomb.

The beautiful and huge Church of Holy Sepulchure built by Emperor Constantine and his mother Queen Helena of Rome remained intact till 614 A.D., when the Persian armies destroyed it. By the contributions of Christians, this church was rebuilt, but it was again destroyed in 1009 A.D. It was partially restored until the Crusaders erected the present church in 1149 A.D. But, this church was again burnt in the great fire accident of 1808 A.D.

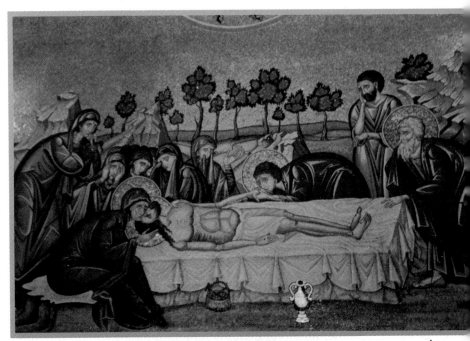

13th station- Painting of Jesus' body laid on a stone to anoint spices ▲

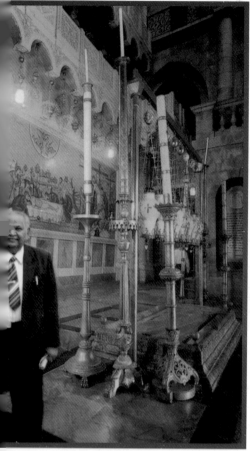

▲ *The Stone of Unction in the Church of Holy Sepulchure*

Within two years, three million dollars were received as contributions and another church was built on this site. It was not so large and beautiful like the earlier churches, yet it is now standing as the Church of Holy Sepulchure. Thus, the original Church of Holy Sepulchure built by Emperor Constantine and Queen Helena of Rome in 335 A.D. was twice destroyed and rebuilt thrice.

Within this Church of Holy Sepulchure, the Roman Catholics, Greek Orthodox, Gregorian Armenian, Jacobites have separate chapels, partitioned from each other and they conduct their own mass. But, on special occasions, these groups of Christians worship in the main Holy sepulchure itself in turns.

Thus, the Church of Holy Sepulchure is the most important church in the entire world. No place in the Christian world has been regarded with so much devotion as the Church of Holy Sepulchure in Jerusalem.

A few meters away from the Church of Holy Sepulchure, on an elevated land of about fifteen feet above the level of tomb is the so called 'True Cross', which is studded with about 7 to 8 million dollars worth of gems and precious jewels. Near this cross, there is a big rock with a crack in it. It is believed that this rock had cracked when it was shaken by an earthquake, which occurred when Jesus Christ died on the Cross. (Matt. 27:51).

Jesus Christ's Last Journey in Jerusalem

- From Bethany to Upper Room for the last supper. (Luke 22:14 to 20)

- From the Upper Room to the Garden of Gethsemane. (Matt. 26:36) – 1.4 kilometers.

- From Garden of Gethsemane to the Palace of High Priest. (Matt. 26:57 to 68) – 1.5 kilometers.

- From High Priest to Pontius Pilate. Luke 23:1)-0.6 kilometers.

- From Pilate to Herod. (Luke 23:7)–0.4 kilometers.

- From Herod to Pontius Pilate. (Luke 23:11) – 0.4 kilometers.

Thus, in one night Jesus Christ was made to walk about 4 kilometers and whipped all the way.

Finally, Jesus Christ was crucified. By the time the judgement was pronounced, it was early morning, because the cock

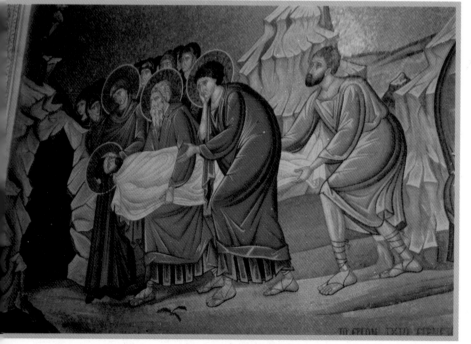

Jesus' body being placed in the rock tomb

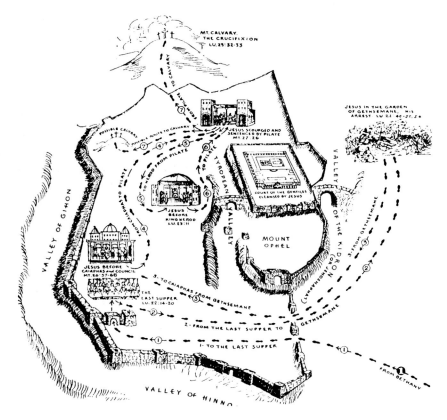

● *Map showing Jesus Christ's last journey during the night*

which is spoken by Jesus Christ. In Greek language, it is known as 'Lithostrotes'. In brief, Jesus Christ had to carry the cross on his shoulders from 'Gabbatha to Golgatha'. Gabbatha was inside the city of Jerusalem, where as Golgotha was outside the city wall in the days of Jesus Christ, a total distance of about 1.5 kilometers. But now, this place is in the old city of Jerusalem.

A plan showing the stages of Jesus Christ last walk, bearing the cross on his shoulders from Gabbatha to Golgotha and the events that took place on this route are indicated by 14 stations.

It can be observed from this plan that the first nine stations, out of the fourteen stations are along the Via Dolorosa, where as the last five stations 10 to 14 stations are enclosed within the Church of Holy Sepulchre. The plan also shows the events that took place at each of these fourteen stations.

crowed, before Peter denied Jesus Christ thrice.

The next morning (Friday), Pontius Pilate delivered Jesus Christ to the people to be crucified. They took Jesus Christ from 'Gabbatha' (Judgement Hall) to 'Golgotha' (the place of skull) with a cross on his shoulders, to be crucified.

'Via Dolorosa'

The term 'Via Dolorosa' is an Italian term. 'Via', means 'Way' and 'Dolorosa' means, 'Sorrow'. So, 'Via Dolorosa' means, the 'Way of Sorrow'. Some times, it is also known as the 'Way of Cross'. This is the way along which Jesus Christ carried the cross on his shoulders from 'Gabbatha', where he was condemned to death by crucifixion before Pontius Pilate to 'Golgotha'

the place of skull on calvary, where he was crucified. The Jewish Judgement Hall is known as 'Gabbatha' in Aramaic language,

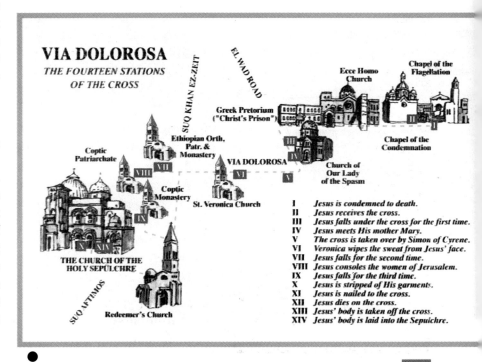

VIA DOLOROSA
THE FOURTEEN STATIONS OF THE CROSS

I	Jesus is condemned to death.
II	Jesus receives the cross.
III	Jesus falls under the cross for the first time.
IV	Jesus meets His mother Mary.
V	The cross is taken over by Simon of Cyrene.
VI	Veronica wipes the sweat from Jesus' face.
VII	Jesus falls for the second time.
VIII	Jesus consoles the women of Jerusalem.
IX	Jesus falls for the third time.
X	Jesus is stripped of His garments.
XI	Jesus is nailed to the cross.
XII	Jesus dies on the cross.
XIII	Jesus' body is taken off the cross.
XIV	Jesus' body is laid into the Sepulchre.

14 Stations of the Cross

1st station:– **Jesus is condemned to death.**

The first station is now in the court yard of the Al-Omariya School.

A picture shows Jesus Christ being taken away by soldiers from the Court of Pontius Pilate.

1st station

2nd station: – Jesus receives the cross.

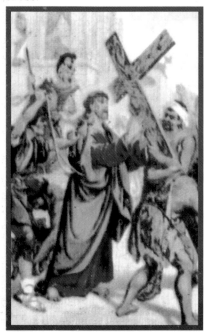

2nd station

Now, Franciscon Chapel of the Flagellation and the Chapel of condemnation commemorate this event of Jesus taking up the cross.

3rd station:– **Jesus falls under the cross for the first time.**

Jesus Christ fell for the first time, with the heavy weight of the cross. When Jesus fell, one of the soldiers hit Jesus with his stick.

An Armenian Catholic Chapel now marks this spot where Jesus fell with the weight of the cross.

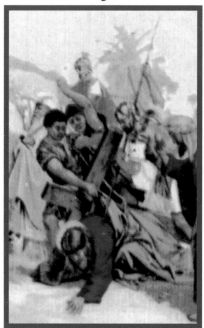

3rd station

4th station:– **Jesus meets his mother Mary.**

The Armenian Church of Our Lady of the Spasm, now marks this event.

5th station: – **The cross is taken over by Simon Cyrene.**

This event is commemorated now by a Franciscon Chapel. From here, the way of cross begins climbing upto Golgotha.

6th station:– **Veronica wipes the sweat from Jesus' face.**

It is believed that when

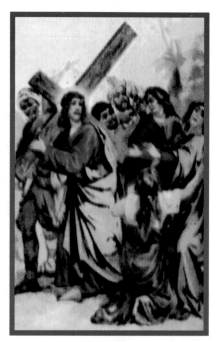

4th station

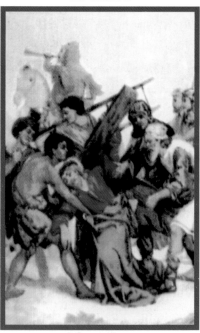

5th station

Veronica wiped the face of Jesus Christ with her scarf, the imprint of Jesus' face was left on this scarf. This scarf is now being preserved at St. Peter's Church in Rome, Italy. It is also believed that from this imprint of Jesus' face, all the present days pictures of Jesus Christ are being printed or painted.

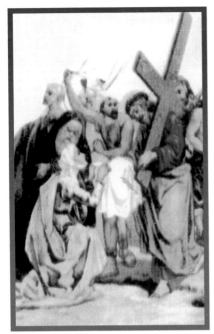

6th station

7th station:– Jesus falls for the second time.

Two Chapels connected by a flight of steps, now marks this event of Jesus Christ falling down for the second time. Inside the Franciscon Chapel, there is a Roman pillar on which, the condemnation of Jesus Christ was

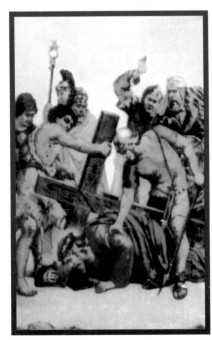

7th station

probably written. It is believed that, there was a 'Gate of Judgement' here, through which Jesus Christ left the city of Jerusalem on his way to Golgotha.

8th station:– Jesus consoles the women of Jerusalem.

A group of women from Jerusalem, like Mary the mother of Jesus, Mary Magdalene and others were sitting at a place on 'Via Dolorosa' and when Jesus came to that spot, carrying the cross on his shoulders, he looked at them and consoled them saying "Daughters of Jerusalem, weep not for me, but weep for yourselves, and for your children". (Luke 23:28).

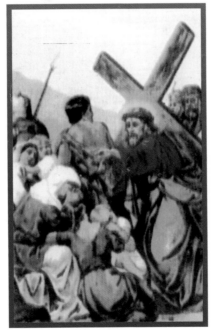

8th station

9th station:– Jesus falls for the third time.

Jesus Christ fell for the third time under the heavy weight of the cross.

In the present day, a column built into the door of the Coptic Church marks this event of Jesus falling for the third time.

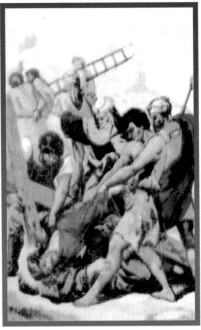

9th station

10th station:–Jesus is stripped off his garment.

According to Matt. 27:35 and Mark 15:22-24, they brought Jesus Christ to a place 'Golgotha', which is being interpreted, 'The place of skull'. They parted with his garments, casting lots upon them, what every man should take.

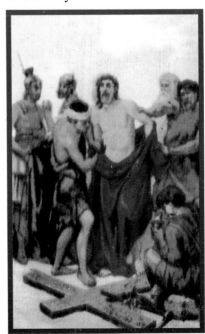

10th station

The 10th station shows, Jesus Christ keeping the cross on the ground, as he is being stripped off his garments.

This event is now depicted at the chapel of the Divestiture. 10th station to 14th stations are enclosed within the Church of Holy Sepulchure.

11th station:–Jesus is nailed to the cross.

When they brought Jesus to Golgotha, they laid him on the cross and hammered big nails into his palms and feet. (Luke 23:33)

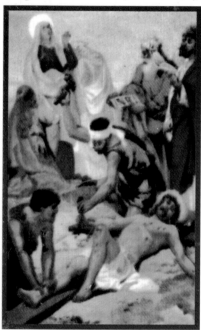

11th station

12th Station:–Jesus dies on the Cross

According to Matthew 27:50 and Mark 15:34-37, at the ninth hour, Jesus cried with a loud voice and gave up the ghost.

A Greek Orthodox Chapel now marks the site of the death of Jesus Christ. The altar in this Church is flanked by two supporting pillars and has a silver disc beneath it, marking the exact place, where the

cross on which Jesus Christ was crucified stood. The Rock of Golgotha can be seen through a cavity in the center. On either side of the altar, there are black discs, marking the sites of the crosses of the two robbers (malefactors), who were crucified along with Jesus Christ. To the right of the altar, there is a fissure in a big rock, believed to have cracked during the earthquake, which occurred, when Jesus died (Matt. 28:51 and 54).

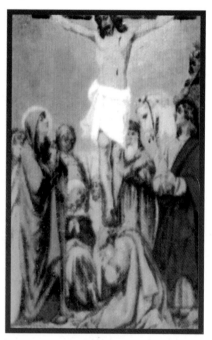

12th station

13th station:– Jesus' body is taken off the cross.

After Jesus Christ died on the cross, the Roman soldiers brought his body down from the cross, using a ladder

14th station:– Jesus body is laid into the sepulchure

According to Matthew 27:57 - 60, Mark 15:46 a rich man of Arimathaea, named Joseph went to Pontius Pilate and begged for

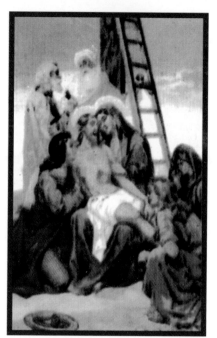

13th station

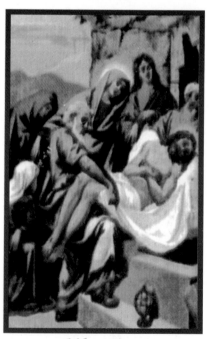

14th station

the body of Jesus. Pilate commanded the body to be delivered to Joseph, who then wrapped it in a clean linen cloth and laid the body of Jesus in his own new tomb, which he had hewn out in the rock and he rolled a great stone to the door of the sepulchure and departed.

Jesus Christ's body was brought down from the cross and laid on a stone. The women among whom Mary the mother of Jesus, Mary Magdalene, Mary the mother of James and of Joseph and Salome were present, ministered to him anointing him with spices and preparing him for burial. Then, they wrapped him in linen and placed the body in the rock tomb of Joseph of Arimathaea.

Thus Jesus Christ's life in this world came to an end by his dying on the cross for the sake of sinners.

In the Church of Holy Sepulchure, the tomb of Jesus Christ was originally in a cave hewn in a rock and a round building was built around it. This sacred rock is covered with a marble and above it are paintings depicting the resurrection of Jesus Christ. The tomb itself is covered with a smooth marble slab, which has been in place since 1555. Over the tomb, 42 lamps (thirteen lamps each for the Latins, Greek Orthodox and Armenians and 3 lamps for the Copts) burn day and night.

Every Friday, groups of Christian pilgrims from different countries led by Franciscon monks retrace these steps, walking along the Via Dolorosa, starting from the Church of Flagellation and ending in the Church of holy Sepulchure. Via Dolorosa is the most sacred place for all the Christians in the world. No pilgrim can miss to walk along Via Dolorosa.

Of all the biblical spots in the Holy Land, Via Dolorosa is the only spot, which is kept more or less in its original form, unlike other churches, which were destroyed and rebuilt again and

again. The road (Via Dolorosa) is narrow and laid with cobble stones. It is believed that some of these stones existing today might be the stones on which Jesus Christ himself might have walked while carrying the cross on his shoulder from Gabbatha to Golgotha. It is therefore firmly believed by all pilgrims, that by walking along Via Dolorosa, they would be walking in the footsteps of Jesus Christ and hence, no pilgrim should miss the walk along Via Dolorosa. This cobble stoned way is narrow with steps and the total length is about 1.5 kilometers.

At each of the 14 stations of the Cross, the stones are arranged in a circular manner to, indicate the stations.

The Chapel of the Ascension, Bethany

According to Luke 24:33 to 55, after resurrection, Jesus Christ appeared to his disciples three times. On the last occasion, when his eleven disciples were in Jerusalem, and were discussing among themselves about all events, Jesus himself stood in the midst of them and saith unto them "Peace be unto you". The disciples gave him a piece of broiled fish and of a honey comb. He took them and did eat before them. Jesus asked them to preach repentance and remission of sins in his name among all nations, beginning in Jerusalem.

Jesus led his disciples out of Jerusalem as far as Bethany, and he lifted up his hands, and blessed them. While he was blessing them, he was parted from them, and carried up to heaven. The disciples worshipped him, and returned to

Jerusalem with great joy. They were continually in the temple, praising and blessing God, Amen.

To commemorate this last event in the life of Jesus Christ in this world, a church was built here for the first time at the end of 4th century. Some pilgrims of the 7th century described this church as having two rows of pillars with arches. The Persians destroyed it in the seventh century. In the twelfth century, the crusaders built a new church at this site and a part of it, stands today.

At present, it is an eight sided (octoganal) small domed building located with in a compound. The Chapel of Ascension is at the summit of the Mount of Olives.

This chapel today functions as

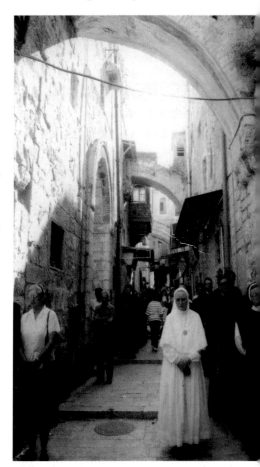

● *Via Dolorosa*

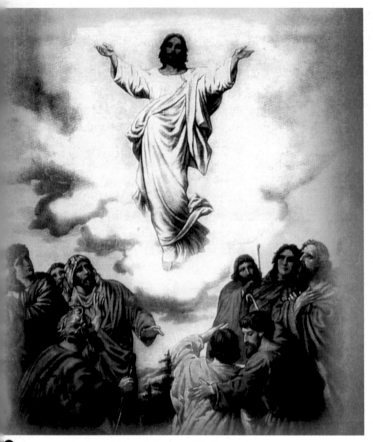

Ascension of Jesus Christ

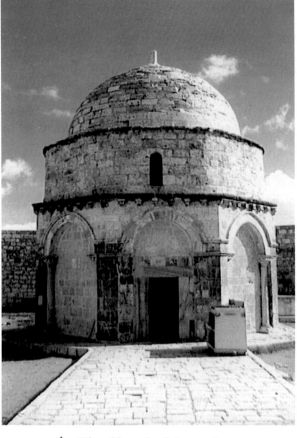

▲ *The Chapel of Ascension*

a mosque but, the various Christian denominations are permitted to celebrate the Feast of Ascension, which falls forty days after Easter. Their altars stand in the courtyard.

Inside this Chapel, there is a rock from which, it is believed that Jesus Christ ascended to heaven. The pilgrims believe that one can see the footprints of Jesus Christ on this rock.

Wailing Wall or Western Wall

Wailing Wall is a very important holy place for Jews. This wall is the only remaining portion of the Second Temple, which was destroyed in 70 A.D. This is located in the old city of Jerusalem. Originally, this wall

was the western wall of the temple court yard. At present, this wall is 2000 feet long and 90 feet high. Archaelogists say that the foundation of this wall is 63 feet below the present ground level, which means that this wall originally should have been 153 feet high. The huge Herodion stones with which it is constructed still stand one over the other without any cement layer in between, as usual to hold these stones.

Though the temple was destroyed in 70 A.D., which means nearly 1936 years ago, still the Jews assemble by the side of this wall and mourn for the destruction of their temple. They stand by the side of this wall with

a prayer book in their hand and say sorrowful prayers, shaking their head. Some Jewish pilgrims say that while they pray at this wall, wailing, the wall itself wails (weeps). The present day wailing wall is called 'The Synagogue of the Wall'. This wall had long been a symbol of Jewish faith and unity.

There are cleavages between these huge stones of this wall. But, they are filled with slips of paper on which the Jews write their prayer for the peace of Jerusalem or for early recovery of any sick person in the family or any other prayer. They also write for the early coming of Messiah.

Stretching along the entire length of 200 feet of this wall, paved plaza had been constructed

with replaceable partition frames for separate entrance for men and women to reach the side of this wall to offer prayers. This wall has become a meeting place of Jews for offering prayers or any other public celebration of Jews.

Just behind this wall, the present days 'Dome of the Rock' is located. The height of this wall at present (90 feet) can be seen by the size of the people standing by the side of the wall and there is a temporary partition for men and women.

Dome of the Rock

Dome of the Rock is an important religious place for Muslims. In the year 691 A.D., Moslem Caliph Abd El Malik constructed this mosque with a huge dome. In 1994, the dome was gold plated. This mosque is very conspicuous in entire city of Jerusalem and can be seen from a distance.

Mosque of El Aska

During 709 to 715 A.D., Caliph Waheel, son of Abd El Malik constructed the mosque of El Aska. It has a beautiful silver dome. Both the Dome of the Rock with its golden dome and the Mosque of El Aska with its silver dome are very conspicuous buildings in Jerusalem and are visible from a distance.

Western Wall Tunnels

Part of Herod's Western Wall is visible at ground level at present. The rest of the wall is underground. Excavations carried out by British archaelogists, Wilson and Waren uncovered remains from the time of King

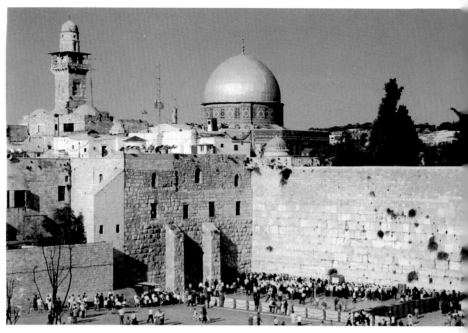

Wailing Wall or Western Wall of the Temple ▲

Solomon onwards. Today, one can walk along the ancient Herodion street, which is at a depth of 50 feet below ground level.

Tower of David or David's Citadel

This citadel constructed by Herod, is visible from many places in Jerusalem and serves as a land mark. Within this citadel, there were three towers, which Herod called after the names of the people, whom he loved-Mariamne, his wife, Phasael, his brother and Hippicus, his friend. Out of these three towers, only the bottom half of one tower remained

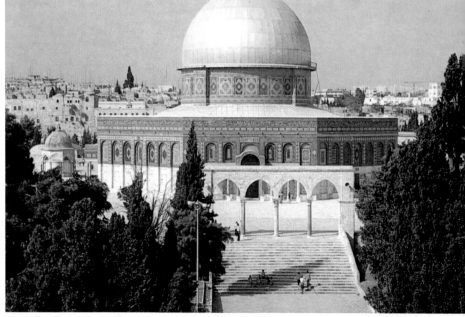

● *Dome of the Rock*

after the destruction of the city by Romans. In the last few years, excavations carried out here have unearthed remains from as far back as the Hasmonean period. The minaret (tall tower) from the later period is erroneously known as the 'Tower of David'. It was used as a moslem prayer house and was called by the Arabs as 'David's Prayer Cell', as they believe that David prayed here.

The tower of Phasael (Herod's brother) is near to Jaffa gate of Jerusalem city wall. From the roof of this tower, there is a wonderful view of the old city of Jerusalem. Steps lead to the walkway, which runs around the top of old city walls.

There is the 'Tower of David's Museum', which traces the history of Jerusalem over 3000 years, using audio-visual program and modern exhibits. During the summer months, a 'Sound and Light' program entitled 'A Stone in David's Tower' unfolds the dramatic story of Jerusalem. This program is arranged in the courtyard of the Museum.

Pool of Siloam

In the days of Jesus Christ, the Gihon spring was Jerusalem's only spring for water supply for drinking purpose. Therefore, during battles, the first priority was to safeguard this spring.

According to the Old Testament, King Hezekiah built the 'Silwan Tunnel', which was also known as 'Hezekiah's Tunnels', around 700 B.C. to bring water directly to the city of Jerusalem. Hezekiah's workers began digging the tunnel in a rock from both the ends and fortunately both met midway. The water in the pool of Siloam being pure water from the spring of Gihon, this water was used for religious ceremonies in the temple.

According to John 9:1 to 7, as Jesus passed by, he saw a man, who was blind from his birth. His disciples asked him, "Master, who did sin, this man, or his parents, that he was born blind?" Jesus answered "Neither hath this man sinned nor his parents: but the works of God should be made manifest in him." Jesus made clay of the spittle, and he anointed the eyes of the blind man with the clay and said unto him "Go, wash in the pool of Siloam." (which is by interpretation, sent). He went his way therefore, and washed, and came seeing.

Pools of Bethesda

In the year 1871, excavations were carried out close to St. Ann's Church in Jerusalem. These excavations uncovered the remains of two large rectangular pools. These are known as the pools of Bethesda.

According to John 5:1 to 9, there is at Jerusalem by the sheep market a pool, which is called in

David's Citadel

Pool of Siloam

Hebrew tongue, Bethesda, having five porches. In these lay a great multitude of impotent folk, of blind, halt, withered, waiting for the moving of the water by an angel and whosoever first stepped into the water was made whole of any disease. Jesus saw a man, who had an infirmity for thirty eight years. Jesus realised his ailment and asked him "Rise, take up thy bed and walk." Immediately, the man was made whole and took up his bed and walked.

MODERN DAYS, PLACES OF INTEREST IN JERUSALEM

Jerusalem being the capital of Israel for many centuries and as many powerful kings ruled over it, there are many places of interest in and around Jerusalem.

Israel Museum

Israel Museum was opened in 1965. It comprises of 4 main sections – Judaic and Art, Archaeology, The Shrine of the Book and The Billy Rose Sculpture Garden. There is always a full programme of lectures by eminent scholars, concerts and films. One of the permanent exhibits is the seventeenth century 'Vittorio Veneto Italian Synagogue' which is a synagogue, beautifully decorated with elaborate design and workmanship.

The Shrine of the Book

An important part of the Israel Museum is the 'Shrine of the Book'. This is a museum containing the Biblical manuscripts found by the shepherd boys in 1947 from one of the caves at Qumran. This museum is a very peculiar one, as its building resembles a lid of the clay jars found by the shepherd boys in Qumran Caves. The Dead Sea Scrolls found in these caves and other articles found by the archaelogists later on in these Qumran caves are also exhibited in this Museum, along the long tunnel like entrance to the Shrine of the Book museum.

The Knesset or the Parliament

Israel's Parliament (known as Knesset in Hebrew language) moved to its present site in 1966. This building is constructed with pink Jerusalem stones. It can accommodate 120 Knesset members. The sessions of Knesset are open to the public.

In this building, there is a synagogue, reading room, a restaurant and conference rooms. In front of this building, there is the 'Menorah', which is a seven-branched Candelabrum (The emblem or Coat of Arms of the State of Israel). This was presented by the British Parliament. This Candelabrum depicts scenes of the history of Jewish people, on it.

Near the Knesset, there is a Public Garden known as 'Sacher Park', which is a picnic spot for the families. Opposite this park, there are luxurious rows of tall white coloured multi-storied apartments known as 'Wolfson Apartments'.

The Bible Land Museum

This Museum was opened in 1992. It contains collections of artifacts (Things made by early people) from ancient times. The civilizations (advancements) of the Bible are exhibited in a chronological order from 6000 BCE to 600 C.E. Each exhibit is accompanied by an appropriate quotation from the Bible.

City Hall

The City Hall is located in

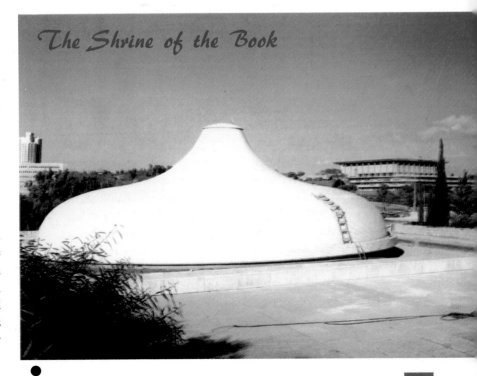

The Shrine of the Book

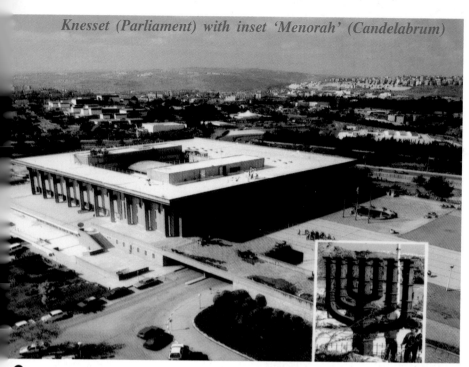

Knesset (Parliament) with inset 'Menorah' (Candelabrum)

between east and west Jerusalem. This was opened in 1993. There is a Plaza for public meetings, shops, galleries, restaurants etc. with lots of ornamental trees.

Ammunition Hill

Ammunition Hill is a memorial commemorating the liberation and reunification of Jerusalem, after the 6 days war. It is located near Mount Scopus in Jerusalem.

Bronze Fountain

In 1989, people of Germany installed a Bronze Fountain in west Jerusalem. Children climb up the Bronze Lions or cool themselves in summer months with water from this fountain. In its background, there is a wind mill known as 'Montefiore'. At a distance, David's Citadel and the walls of old city of Jerusalem are located.

The Hebrew University

This University was originally located on Mount Scopus. But, it has been shifted to the new Givat Ram Campus in west Jerusalem. This University has many modern courses of study and research. It has a very good library with books on biblical subjects and ancient history of Israel and Jerusalem in particular.

The Supreme Court

The Supreme Court was opened in 1992. This is located near the Bank of Israel. It is a beautiful building to visit.

Machane Yehuda Market

This is the oldest market in Jerusalem but, still popular market, as all kinds of fruits and vegetables are available here. This market is located near Jaffa Road. A peculiarity of this market is that every Friday, just before the market closes for the sabbath on the next day, the prices are all throw away prices, as vegetables deteriorate in one day.

Another market, which is dominated by Jews is the 'Mea Shearim' market.

The Jerusalem Mall

This is the largest shopping mall in Israel and known as the 'Canion Yerushalayim', in Malha. All kinds of goods are available in this market. The entire mall is completely air conditioned. There are 8 cinema theatres, many fast food counters, restaurants and cafes for the entertainment and relaxation of the visitors to the mall.

The Tisch Family Zoological Gardens

The zoo is located in west Jerusalem near the Canion Yerushalayim market. The animals are kept in a natural environment. For reptiles kept in rooms, large glass windows are provided for a good view to the visitors. There is a large pond with different kinds of water fowls swimming in it.

The Sherover and Haas Promenade (Tayelet)

This is a broad Promenade (public place for walking) located between Mount of Olives and the City of David. From here, one can view the spectacular city of Jerusalem.

PLACES OF INTEREST OUTSIDE JERUSALEM

EMMAUS

Luke 24;13-34 say that after resurrection of Jesus Christ, two men were going from Jerusalem to a village called 'Emmaus', which was about three score furlongs (about 7 miles or 10

kilometers) from Jerusalem.

After resurrection, Jesus Christ drew near them and walked with them. But, their eyes were closed that they should not know him. They narrated to Jesus the things that happened in Jerusalem and how Jesus Christ was crucified etc., not knowing that it was Jesus to whom they were telling all that happened to Jesus. As it was evening by the time they reached the village Emmaus, they invited him to abide with them for the night. As they sat at meat (supper). Jesus took bread, blessed it and broke it and gave to them to eat. Then, their eyes were opened and they knew that it was Jesus himself with whom they travelled. Jesus vanished out of their sight.

The exact location of this village Emmaus is controversial, at present. Archaelogists suggest places like, Latroun, Abu Ghosh and El-Qubeibe as the possible sites of the village Emmaus. But, El-Qubeibe, being 7 miles (three score furlongs) form Jerusalem, it is confirmed as the exact place of the earlier village of Emmaus. The names of the two men, who travelled from Jerusalem to Emmaus along with Jesus (not realised by them) are Cleophas and Simon.

In the recent years, the Franciscons constructed a Church on the spot, where Cleophas's house was believed to have stood.

BETHEL

The word 'Bethel' means the 'House of God'. Bethel is not mentioned in the new Testament. But, as this place is located on the main road from Jerusalem to Shechem (Sycar in Samaria), Jesus Christ might have passed through Bethel many times. Bethel is located 12 miles (19 kilometers) north of Jerusalem.

According to Gen 12:8 and 13:3, Abraham built a second altar and pitched his tent at Bethel. Later on, Jacob the grandson of Abraham had a vision of angels going up and coming down on a heavenly ladder (Gen 28:12). After 20 years, Jacob set up an altar and called the place as 'Beth-el', which means the 'House of God' (Gen 28:19). He erected a pillar at Bethel to mark the spot of his vision (Gen 28:22 and 31:13) and he worshipped the Lord there, (Gen 35:1 to 16). There were many battles fought in Bethel. Israelis were worshipping in Bethel. Later on, Bethel became a center for idolatry (Jeremiah 48:13 and Amos 5:5 and 6). Hosea, deploring the wickedness of Bethel (Hosea 10:5 and 15) called it 'Beth Aven',

● *The Church at Emmaus*

which means 'House of Idols'. Thus, Bethel, which was once the 'House of God' deteriorated into a 'House of Idols'.

King Josiah broke down the altar at Bethel. (II Kings 23:15). When Jewish people returned from captivity in Babylon (Ezra 2:28 and Nehemiah 11:32), Bethel again turned to the Lord. Now a days, Bethel is known as 'Beitin'.

JACOB'S WELL AT SYCHAR (SAMARIA) OR NABLOUS

In the Old Testament, this place 'Sychar' was known as 'Shechem'. Now, it is known as 'Nablous'. This place is 63 kilometers, north of Jerusalem. Samaria was known as 'Sebaste' in B.C. 720. Arabs, now call it 'Sebustieh'.

Shechem has many events which took place there. Jacob bought a 'Parcel of Ground' at Shechem and gave it as an inheritance to Joseph. The 12 sons of Jacob, Eleazer, Joshua were all buried in Shechem.

According to John 4:5-30, Jesus came to a place known as Sychar in Samaria, on his way from Judea to Galilee. Jacob's well was there at Sychar. (2 kilometer east of present Nablous). Jesus, being wearied with his journey, sat on the well and it was about the sixth hour (twelve noon). There cometh a woman of Samaria to draw water. Jesus saith unto her "Give me to drink". The woman said "How is it, that thou being a Jew, askest drink of me, which am a woman of Samaria?" (for the Jews have no dealings with the Samaritans). Jesus said "If thou knowest as to who is asking for a

drink and asked him, he would have given you living water." The woman said "Sir, thou hast nothing to draw with and the well is deep: from whence then hast thou that living water? Art thou greater than our father Jacob, who gavest this well and drank thereof himself and his children and his cattle ?"

To commemorate this event, a Greek Orthodox Church was built here with Jacob's well in the center of its crypt (A room beneath the floor of a church).

This well is 32 meters (105 feet) deep. The pilgrims, who desire to see the depth of this well and take water from this well in bottles, request the attending priest to let down the steel vessel with

lighted candle on it so that, they can watch in the dark and deep well, how deep the candle goes. This water is cool and refreshing.

CANA OF GALILEE

Cana of Galilee is presently known as 'Kefar-Kanna'. It is located about 4 miles (6 kilometers) to the north-east of Nazareth.

Cana is noted as a place, where Jesus Christ performed his first miracle of converting water into wine, at a wedding.

According to Jn. 2:1-11, Jesus, along with his disciples attended a wedding in Cana, where Jesus' mother, Mary was also there. When they wanted wine, Mary said to Jesus "They have no wine".

Jesus said "Woman what have I to do with thee? Mine hour is not yet come." Jesus said to the servants to fill up six water pots of stone. They filled them up to the brim. Then, Jesus simply said "Draw out now and bare unto the Governor of the feast". He tasted it and found to be good wine.

To commemorate this first miracle of Jesus Christ at Cana, two churches were built – The Franciscon Church and The Greek Orthodox Church.

Within this Church compound, there is a 'Chapel of Wedding'. Some couples among the pilgrims get married again in the presence of a priest, to remember their earlier wedding.

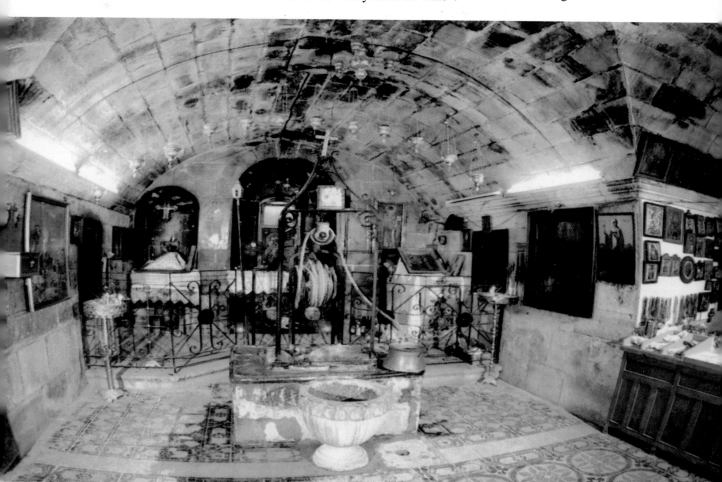

Jacob's well in the center of the crypt

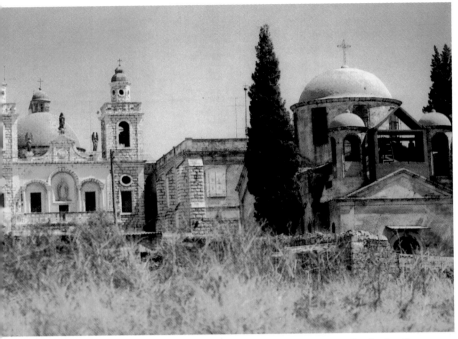

in the four Gospels, but according to tradition, it is the high mountain onto which Jesus Christ took Peter, James and John and was transfigured before them. Mark 9:2-5 says that when Jesus Christ was transfigured on this high mountain, his raiment became shining, exceeding white as snow: so as no fuller on earth can white them. There appeared unto them, Elias with Moses: and they were talking with Jesus. Peter said to Jesus, "Master, it is good for us to be here: and let us make three tabernacles (places of worship); one for thee, and one for Moses and one for Elias."

Mount Tabor is located at 30

▲ *Two Churches at Cana-Franciscon and Greek Orthodox*

MEGIDDO OR ARMAGEDDON

The place Megiddo is located between southern Galilee and northern Samaria and to the southern end of the Jezreel valley. It is actually to the south-west of Nazareth.

Megiddo was a place of many battles in the past. As a result, ruins of many palaces, temples, synagogues, security towers and residential places can be found in this place. Excavation carried out at Megiddo revealed 20 super imposed cities, the oldest dating back to 4000 B.C. An underground water tunnel was connecting a water source from outside the walls of the city. The name of Megiddo is mentioned in the books of Joshua, Judges and Chronicles.

SEPPHORIS OR ZIPPORI

Sepphoris is located north of Nazareth. In the days of Jesus, it was the largest city in Galilee.

It was the native place of Virgin Mary's parents, Anne (mother) and Joachim (father).

Excavations conducted at this place revealed a big amphitheatre, water systems, residential quarters etc. Now, ruins of St. Anne's Church can be seen in this area.

MOUNT TABOR OR MOUNT OF TRANSFIGURATION

The name of Mount Tabor is mentioned in the Old Testament (Judges 4:14), when Barak went down from Mount Tabor to fight Sisera.

The name of Mount Tabor is not mentioned

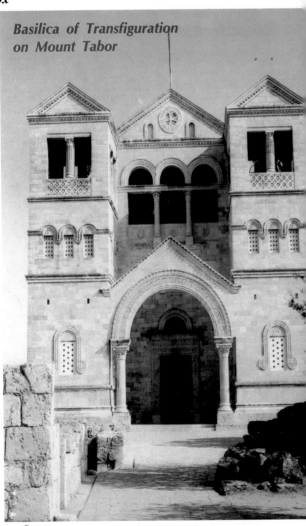

Basilica of Transfiguration on Mount Tabor

kilometers east of Nazareth and 40 kilometers west of Yardinit, the baptism site in River Jordan. This mountain is about 3,500 feet long, 800 feet wide at its base and 1800 feet high. The Arabs call this mountain as 'Jebel-et-tur', which means 'The most beautiful mountain.'

In 400 A.D. churches were build on Mount Tabor to commemorate this event of Transfiguration of Jesus Christ. But, they were destroyed later on. The Crusaders constructed a strongly fortified monastery on Mount Tabor. Finally, the Franciscons bought this property and are still maintaining it, till today.

The new Basilica of Transfiguration was consecrated in 1924. It was designed by Antonio Barluzzi, a renowned Italian architect, who was responsible for the design of many other Roman Catholic Churches in the Holy Land. An outstanding feature of this church is the facade (front of the building), which consists of two massive towers linked by a large Byzantine style arch.

The interior of this Basilica is divided by three pillars into naves (Central part of church). The central nave is terminating in a semi-circular apse. The dome of this apse has beautiful mosaics depicting the transfiguration of Jesus Christ standing in the middle and Moses and Elias on each side and the disciples, Peter, James and John a little below them.

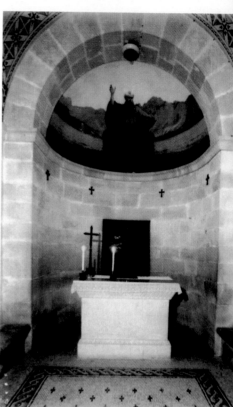

● *The Chapel of Moses in the Basilica of Transfiguration*

There are three chapels within this Basilica to commemorate Peter's proposal to build three tabernacles- one for Jesus, one for Moses and one for Elias.

The grotto of Jesus Christ is at the eastern end of the Basilica. The Chapels of Moses and Elias are located in the two towers, separately.

NAIN

The place, Nain is located at 3 kilometers south of Mount Tabor. Nain, means "Beauty."

According to Luke 7:11 to 15, Jesus went

● *Mosaic in Basilica of Transfiguration on Mount Tabor*

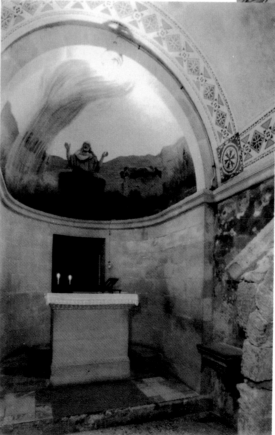

●*The Chapel of Elias in the Basilica of Transfiguration*

into a city called Nain and saw a dead man being carried. He was the only son of a widow. Jesus had compassion on the widow and consoled her by saying "Weep not.'' Jesus touched the beir (coffin) and said "Young man, I say unto thee, Arise''. He that was dead sat up and began to speak. Jesus handed him over to his mother.

SURROUNDINGS OF BETHLEHEM

Surrounding places of Bethlehem, which are not connected with the birth of Jesus in Bethlehem, but these places are of importance.

KING SOLOMON'S POOLS

Three huge reservoirs were constructed at the time of King Solomon, to collect rain water from the surrounding hills and store the water. This water was supplied to Jerusalem round the year, through aqueducts. These three pools are located at 4 kilometers south of Bethlehem.

The two upper pools receive water from the springs in the hills of Hebron (in Wadi el-Arrub and Wadi el-Biyar). Through the upper aqueduct water flowed to Jerusalem, while from the lower pool, another aqueduct carried water directly to the temple mount, which required lot of good water for performing many purification rituals. These three pools and two aqueducts were in use till 1967 but, later on discontinued, being economically unfeasible. The three pools were constructed along the bed of Artas valley in a cascading manner to allow flow of water from one pool at a higher level to the other pools at lower levels.

HERODION OR HILL OF HERODION

Herodion is one of the many fortresses constructed by King Herod to protect himself from his many enemies in Jerusalem.

Herodion is located at 7 kilometers south-east of Bethlehem. This mountain fortress was built between 24 and 15 B.C. Herodion is a concentric fortress with four towers surrounded by stones, mud etc., giving it an appearance of a volcano.

Archaelogical excavations carried out at this site revealed many palaces, defence towers, bath houses, and elaborate underground water cisterns and an aqueduct for bringing water from a far off place. ●

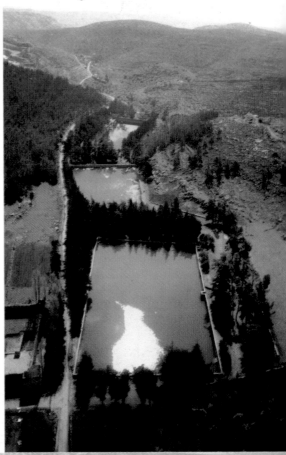

Three water pools of King Solomon

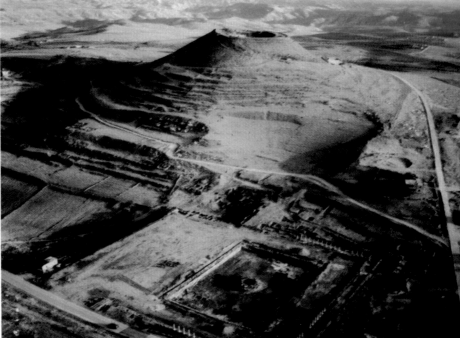

Herodion – Volcano like fortress ●

● *Herodion Fortress on the top of volcano like hill*

According to the wish of Herod, he was buried in Herodion.

HEBRON

Hebron is an Arab town located at about 25 miles from Jerusalem and 20 miles south of Bethlehem.

Hebron is one of the oldest towns in the Holy Land and is very much mentioned in the Old Testament. Abraham's son, Issac was born in Hebron, as Abraham dwelt in the plains of Man're, which was in Hebron. (Gen. 13:10). The cave of Machpelah was purchased by Abraham and the tombs of his wife Sarah, Issac, Jacob, Rebekah, Leah were in this cave. Finally Abraham himself was buried here.

Just above this cave, Haram-el-Khalil was constructed. This is also known as Issac and Rebekah Tomb. It is also known as the Mosque of Hebron. Hebron is considered as a holy place by Christians, Jews and Muslims.

Hebron is noted for pottery and leather works.

In the northern part of Hebron, there are famous glass factories, which make many items in blue glass.

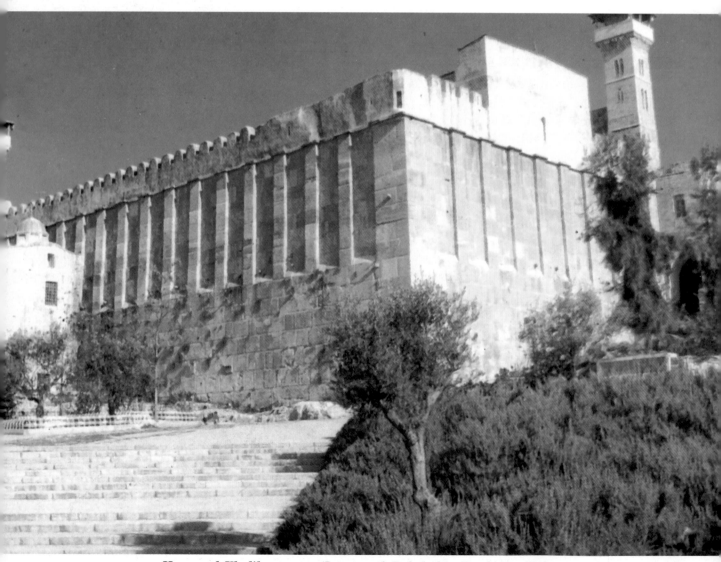

Haram-el-Khalil mosque (Issac and Rebekah's Tomb) in Hebron ●

9. Western Region of Israel
MEDITERRANEAN SEA COAST

The biblical spots located in the Western Region of Israel, adjoining the Mediterranean Sea and its coasts are all mentioned in the Old Testament. The events that took place in this region are more or less of historical importance.

TEL AVIV

The city of Tel Aviv is the International Airport of Israel. The name of the Airport is 'Ben Gurian'. The actual airport is about 30 kilometers from the city of Tel Aviv. Some times, the pilgrims land at this airport and start their tour of the Holy Land from here. Some times, the pilgrims end their tour in Tel Aviv.

Neot Kedumim Biblical Landscape Reserve

Here, all the plants mentioned in the Bible are grown to enable the pilgrims to have an idea of the plants like, Sycamore, Fig, Olive, Palm, Grapes etc.

Pilgrims can also visit a Chapel,, where 1600 years ago, Christians prayed. Pilgrims can also observe how olive oil is extracted from olives. Pilgrims can also taste a 'Biblical Meal' at this spot.

Mini Israel

Here, a large number of miniature models of holy sites of Christians, as well as others located all over the country of Israel are arranged. The main purpose of this is when

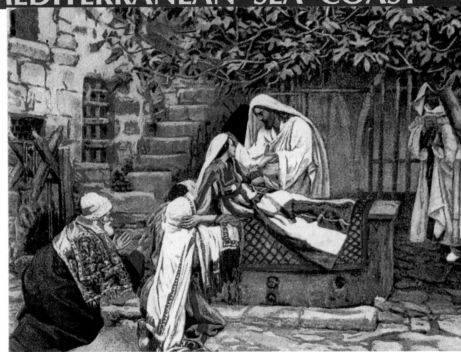

Peter raising Tabitha, who was dead in Joppa or Jaffa

the pilgrims visit 'Mini Israel' they can know in advance, what they will be seeing in different places. On the other hand, if the pilgrims visit 'Mini Israel' finally after completing their tour of Holy Land, they will get the sweet and unforgettable remembrances of what they had seen. Mini Israel is located near the Latroun Trappist Monastery and hence, the pilgrims can visit the monastery also.

Other places of interest near Tel Aviv are 'Ramle' and 'Lod', which were Holy Land centers during Crusaders time. Lod was the place, where Aeneas was healed by Simon Peter, during his visit to his place. (Acts 9:32-35).

JAFFA OR JOPPA

To the south of Tel Aviv is the ancient sea port of Joppa. Now a days, Joppa is known as Jaffa. Arabs call it 'Yafa'. This is the main sea port of Judea. It was at this port that cedar wood sent by King Hirum of Tyre for the construction of temple by King Solomon were unloaded and transported to Jerusalem on land.

Joppa is known to all Christians as it was at Joppa that Jonah attempted to flee from God by getting into a ship going to Tarshish instead of going to Nineveh as desired by God (Jonah 1:1 to 17). But, as there was a storm, the mariners felt that Jonah was responsible for this storm and threw him into the sea. The Lord had prepared a great fish to swallow up Jonah and he was in the belly of this fish for three days and three nights. According to Jonah 2:1 to 10, Jonah prayed to

God from the belly of the fish. The Lord ordered the fish to vomit Jonah on dry land. Then, Jonah went to Nineveh, as ordered by Lord.

Another interesting event that took place at Joppa was the vision of St. Peter. According to Acts 10:1 to 48, Peter, who was at Joppa went up the house top to pray at about sixth hour (12 noon). He was hungry and fell into deep sleep. He had a vision, in which he saw heaven opened and a certain vessel descending unto him as it had been a great sheet knit at the four corners and let down to the earth where in were all manner of four footed beasts of the earth and wild beasts and creeping things, and fowls of the air. There came a voice to him- "Rise, Peter; kill and eat". But, Peter said, "Not so Lord; for I have never eaten anything that is common or unclean". The voice spake unto him again "What God hath cleansed, that call not thou common." The voice came again for the third time, and the vessel was received up again into heaven.

This vision was on the roof of the house of Simon the tanner in Joppa. Even now, it stands in the old city of Jaffa, as a visitor's spot.

Close to Tel Aviv Botanic Garden, the grave of Tabitha (Dorcas) is a visitor's spot now a days. As it is written in Acts 9:36 to 43, at Joppa, a certain disciple named Tabitha, which by interpretation is called Dorcas: was sick and died. Peter was at Lydda, which was near to Joppa. So, they sent two men to Peter to called him to Joppa. Peter came, kneeled down and prayed and turning to the body of Tabitha he said "Tabitha, arise" and she opened

her eyes: and when she saw Peter, she sat up. Peter gave her his hand and lifted her up and presented her alive to saints and widows in Joppa. Many believed in the Lord.

CAESAREA

Towards north of the city of Tel Aviv and Jaffa, the city of Caesarea is located on the Mediterranean Sea coast. As the pilgrims approach Caesarea, they can see the tall chimneys of the electric power generation plant. It is known as Haifa Power Station, as the city of Haifa is also nearby.

Caesarea was built by Herod the Great in 20 B.C. and named after Caesar Augustus. It was one of the most splendid cities of the ancient world provided with a large harbour, an aqueduct to bring water to the city, an Amphi Theatre, Hippodrome, hot water baths etc. For 600 years, it was the capital of the Roman Province of Judea and official residence of its Governors, including Pontius Pilate.

Simon Peter preached to a gentle congregation here at the house of Cornelius, a centurian of the band called the Italian Band. (Acts 10:1 to 8). Cornelius had a vision in which he was asked by the angel of the Lord to send men to Joppa and call for one Simon, whose surname was Peter. Accordingly he brought Simon Peter to Caesarea, where he preached and baptised many people.

Another event was that from Caesarea, Paul was sent to Tarsus.

In 66 A.D., the Jewish revolt against the Romans resulted in partial destruction of Caesarea also. Later on, Crusaders rebuilt Caesarea as a Citadel town. The massive fortified walls of the Citadel can still be seen in Caesarea.

There was a huge aqueduct outside Caesarea to bring water to the city from a distant source of water.

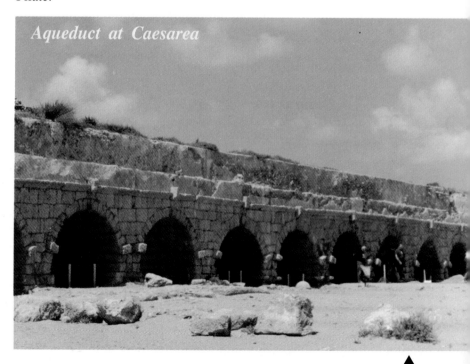

Aqueduct at Caesarea

STELLA MARIS

At the top of Promontory (high land extending into sea) there is a large Carmelite Monastery, from where a good view of the city of Haifa can be had. The church was built over a cave associated with prophets Elijah and Elisha. Nearby is the light house called 'Stella Maris', which means 'Star of the Sea'. In the lower garden of the monastery, there is a cave of Elijah, where he lived.

MUKHRAKA

According to I Kings 18:1 to 46, the people were worshiping their God 'Baal' and his consort, 'Ishtar'. Prophet Elijah challeged the 450 prophets of Baal to prove as to whose God was true God. The prophets of Baal prepared the sacrifice of a bullock and prayed the whole day but no fire from heaven came down to consume the sacrifice. Then, Elijah prepared his sacrifice of another bullock and got the altar drenched three times with plenty of water. He then made a long prayer. The fire of the Lord fell and consumed the sacrifice and even wood, stones and water also. All the people who saw this, fell on their face and said "The Lord, he is the God, the Lord, he is the God".

Elijah said unto them "Take the prophets of Baal; Let not one of them escape." They took them: and Elijah brought them down to the brook Kishon, and slew them there.

To commemorate this event, a Carmelite Monastery was built there in 1886. In the courtyard of this Monastery, there is a big statue of Elijah raising his sword to kill the prophets of Baal; and a head of such prophet under the foot of Elijah.

HAIFA

The city of Haifa is further north of Caesarea on the coast of Mediterranean sea. This city was built on the slopes of Mount Carmel. This harbour can

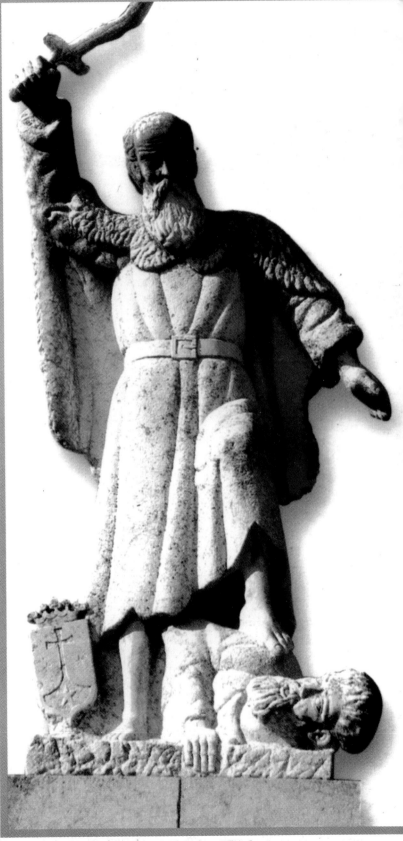

▲ *Statue of Prophet Elijah*

▲ *Bahai Temple in Persian Garden*

accommodate all kinds of ships.

The city of Haifa is noted for a beautiful Golden Domed Bahai Temple with a large garden around it. This temple was built by Bahai Trust in the premises of a Persian garden. Bahai faith stresses on unity of God and the brotherhood of the mankind. Bahai has many such temples in different countries.

ACRE

Acre is also known as 'Akko'. It is also known as 'Ptolemais'. From the ancient times, Acre is noted as an important city and harbour. Acre is located to the north of Haifa city.

According to Acts 21;7 and 8, after finishing his work at Tyre,

Paul came to Ptolemais (Acre) and saluted the brothern and abode with them one day. The next day, Paul went to Caesarea.

In 1104 A.D., Crusaders made Acre as their capital, setting up the kingdom of Acre, which was ruled by the knights of St. John and lasted until 1291. A secret underground tunnel was constructed in Acre to enable the knights to escape in case of a siege, and reach the harbour through the tunnel. This port lost its importance after the advent of large steam ships.

MOUNT CARMEL

Mount Carmel is located towards the south of the city of Haifa. This mountain is a ridge of about 8 miles long and 1200 feet above the sea level. From a hill at Nazareth, Mount Carmel can be seen. From the top of Mount Carmel, Mount Tabor, Mount Hermon and Mount Gilboa are visible.

At the summit of Mount Carmel there is a convent of St. Elias. At the foot of Mount Carmel, a town by name 'Chaifas' is located. To the right of Mount Carmel, at a distance, one can see the snow clad Mount Hermon. Towards south-east, Mount Carmel is connected with the mountains of Samaria by a broad range of wooded hills.

TYRE AND SIDON

Tyre is also known as 'Sur'. These two cities- Tyre and Sidon are located still north of the city of Haifa.

According to Matt. 15:21 to 28 and Mark 7:24 to 30, Jesus

Christ visited Tyre and Sidon and healed a daughter of a woman, who had great faith. Paul also visited Tyre and Sidon many times.

It was from Tyre that King David and his son King Solomon got cedar wood for the construction of palace and later on for Jerusalem Temple. King Hiram of Tyre helped them to get this wood.

ASHDOD

Ashdod was one of the five major Philistine cities to which the Philistines took the ark of God and set it into the house of Dagon. But, every morning, the people of Ashdod found that Dagon had fallen upon his face to the earth before the ark of the God. So, the people of Ashdod transferred it to Gath, and then to Ekron, Gaza, and Ashkelon with disastrous consequences. (I Samuel, 5th and 6th chapters). Now a days Ashdod is a major sea port.

ASHKELON

4000 years ago, Ashkelon was a Canaanite city, under the protection of Egypt. Later on, it became one of the five major Philistine cities. As it was the birth place of Herod the Great, it was developed very much, when Herod was in power. The Crusaders made Ashkelon as their coastal fortress. But, after the crusaders were defeated, this place was completely neglected. Now a days, Ashkelon is a residential and vacation town. All the statues installed by Herod the Great in Ashkelon have now been placed in the National Park.

10. Southern Desert Region of Israel

The two prominent deserts areas in Israel are Judean desert and Negev desert.

Judean desert area has many spots of biblical interest, like Jerusalem, Bethlehem, Nazareth, etc. as explained in the earlier pages.

Negev desert is located in the extreme south of Israel. Since the ancient times, not many events of biblical importance had taken place in this desert region. The capital of this region is 'Beersheba'. In this region, Beersheba and Eilat are of much importance.

BEERSHEBA

This city was founded by Abraham nearly 3000 years ago. Here, Abraham dug many wells. The meaning of the word 'Ber Sheba' is well of the oath. Its name originated with the oath between Abraham and Abimelech (King of Gerar). According to Genesis 21:32 and 33, Abraham and Abimelech made a covenant at Beeersheba and Abraham planted a groove in Beersheba.

Out of all the wells dug by Abraham in Beersheba, two wells still exist. These wells are of 12.5 feet in diameter and 66 feet deep. Even today, many camels and sheep drink the water drawn and poured into stone or cement troughs.

Another ancient event that took place at Beersheba was that it was from Beersheba that Abraham sent away his Egyptian handmaid, Hagar and her son Ishmael. (Gen 21:14)

Another spot near this is known as Karkom, which is believed to be site on Mount Sinai, where Moses brought the 'Ten Commandments' from Mount Sinai.

EILAT

Eilat is the southern most town of Israel. It is located at the Head of the Gulf of Eilat, opening into the Red Sea. The name of Eilat is mentioned in the Old Testament.

From the year 1967 onwards, pilgrims started visiting Eilat in large numbers to enjoy the year round mild summer and other sceneries.

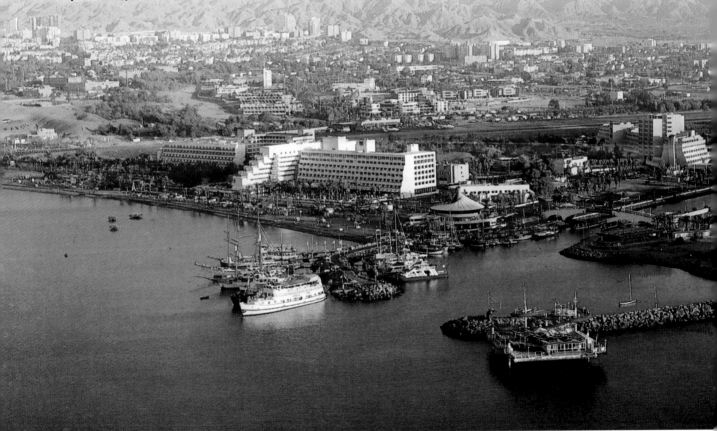

Eilat

11. Biblical Spots in the Country of Jordan

Normally, the pilgrims who have come from distant countries, desire to visit the biblical spots in the adjoining country of Jordan also.

The country of Jordan and country of Israel are separated by River Jordan. The three important places of biblical importance in Jordan are: Madaba, Mount Nebo and the first baptismal site in River Jordan.

MADABA

Madaba is located 30 kilometers south of the city of Amman, which is the capital of the country, Jordan.

The importance of Madaba is that in the year 1896, a most important geographic mosaic of Byzantine period was discovered under the floor of St. Stephen's Church at Umn-al-Rasas, situated close to the city's north gate. It is a rectangular panel of 15.7 meters long and 5.6 meters wide. This map shows the Holy Land, Jordan, Lebanon, Syria, Sinai desert, Nile delta in Egypt etc. This map covers all areas from Tyre and Sidon in the north up to Arabian desert in the south. There are more than 150 captions in Greek language. The center of the map depicts the Holy city of Jerusalem.

MOUNT NEBO

Mount Nebo is close to the village 'Faysaliyah', about 37 kilometers south of Amman (Capital of Jordan) and about 7 kilometers

● *Map of Madaba*

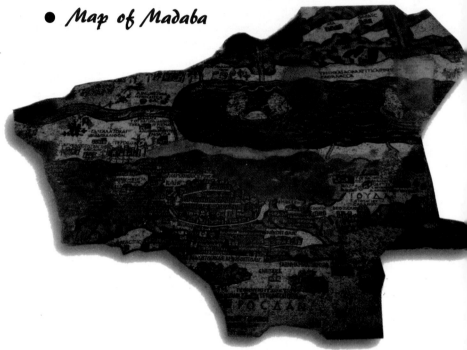

south of the city Madaba.

Mount Nebo's highest peak is 800 meters above the surrounding plains. On a clear day, one can see with naked .eyes, as far as Bethlehem, Jerusalem, Jericho, Dead Sea etc, from Mount Nebo.

According to Deuteronomy 34:1 to 5, Moses went up from the plains of Moab unto the mountain of Nebo, to the top of Pisgah, that is over against Jericho. The Lord showed him all the land of Gilead unto Dan, and many more areas. The Lord said to Moses "This is the land, which I swore unto Abraham, unto Issac and unto Jacob, saying, I will give it unto thy seed: I have caused thee to see it with thine eyes, but thou shalt not go over thither."

Moses was an hundred and twenty years old. Moses died there in the land of Moab and was buried in a valley in the land of Moab, over against Beth-peor; but no man knoweth of his sepulchure unto this day.

According to Numbers 21:5 to 9, the people spake against God and against Moses, complaining that there was no bread and water. The Lord sent finery serpents among people and they bit the people and many died. The people requested Moses to take away the serpents. The Lord said to Moses, "Make thee a fiery serpent and set it upon a pole: and it shall come to pass that every one that is bitten, when he looketh upon it, shall live."

Medaba is an ancient city in Transjordan which is mentioned in Numbers 21:30. Christians lived in this large settlement during the Roman and Byzantine period, building houses and churches.

When a Greek Orthodox Church was erected in 1884 on the ruins of an earlier church from the sixth century A.D., the mosaic map was discovered. It portrays the Holy Land and its neighbours.

The Greek name-places are those of settlements mentioned in the Bible.

The following is a list of some of the places and incidents shown on the map:

1. **The Dead Sea.**
1A. **Adam and Eve with the serpent.**
 The mosaic was disfigured, in keeping with the custom of the times not to portray human figures.
2. **The hot baths.**
3. **The Jordan River flowing into the Dead Sea.**
4. **Jericho** - one of the oldest cities in the world. An oasis, where date palms, sub-tropical fruits and exotic flowers grow in abundance.
5. **The Mountains of Moab.**
6. **Jerusalem** - the map depicts the two main roads with avenues of columns. Parts of one of these avenues - the Cardo - have been excavated and reconstructed. The mosaic also shows the Tower of David, the Church of the Holy Sepulcher, Mount Zion, the Damascus Gate and the Pillar of Hadrian.
7. **Bethlehem.**
8. **Judah.**
9. **Hebron - the Cave of Machpelah.**
10. **Tekoah.**
11. **Emmaus.**
12. **Lydda (Lod)**
13. **Yavneh** - on the coast, where the Sanhedrin was re-established by Jews who had managed to escape from Jerusalem, when it was razed by Titus in 70 A.D.
14. **The Tribe of Dan.**
15. **Jaffa-** the sanctuary of Jonah the Prophet.
16. **Jacob's Well - Nablus.** Dug by the Patriarch over 3,000 years ago. This is considered a hallowed spot and has remained a place of pilgrimage over the centuries.

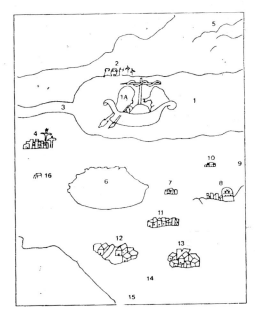

Moses made a serpent of brass and put it upon a pole and it came to pass that if a serpent bit any one and he beheld the serpent of brass, he lived.

To depict this event, in the courtyard of Moses' Church on Mount Nebo, just in front of this Church, there is huge Statue of 'Moses' Serpent'. On a circular wooden rod, a serpent made of metal is erected.

According to Exodus 17:1 to 6, when the children of Israel journeyed from the wilderness of sin, after their journey, there was no water for the people to drink. Moses prayed to the Lord, who said, "I will stand before thee there upon the rock in Horeb; and thou shalt smite the rock and there shall come water out of it, that the people may drink." Moses did so in the sight of the elders of Israel and got water. Moses called this place as 'Massah' and 'Meribah'.

From Mount Nebo, down in the valley, among thick trees, the pilgrims can see with naked eyes, a small white structure, which is believed to be the spring of Moses. But it very difficult to reach this place in the valley.

FIRST BAPTISMAL SITE BEYOND JORDAN

According to John 1:28, the first baptismal site of John the Baptist on River Jordan was at a

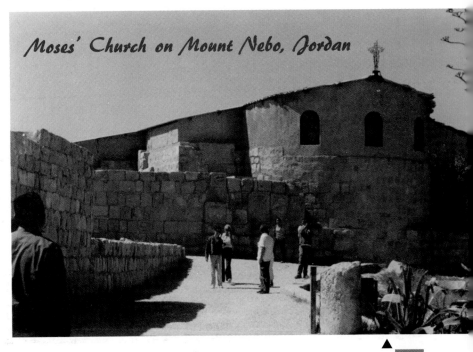

Moses' Church on Mount Nebo, Jordan

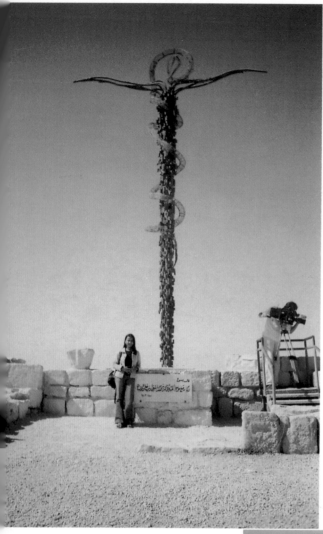

portions of the Bible. Towards the end of this long path, there is a small church, just on the bank of River Jordan.

Proceeding a little further, the pilgrims can reach the river. Here, River Jordan is only about 15 feet wide and 10 feet deep. The water is light brown in colour.

Conclusion

Though the country of Israel (The Holy Land) is a very small country, with a total land area of about 10,840 square miles, wherein more than 50% of the land area is occupied by deserts, mountains, valleys and caves, it was in this country that our Lord and

Saviour Jesus Christ chose to be born, brought-up and conduct his mission of preaching for the repentance of all sinners and healing the sick people by performing miracles. Finally, Jesus Christ was crucified in this country for the sake of all sinners in this world.

All the events mentioned in the New Testaments and major events of the Old Testament had taken place in this small country itself. Thus, every inch of land in the Holy Land is connected, in one way or the other, with the events mentioned in the Holy Bible.

Having visited the most important biblical spots in a short time, the pilgrims will now return to their own countries with greatest satisfaction of fulfilling their life's desire of visiting the Holy Land and walking in the footsteps of Jesus Christ. Though the pilgrims have actually seen these biblical spots with their own eyes during their tour to the Holy

■ *Statue of Moses' serpent on Mount Nebo*

place known as 'Bethabara' in the country of Jordan. Bethabara is also known as Bethany No: 2.

To reach the actual baptismal site in river Jordan at this site, the pilgrims have to walk about one kilometer from the vehicle parking place. The route is cemented flooring in the midst of casurina trees. On this route, here and there, wooden constructions of Prayer Halls are there, where the pilgrims can have prayers, singing hymns and reading

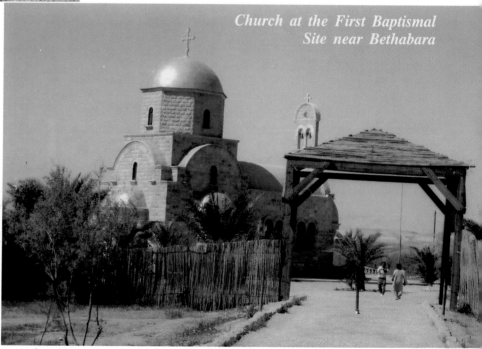

Church at the First Baptismal Site near Bethabara

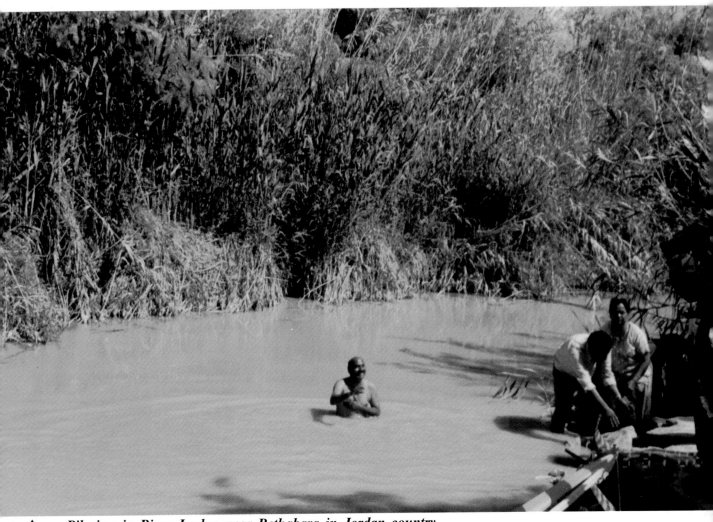

▲ *Pilgrims in River Jordan near Bethabara in Jordan country*

Land, by going through this book now and then, they will, with great happiness recollect their visits, which are unforgettable memories in their hearts. They will be able to explain to their relatives and friends (who have not visited the Holy Land), their experiences with the help of more than 150 coloured pictures printed in this book.

Reading this book is as good as watching a film of the Holy Land.

The author hopes that many will read this book and be blessed.

AUTHOR'S PRAYER

The author prays that the blessings of the Holy Land may be showered upon every one, those who have already visited the Holy Land or likely to visit or unable to visit.

May Our Lord and Saviour Jesus Christ Bless You All Abundantly

12. Index

PEOPLE AND THEIR LANGUAGES IN ISRAEL

In the year 2004, Israel's population was 6,631,000. Out of these 77% were Jews, 19% were Arabs (mostly Muslims), and the remaining 4% were Christians and others. Thus, Israel was founded as a Jewish State and still remains as such.

JEWS

The name "Jews" was first given in the ancient days to the people living in Judah (when the Israelites were divided into the two kingdoms of Israel and judah). After the Babylonian captivity, all the descendents of Abraham were called 'Jews'. In the New Testament, the term 'Jews' is used for all Israelites, as opposed to the 'Gentiles', or those of non-jewish blood.

After Israel was declared as a State in the year 1948, the Jewish population in Israel increased many folds as a result of mass migration of European Holocaust survivors and refugees from Arab countries. From that time onwards, Jews continued to come in varying numbers, both from countries of oppression and from the free world. In two major efforts (of 1984 and 1991) virtually, the entire Jewish community of Ethiopia, believed to have been there since the time of King Solomon came to Israel. Another large wave of

Ultra-Orthodox Jews with black long suits and felt hats ●

immigration, which began in 1989 is comprised of over one million Jews from the former Soviet Union. Thus, Israel's Jewish population, while untied by common faith and history, is characterized by a diversity of outlooks and life styles, resulting in a society, which is partly Western, partly East Europen, partly middle Eastern, but mainly Israeli. Over half of the present Jewish population in Israel are born in Israel itself and the rest have migrated to Israel from about 70 countries around the world.

But, unfortunately, from King Solomon's days, Jews had to struggle and fought many battles to save the Holy Land from the hands of many enemies. On the

Masada mountain in 72 B.C., 967 Jews had to commit suicide fighting against Roman Soldiers.

Jews observe "Sabbath" from the sunset on Friday to sunset on Saturday, that is mainly on Saturday, as a prayer day. All the shops and other establishments managed by Jews are completely closed on Sabbath days. On Sabbath days, Jews do not do any type of work, including travel by vehicles, except in times of life and death. The use of electricity is also, prohibited. On Sabbath days, all Jews attend prayers in the synagogues, learn 'Torah' (five books of Moses) and spend time with their families. For Jews, two festivals have become collective National Vacations. They are

'Succot', which is Feast of Tabernacles and 'Pesach'. Which is the Feast of Passover. On these festivals, the Jews make trips to the countryside or enjoy other leisure activities. But, religious Jews spend the time in prayer, study and with families. The Jews all over the world pray in the direction of Jerusalem.

The District of 'Mea Shearim' founded in 1872 is inhabited almost entirely by 'Ultra-Orthodox Jews'. These Jews are usually dressed in their customary fashion with long black coats, black trousers and a black round felt hat. Majority of them grow long beards, side locks and some of them have long mustache also.

The women and young girls of Ultra-Orthodox Jews wear long sleeved dresses with long skirts and keep their head covered with scarf, if they are married.

Visitors to these families are asked to conform to the local atmosphere and to dress modestly. These Jews have many ritual baths, a communal bake house and other aids for community living. These Jews start their day with morning prayers, strictly observing sabbath days, major festivals and minor fasts etc.

Generally, Jews speak Hebrew language.

CHRISTIANS

Though, Christians form only 4% of the total population in Israel, there are so many different types of Christians in Israel. Some of the prominent groups of Christians in Israel are as follows:-

- Roman Catholic Christians,
- Greek Orthodox Christians,
- Armenian Orthodox Christians,
- Russian Orthodox Christians,
- Franciscons,
- Sisters of Zion,
- Protestant Christians with many denominations,
- Jacobites.

All Christians observe Sunday as the Holy Day. But, the Seventh Day Adventist Christians observe Saturday as the Holy day.

Generally, all Christians speak English.

ARABS

Arabs form about 19% of the total population in Israel. Many Arabs had also settled down in Israel from the days of Muslim rule in 637 A.D., onwards. Most of the Arabs are Muslims. They speak Arabic language. They observe Friday as the Holy day.

Arabs and Jews live side by side in Jerusalem with contacts on economic and political levels.

CHAPELS, MONASTERIES AND IMPORTANT CHURCHES IN THE HOLY LAND
(Events Commemorated)

1. NAZARETH

i) Church of Annunciation, — Announcement of Jesus' birth by Angel Gabriel. Page-22

ii) Church of Archangel Gabriel. — Angel Gabriel's visit. Page-23

2. EIN KAREM

i) Church of Visitation (Church of Magnificat). — The visit of Virgin Mary to Elizabeth. Page-26

ii) Church of St. John the Baptist — In memory of John the Baptist. Page-27

3. BETHLEHEM

i) Church of Nativity. — Place, where Jesus was born. Page- 30

ii) Church of St. Catharine of Alexandria. — St. Catharine of Alexandria. Page- 32

iii) Church of Milk Grotto, — The flight of the Holy family to Egypt. Pages- 32 and 33

iv) Church of the Shepherd's Field — Church built over the cave of the shepherds. Page- 33

4. NEIGHBORHOOD OF SEA OF GALILEE

i) Church of St. Peter's Primacy. – The appearance of Jesus Christ to Peter. Page- 39

ii) St. Peter's Church, Capernaum. – Church constructed over the house of Peter. Page- 40

iii) Church of Beatitudes, – The Sermon on the Mountain. Page- 41

iv) Church at Tabgha. – The miracle of feeding the multitude. Pages- 41and 42

5. JERICHO

i) Chapel of Temptations. – Jesus Christ tempted by Satan. Page- 56

6. BETHANY

i) Church of St. Lazarus. – The tomb of Lazarus. Page- 58

ii) Chapel of Ascension. – Jesus Christ's ascension to heaven. Pages- 89 and 90

7. BETHPHAGE

i) Church at Bethphage. – The event of Jesus Christ entering Jerusalem. Page- 59

8. JERUSALEM

i) Church of All Nations (Church of Agony). – Jesus Christ's agony in the Garden of Gethsemane. Page- 72

ii) Church of The Pater Noster. – The place, where Jesus Christ taught his disciples, the Lord's Prayer. Page- 73

iii) Church of Dominus Flevit. – The place where 'Jesus Wept' over Jerusalem. Page- 74

iv) Church of Mary Magdalene. – Church on Mount of Olives to remember Mary Magdalene. Page- 75

v) Church of St. Peter in Gallicantu. – To remember Peter denying Jesus Christ thrice, before the cock crew. Page- 77

vi) Chapel of the Flagellation. – Where Pontius Pilate punished Jesus Christ. Page- 78

vii) Chapel of Condemnation. – Where Jesus Christ was condemned. Page- 78

viii) Ecce Homo Chapel. – To remember the words of Pontius Pilate 'Behold the Man', while handing over Jesus Christ for crucifixion. Page- 78

ix) Dormition Abbey (Church of Hagia Maria Zion). – The place, where Virgin Mary fell into eternal sleep. Pages- 78 and 79

x) Church of the Holy Sepulchure. – Where the last five stations of the cross are enclosed, Jesus' crucifixion and tomb. Page- 81

9. EMMAUS

i) Church at Emmaus. – Where Jesus Christ travelled with two men from Jerusalem to Emmaus, broke the bread with them and vanished. Pages- 94 and 95

10. SYCAR (NABLOUS)

i) Church on Jacob's well. – The event of Jesus Christ meeting a Samaritan woman at Jacob's well at Sycar (Samaria). Pages- 95 and 96

MONASTERIES

Nearly 1400 years back, a few hundreds of monasteries existed in the Judean desert terrain.

But, now a days, only five monasteries are active. These are as follows:-

1. St. George's Monastery in Wadi Kelt.
2. Qurantal Monastery, Mount of Temptation.
3. St. Gerosimous Monastery, in Jordan-Jerico Wadi.
4. Mar Saba Monastery, on the banks of Kidron Valley.
5. St. Theodorus Monastery, on Bethlehem –Dead Sea Road.

SPRINGS, RIVERS, POOLS AND SEAS IN ISRAEL

A. SPRINGS

1. *Banias, Dan and Hazbani Springs.* Pages- 37, 47

 These three springs originate in the Golan Heights at the northern most part of Israel, near Mount Hermon. They merge to from River Jordan.

2. *Spring of Elisha.* Page- 54

 This spring is located near the city of Jericho. According to II King 2:19 to 21, the men of the city said to Elisha that the water is naught and the ground is barren. So, Elisha went to the spring of water and cast salt into the water and said that there will not be any barren land. So the waters are used for unto this day.

3. *Gihon Spring.* Page- 92

 This spring is located outside the walls of the city of Jerusalem and a part of the water supply to the

city is from this spring. Gihon spring was the place, where King Solomon was anointed and proclaimed king. Later on, it become customary for all kings to drink water from Gihon Spring at the time of coronation. (I King 1:33-45).

4. *David's Spring.*Page- 50

 David's Spring is located in Ein Gedi area.

5. *Virgin's Spring or Mary's Well.* Page- 24

 Located in Nazareth, it is also known as Mary's Well. This spring, which begins from interior of the Church of St. Gabriel flows into the heart of Nazareth. It was at this spring that angel Gabriel appeared to Virgin Mary and announced the birth of Jesus.

6. *Spring Ein Haiye.*

 It is located in the Valley of Refaim.

7. *Spring En Yael.*

 There is a water tunnel leading from this spring.

B. RIVERS

1. *River Jordan.* Pages- 2, 36

 The biggest river in the Holy Land is River Jordan. It is considered to be a holy river, as Jesus Christ was baptised in this River by John the baptist.

 In addition to River Jordan, there are a few small rivers also, like Kishon, Tavot, Kidron etc.

C. POOLS

1. *Pool of Siloam.* Pages- 15, 69, 92

 Pool of Siloam is located in Jerusalem itself. Water from the Pool of Siloam is pure and hence, used in the temple for religious ceremonies.

2. *Pool of Bethesda.* Pages- 68, 92

 This pool was a spring fed pool, surrounded by five porches. It is believed that sheep were being washed in this pool, before they were sacrificed. It was at this pool that Jesus healed a man who had infirmity for thirty eight years.

3. *Struthion Pool.*

 Built by Hadrian in 135 A.D., it is located to the north-west corner of the Antonianum fortress. It was originally used as water reservoir by the Roman armies in the fortress. Today, this pool can be seen within the convent of the Sisters of Sion. Rain water is the main source of water to this pool.

4. *Pools of King Solomon.* Page- 99

 About 4 kilometers south of Bethlehem, three large pools to collect rain water to supply water to Jerusalem city were constructed. The Christian travellers to this area have given the name of 'Solomon Pools' to these three reservoirs, but they were actually constructed 800 years after King Solomon, during the Hellenistic and Roman period.

D. SEAS

1. *Mediterranean Sea.* Pages- 2, 8, 101-103

 Mediterranean Sea is in the western border of the country of Israel. There are many ports, the main being Yafa (Joppa) near Tel Aviv. Trade with western countries is conducted from these ports.

2. *Dead Sea or Salt Sea.* Pages- 3, 4, 37, 46-51, 93

3. *Sea of Galilee.* Pages- 1, 3, 4, 11, 12, 14, 21, 35, 37, 47

4. *Gulf of Eilat.* Page- 3

Gulf of Eilat is in the southern most part of Israel. This gulf opens into the Red Sea. The city located near this gulf is Eilat. It has become an important tourist spot of Israel.

MOUNTAINS, VALLEYS, CAVES OR GROTTOS AND DESERTS IN ISRAEL

A. MOUNTAINS

Israel is a mountaneous country with many mountain peaks and range of mountans, spreading over vast areas. Some of the mountains in Israel are as follows:-

1. *Mountain Hermon.* Pages- 2-4, 36, 46, 47, 104

Located in the northern most part of Israel, it is the border between the country of Israel and its northern neighbouring countries of Syria and Lebanon. This is the highest mountain in Israel with a height of 9,220 feet.

2. *Mountain Ramon.* Page- 3

Located in Negev desert, it is in the southern most part of Israel, its height is 3,396 feet.

3. *Mount Meron.* Page- 2

Located in Upper Galilee, its height is 3,964 feet.

4. *Mount of Olives.* Pages- 3, 8, 15-17, 57, 59, 60, 66, 68-71, 89

Located on the east side of the city of Jerusalem, it has many important churches and biblical spots located on this mountain. Its height is 2,739 feet.

5. *Mount Tabor.* Pages- 2, 4, 54, 97, 104, 113, 115

Located in Lower Galilee is it also known as Mount of Transfiguration, as Jesus Christ was transfigured in the presence of his three disciples, Peter, James and John. Its height is 1,930 feet.

6. *Mount Carmel.* Pages- 2, 104

This mountain is located towards the south of the city of Haifa. At the summit of Mount Carmel, there is a convent of St. Elias. The height of this mountain is 1,792 feet.

7. *Mount of Temptation.* Pages- 56

This mountain is located 1.5 kilometers north-west of Jericho city. On this mountain, Jesus Christ was tempted by Satan.

8. *Mount of Beautitudes.* Pages- 38, 40, 41

This mountain is located on the shore of Sea of Galilee. It is on this mountain that Jesus Christ gave the famous 'Sermon on the Mountain'.

9. *Mount of Masada.* Pages- 50-53

This mountain is located 2.5 miles from the west shore of the Dead Sea.

10. *Mount Herodion.* Page- 99

This is located 7 kilometers south-west of Bethlehem. On this mountain, which looks like a volcano, King Herod constructed a fortress to protect himself from enemies.

11. *Mount Scopus.* Pages- 60, 71, 94

This mountain is located towards the eastern side of the city of Jerusalem. Under this mountain, there is a long tunnel for the entry of vehicles from Jericho side into the city of Jerusalem.

12 *Mount Moria.* Pages- 60, 75

This mountain is located right in the city of Jerusalem, where the temple was located earlier.

13. *Mount Zion.* Pages- 60, 63, 68, 76, 78, 79

This mountain is also located in the city of Jerusalem. On this mountain, biblical places like Upper Room, Church of Peter in Gallicantu, Church of Flagellation etc. are built.

14. *Mount Gilo.*

It is 923 meters high, between Jerusalem and Bethlehem.

B. VALLEYS

1. *Kidron Valley or (Valley of Jehoshapat).* Pages- 59, 66, 69, 70, 75
Kidron valley is located in between the eastern wall of Jerusalem city and the Mount of Olives. This valley is just half a mile in width and stretches from north of Jerusalem to south upto Judean wilderness.

It is known as kidron valley, as a seasonal brook, known as Kidron brook flows through it.

2. *Jordan Valley.* Page - 57

Jordan valley extends along the river Jordan. Archaelogists say that at one time Jordan valley must have been a large lake. But, in subsequent years, earthquakes and tremors over centuries have dumped loose soil and gravel from the valley into the river Jordan, which made the river change its course.

3. *Jezreel Valley.* Page- 97

According to the Old Testament, this is the valley that separated Samaria province from Galilee province. Some times, the western part of its valley is called Esdraelon while the name Jezreel is restricted to the eastern part of this valley.

4. *Esdraelon Valley.* Pages- 2, 3

The word 'Esdraelon' is the Greek form of the Hebrew word 'Jezreel'. Esdraelon is a triangular plain of about 24 kilometers by 32 kilometers located about 89 kilometers north of Jerusalem.

5. *Rift Valley.* Page- 3

This valley is located in the far eastern part of Israel. This is a long strip of land which includes, Jordan River, Dead Sea and the Gulf of Eilat in the south of Israel. Most of this region is below sea level.

6. *Hinnom Valley.* Pages-65, 69

This is a deep and narrow ravine located south-west of Jerusalem. Here people constructed pagan altars and sacrificed their children as burnt offering.

7. *Hula Valley.*

Hula valley is located in the northern most part of Israel, near the Golan Heights. River Jordan starts here by the merger of three mountain springs- Banias, Dan and Hazbani.

8. *Artas Valley.* Page- 99

Artas valley is located to the south of Bethlehem, where King Solomon's three pools are situated. These three pools are along Artas valley.

9. *Arava Valley.* Page- 3

Arava valley is located near Eilat, which is in the southern most part of Israel.

C. CAVES OR GROTTOS

Israel, being a hilly country, there are many natural caves in the hilly areas since ancient times. Caves are known as 'Grottos' in Israel, but some scholars feel that 'Grotto' is an artificially made cave, usually, in a garden.

1. *Machpelah Cave.* Page- 100

This cave was purchased by Abraham to bury his wife Sarah, and later on Issac, his wife Rebekah, Jacob, Leah and Abraham also. (Gen 23:9-20; 49:30 and 50:13).

2. *Adullam Cave.* Page- 50

David departed thence and escaped to a cave Adullam. This is located in Ein Gedi. (I Sam 22:1)

3. *Cave at Sheepcotes.* Page- 50

When Saul heard that David was hiding in the caves of Ein Gedi, he took 3000 chosen men to seek David. When Saul came to the sheepcotes by the way, where there was a cave, Saul went into it, to cover his feet. David and his men were also in the side caves. (I Sam 24:1-3)

After the death of Lot's wife, Lot and his two daughters lived in a cave near Zoar. (Gen 19:30)

Prophet Elijah travelled forty days and forty nights to Horeb, the mount of God and he lodged in a cave. (I Kings 19:9)

In the New Testament also, many caves have been mentioned, which are as follows:-

4. *Grotto of Annunciation.* Page- 23

This grotto is in the lower section of the Basilica of Annunciation, in Nazareth. This depicts the exact place, where the angel Gabriel appeared to Mary and announced the birth of Jesus.

5. *Grotto of Ancient Spring.* Page- 23

This grotto is located in the Church of the Archangel Gabriel in Nazareth.

6. *Grotto of the birth of St. John.* Page-27

Located in the Church of John the Baptist in Ein Karem, where Elizebeth had to hide John to escape killing by Herod's soliders.

7. *Grotto of Benedictus.* Page- 27

This is located in the Church of Visitation in Ein Karem. Under its altar, there is a star marking the place, where John (the Baptist) was born.

8. *Grotto of Shepherd's Field Church.* Pages- 33-34

This cave is located in Bethlehem and it is believed that this cave was being used by the shepherds. This cave is now in the Shepherd's Field Church.

9. *Grotto of Nativity.* Pages- 30-32

Jesus was born in a cave that was used as a stable. This grotto is now located in the Church of Nativity in Bethlehem. The sacred 'Star of Bethlehem' is in this grotto.

10. *Milk Grotto.* Pages- 30, 32, 33

It is believed that while fleeing to Egypt to escape the killing of infants by the soliders of Herod, the Holy family stopped in a cave in Bethlehem, as Mary had to feed the infant Jesus.

11. *Grotto of Holy Family.* Page- 23

This is the cave where Joseph, Mary and Jesus stayed. It is also believed that this was the workshop

of Joseph, who was a carpenter.

12. ***Grotto of St. Sabas.***

This is located in the Monastery of Mar Saba near Kidron Valley. It is believed that St. Sabas lived for five years in cave here and 150 monks also lived in their own cells.

13. ***Grotto of Christ on Mount Tabor.*** Page- 98

On Mount Tabor, Jesus was transfigured in the presence of his three disciples, Peter, James and John. This Grotto is at eastern end of a Church constructed here.

14. ***Grottos on Mount of Temptation.*** Page- 56

After the baptism, the spirit drove Jesus into wilderness to be tempted by Satan. On this Mount of Temptation, many monks live in caves. Jesus might have spent forty days in one of these caves.

15. ***Caves of Qumran.*** Pages- 49, 50, 93

Qumran is located at the north shore of the Dead Sea on western side. There are hundreds of caves in this area. After the discovery of "Dead Sea Scrolls" by two shepherd boys, archaeologists excavated so far about 50 caves and found many vessels, coins, furniture etc., all this shows that people were living in these caves in ancient times.

16. ***Caves of Monastery of St. George, Wadi-Kelt.*** Page- 113
Wadi Kelt is located 5 kilometers west of Jericho. A few hundreds of hermit monks were residing in the caves there.

17. ***Cave of Lazarus' Tomb.*** Page- 58

The cave of Lazarus tomb is in Bethany. Just above this cave is a minaret of a Moslem mosque. Church of Lazarus is also in Bethany.

18. ***Grotto of the Eschatological teaching of Jesus Christ.*** Page- 74
This grotto is in the Church of Pater Noster on Mount of Olives. Here, Jesus taught his disciples, the 'Lord's Prayer'.

19. ***Candle-lit cave of Mary.*** Page-79

This cave is in the Church of the Tomb of Virgin Mary on Mount Zion. Mary's body was laid here and then taken up to heaven.

20. ***Cave of Jesus's Tomb.*** Page- 89

This cave is in the Church of Holy Sepulchure in Jerusalem. This tomb was originally in a cave hewn in a rock, and a Rotunda was built over and around it.

21. ***Cave Tomb of Jesus Christ in Garden.*** Page- 80
This cave tomb is located in the garden near Damascus Gate in Jerusalem. This cave was hewn in a rock and has two chambers, belonging to Joseph of Aremathea.

22. ***Cave of Elijah.*** Page- 103

This cave is in the lower garden of the monastery of Stella Maris near Mount Carmel. Prophet Elijah had this cave as his temporary residence.

23. ***Cave of Chariton.***

Chariton was the first monk in the Judean desert. On the descending slope of Wadi Khureitun, is the cave of Chariton. This is a big natural cave, comprising of several halls with an area of 180 square meters. There are tunnels, and narrow passage ways. At the entrance of this cave, there are two large stones, which are known as the Ten Commandments.

24. *Grotto of Gethsemane.* Pages- 17, 71-73, 84

Where Jesus and his disciples would stay, when ever they were in Jerusalem. It was from this small grotto that Jesus took Peter, James and John to the Garden of Gethsemane for his last prayers.

D. DESERTS:

The main deserts of Israel are i) Negev desert and ii) Judean desert, apart from a few other small deserts.

1. *Negev desert.* Pages- 2, 3, 105

The word 'Negev' means, 'Dry'. This desert is located in the southern part of Israel. It has a total area of about 4500 square miles, which is almost about 50% of the total area of the entire country of Israel, which is about 10,840 square miles.

Negev desert has many copper mines and copper is traded with Egypt and Arabia. The biggest city in Negev desert is Beersheba.

In recent years, the Government has introduced efficient irrigation system, known as the 'National Water Carrier of Israel' by which water from northern parts of Israel flows to southern parts like Negev desert, for irrigation.

2. *Judean desert.* Pages-50, 105

Judean desert comprises of the eastern slopes of Judea.

There are deserts and wilderness in this region. There are small settlements of "Bedouin" in this desert and they develope live stock like, camels, goats, sheep etc.

3. *Tzin desert, Paran desert.*

These are small deserts in the southern part of Israel. They may be considered as part of the great Negev desert.

HOLY ROCKS AND STATUES IN ISRAEL

A. HOLY ROCKS

1. *Rock in which infant John (the Baptist) was hidden to escape killing by Herod's soldiers.* Page-25

This rock is fixed in one of the walls of the Church of visitation in Ein Karem.

2. *Foot Anointing Stone of John the Baptist* Page- 26

During excavations of Ein Karem area, where John the Baptist practised his Baptismal proceedures, a stone, believed to have been used for foot anointing by John, was found.

3. *Stone of Temptation* Page- 56

When Jesus Christ was fasting for forty days on the Mount of Temptation and tempted by Satan, it is believed that Jesus was sitting on a stone during these forty days.

4. *Mensa Christi or the Rock Table of Christ* Page- 39

This rock table on which Jesus ate with his disciples after his resurrection is now in the Church of St. Peter's Primacy near the Sea of Galilee.

5. *Rock of Mounting* Page- 59.

Jesus Christ sat on a colt at Bethphage and went to Jerusalem, where people held palms and sang 'Hosanna'. It is believed that Jesus Christ mounted the colt by keeping this foot on a rock.

6. *Rock of multiplication of loaves and fishes* Page- 42

This rock, was used as a table while multiplying five loaves and two fishes to feed 5000 people.

7. ***Rock of Agony*** Page- 72

 This is the rock on which Jesus Christ fell on his face and prayed in the Garden of Gethsemane before his arrest.

8. ***Stone of Unction, (Anointing)*** Pages- 82-84

 When Jesus Christ died on the cross, his body was brought down from the cross and was laid on a the 'Stone of Unction' (Anointing) to anoint his body with spices, and aromatics, preparing for burial.

9. ***Rock of Ascension*** Pages- 71, 75, 89, 90, 94

 This is the rock from which Jesus Christ ascended to heaven near Bethany in the presence of his disciples. Pilgrims believe that they can see the foot print of Jesus Christ on this rock.

B. STATUES

1. ***Statue of St. Jerome*** Page- 33

 St. Jerome came from Italy to Bethlehem to translate the scripture into Latin. He stayed for a number of years in Bethlehem and died there.

2. ***Statue of St. Peter in Capernaum*** Page- 40

 In the compound of St. Peter's Church in Capernaum, there is a big statue of St. Peter, holding a staff in his left hand and big key in his right hand. The key is to depict the key to the kingdom of Heaven told by Jesus Christ.

3. ***Statue of Jesus Christ appearing to his disciples for the third time after his resurrection*** Page-39
 This statue depicts Jesus Christ standing and Peter kneeling down, Jesus telling Peter 'Feed my sheep'. This statue is near Tabgha and Church of Peter's Primacy, overlooking the Sea of Galilee.

4. ***Statue of Elijah*** Page- 103

 This statue depicts Elijah killing the priests of Baal with his sword after he won the battle of proving the true God.

5. ***Statue of Pope Paul VI***

 His Holiness Pope Paul VI visited the Holy Land in the year 1964. A statue of his bust is now at Mount Tabor in the compound of the Church of Transfiguration.

6. ***Moses' Serpent Statue*** Page-108

 On Mount Nebo in the country of Jordan there is a big statue depicting the brass serpent on a wooden pole meant for saving Israel is bitter by fiery serperts sent by God.

COMMON TREES IN THE HOLY LAND

1. OLIVE TREES: Page- 71

Olive tree is botanically known as 'Olea europaea'.

Olive trees grow up to a height of about 6 meters with twisted trunks and numerous branches. Olive tree is a symbol of peace. When Jesus Christ sat on a colt and entered Jerusalem for the last time, the people were holding olive and palm leaves in their hands, singing 'Hosanna'.

2. PALM TREES: Page- 55

Botanically known as 'Phoenix dactylifera' date palm also grow to a height of about 30 meters.

Palm leaves, which are usually 3 to 4 meters long are symbol of victory and rejoicing. When Jesus Christ was seated on a colt and triumphantly entered Jerusalem for the last time, people were holding palm leaves (branches) in their hand and singing 'Hosanna, Blessed is the King of Israel'.

3. FIG TREES: Pages- 16, 57

Fig tree is botanically known as 'Ficus carica'. Fig tree grows upto a height of about 11 meters. In rocky places, it has many stems and looks like a shrub. Fig trees are usually planted along with grape vines. (Luke 19:6 and I Kings 4: 25)

The children of Israel guided by Moses to the desert of Zin, complained that it was no place for figs, vines, pomegranates. Adam and Eve knew that they were naked; and sewed fig leaves together, and made themselves aprons (Gen 3:7). Even Jesus Christ desired to eat figs. (Mark 11:11-14)

4. SYCOMORE TREES: Page- 55

Sycomore tree is botanically known as, 'Ficus sycomorus'.

It is sturdy tree with a short trunk and growing up to a height of 10 to 13 meters. King David appointed overseers to look after the olive trees and the sycomore trees. Zaccheus climbed up sycomore tree in Jericho to see Jesus (Luke 19:4).

5. CEDAR TREES: Page- 60

Cedar tree is botanically known as 'cidrus libani'.

It is a very large spreading coniferous tree and has a great value for its wood. Cedar wood is highly durable and has a beautiful colour and hence, it is very expensive. Cedar tree grows as high as 40 meters. King David got Cedar wood from kingh Hiron of tyre for his palace. King Solomon got Cedar wood for temple. (II Sam 5:11 and I Kings 5:6-10)

King Solomon had chariots made of cedar wood. All this shows that cedar wood is very expensive and rich kings alone can afford to use it.

6. PINE TREES: Page- 59

There are different varieties of pine trees, which grow to a height 20 to 40 meters. Some of the varieties of pine trees are Jerusalem pine, Cypress pine, Cedar pine etc.

7. OAK TREES: Page- 70

In the Holy Land, there are three species of Oaks. The botanical name of Oak is 'Quercus'. These three species are:-

i) The Kermes Oak (Q.coccifera), or (Q.calliprinos).,

ii) The Deciduous Oak (Q.infectoria), and

iii) The Vallonea or Tabor Oak (Q.aegilops), or (Q.ithaburensis).

All species of oak trees are sturdy trees with stout trunks. They live for a very long time.

Absalom was caught by his hair in an oak (II Samuel 18:9 and 10). In the Russain Monastery Church-Holy Trinity garden, there is a very large and ancient Oak tree, which is called 'Abraham Oak'.

8. OTHER TREES:

Trees like Almond, Apple, Ebony, Pomegranate, Mulberry, are common in all other countries and hence, they are not explained here.

All these trees can be seen in "Neot Kedumin Biblical Landscape Reserve" in the city of Tel Aviv.

ISRAEL GOVERNMENT TOURIST OFFICES ABROAD

EUROPE:

AUSTRIA

Offizelles Israelisches Verkehrsbureau
Rossauer laende 41/12, A-1090 Wien
Tel: 1-310-8174, Fax: 1-310-3917
e-mail: igto-wien@inode.at
www.goisrael.at

CIS

Israel Government Tourist Office
B.Ordinka 51, Office 4, 113095 Moscow
Tel: 095-9373-642/3, Fax: 095-935-7649
e-mail: igtomos2@co.ru
www.goisrael.ru

FEDERAL REPUBLIC OF GERMANY

Staatliches Israelisches Verkehrsburo
Friedrichstr.95, D-10117 Berlin
Tel: 030-203-9970, Fax: 030-203-99730
e-mail: Israel@igtodeutschland.de
www.goisrael.de

FRANCE

Office National Israelien du tourisme
22 Rue des Capucines, 75002 Paris
Tel: 1-4261-0197, 1-4261-0367
Fax: 1-4927-0946, 1-4703-3831
www. Otisrael.com
e-mail: info@otisrael.com

HOLLAND-BRLHIUM

Israelisch National Bureau voor Tourisme
(Office National Israelien du Tourisme pour le Benelux)
Stadhouderskade 2, 1054 ES Amsterdam
Holland ; Tel: 020-612-8850, Fax: 020-689-4288
Belgium: Tel: 02-241-3597, Fax: 02-223-7828
e-mail: info@goisrael.nl

ITALY

Ufficio Nazionale Israeliano del Turismo
Corso Europa 12, 20122 Milano
Tel: 02-7602-1051, Fax: 02-7601-2477
e-mail; general@israele-turismo.it
www.israele-turismo.it

SPAIN

Oficina Nactional Israeli de Turismo
Para la Peninsula lberica e lberoamerica
Carranza 25-7p, 28004 Madrid
Tel: 91-594-3211, Fax: 91-594-4372
e-mail: israel@turisrael.com
www. Turisrael.com

SWEDEN

Israeliska Statens Turistbyra
Sveavagen 28-30, 4 tr
Box 7554, 10393 Stockholm
Tel: 8-213-386, Fax: 8-217-814
e-mail: info@igto.se
www. Goisrael.nu

SWITZERLAND

Offizielles Israelisches Verkehrsbureau
Lintheschergasse 12, 8021 Zurich
Tel: 1-211-2344/5, Fax: 1-212-2036
e-mail: igto@access.ch
www.israel-touristoffice.ch

UNITED KINGDOM

Isarel Government Tourist Office
UK House, 180 Oxford Street
London WIN 9DJ
Tel: 207-299-1113, Fax: 207-299-1112
e-mail: information@igto.co.uk
www.go-israel.co.uk

NORTH AMERICA:

TOURISM COMMISSIONER
FOR NORTH AMERICA

800 Second Avenue, New York, New York 10017
Tel: 212-499-5640, Fax: 212-499-5645
e-mail: info@goisrael.com
www.goisrael.com

INFORMATION CENTRE

For the General Public: Tel: 1-888-77-ISRAEL
For The Travel Industry:
Tel: 1-800-514-1188. Fax: 212-499-5665
e-mail: info@goisrael.com
www.goisrael.com

U.S.A.

Israel Government Tourist Office
800 Second Avenue,
New York, New York 10017
Tel: 212-499-5650, Fax: 212-499-5655
e-mail:igtnewyork@imot.org
Israel Government Tourist Office
6380 Wilshire Boulevard #1718
Los Angeles. California 90048
Tel: 323-658-7462/3, Fax: 323-658-6543
e-mail: igtola#imot.org

CANADA

Israel Government Tourist Office
180 Bloor Street West, Suite 700
Toronto, ontario M5S 2V6
Tel: 1-800-669-2369, 416-964-3784
Fax: 416-964-2420
Email: info@igto-ca

AFRICA:

SOUTH AFRICA

Israel Tourist Information
5th Floor Room 502, Nedbank Gardens
33 Bath Avenue, Rosebank 2132
P.O. Box 5256-, Saxonwold, Johannesburg
Tel: 11-788-1703/4, Fax: 11-447-3104
e-mail:igto@icon.co.za

ASIA & AUSTRALIA:

KOREA

Isarel Government Tourist Office
10 Fl. Room 1011 Hanaro Bldg., 1944
Insa-Dong, Jongro-Gu, Seoul,
Korea 110-794
Tel: 2-738-0882, Fax: 2-736-5193
e-mail: igto@israel.co.kr
Internet site: www.israel.co.kr

AUSTRALIA

Australia-Israel Chamber of Commerce
Tourism Department
395 New South Head Road
Double Bay, Sydney, N.S.W. 2028
Tel: 2-9328-1700, Fax: 2-9326-1676
e-mail:david@aicc.org.au
www.aicc.org.au

USEFUL ADDRESSES:

1. Incentive & Leisure Travel Consultants
 202-203, Kanishka Commercial Complex,
 Plot No. 3, Saini Enclave Community Centre,
 Vikas Marg, Delhi-110092
 India.
 Tel: 91-11-42508355, 42508366, 42508377
 Cell: 91 9810189955 Fax: 91-11-42508377
 E-mail: yovita@iltcindia.com

2. Association of Israel Tourist Guides:
 90, Bialik Street,
 PAMAT GAN –52536
 ISRAEL.
 Tel: 03-7511132, Fax: 03-7511233
 E-mail: itga@netvision.net.il

3. ISRAEL INCOMING TOUR OPERATORS ASSOCIATION
 Incorporating the Israel Travel Agetns Association,
 14, Ben Yehuda Street,
 TEL AVIV,
 ISRAEL.
 Tel: 03-6299348, Fax: 03-5256526
 E-mail: iitao@isdn.net.ii

4. Israel Youth Hostel Association,
 1, Shazar Street, JERUSALEM –91060,
 P.O.B. - 6001
 Tel: 02-6558406, Fax: 02-6558432
 E-mail: iyhtb@iyha.org.il